1-4

八瀦南鍼

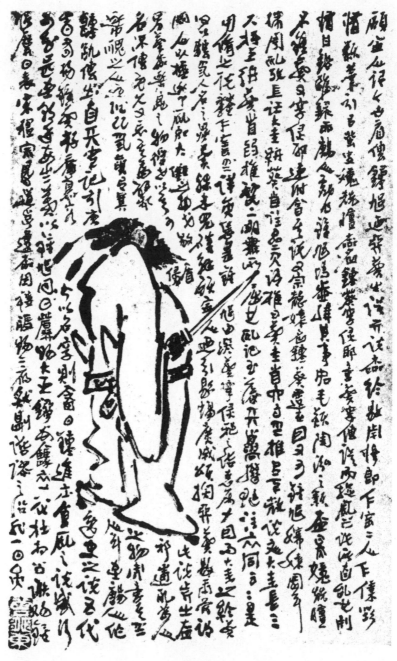

PLATE I

A charming example of the happy blending of painting with calligraphy,
by Tsêng Yen-Tung (曾衍東), an artist of the Ch'ing dynasty

(*Collection of Liu Mao-Chih, Shanghai*)

CHINESE CALLIGRAPHY

AN INTRODUCTION TO ITS AESTHETIC AND TECHNIQUE

BY

CHIANG YEE

With a Foreword by

SIR HERBERT READ

WITH 22 PLATES AND 157 TEXT ILLUSTRATIONS

Third Edition
Revised and Enlarged

HARVARD UNIVERSITY PRESS

Cambridge, Massachusetts

1973

First published by Methuen & Company, Ltd., 1938
Second Edition, with a new Preface, 1954
Third Edition, revised and enlarged, 1973
Second printing, 1973

Library of Congress Catalog Card Number 72–75400
SBN 674–12225–9

Printed in the United States of America

TO
ANOTHER
C. Y.

PREFACE

WHEN the first edition of *Chinese Calligraphy* appeared
in 1938, I was immediately struck by its significance
for the general philosophy of art, and more particu-
larly by its bearing on certain aspects of modern art. Ever
since we Westerners became familiar with Chinese civilization,
we have known that the Chinese attached what seemed to be
an inordinate importance to their handwriting. Most people
probably interpreted this peculiarity in terms of scholastic
discipline, for that is the way we have treated handwriting. To
write what was called 'a good hand' meant to conform to
a universal pattern, to suppress eccentricities, to approach as
closely as possible to 'copperplate', the standard lettering of
the engraver. It is only comparatively recently that a certain
'freedom' has been allowed, and even encouraged, in schools.
Another and very recent development is the popularization of
Italic or Humanist 'script' writing. This is sometimes con-
ceived as another formal discipline, in this respect not different
from copperplate ; but more generally it expresses a feeling for
the beauty of handwriting, and in this respect is nearer to the
Chinese conception of calligraphy.

Mr. Chiang, in his chapter on 'The Abstract Beauty of
Chinese Calligraphy', describes with great clarity the aesthetic
principles underlying this art. They turn out to be the aesthetic

principles of all genuine art, and what is really distinctive about Chinese calligraphy is the fact that it is not a separate and inferior craft, but an essential element in the artistic life of the Chinese people. 'The aesthetic of Chinese calligraphy is simply this: that a beautiful form should be beautifully exe-cuted.' But the aesthetic of Chinese painting is simply that too; and so is the aesthetic of Chinese sculpture or Chinese pottery. I would say that this is a universal principle of all art, and it implies, not merely that the work of art should be formally perfect, but that it should also be organically vital. In Chinese calligraphy, says Mr. Chiang, the main principle of composition is in every case a balance and poise similar to that of a figure standing, walking, dancing, or executing some other *lively movement*. 'The beauty of Chinese calligraphy is essen-tially the beauty of plastic movement, not of designed and motion-less shape.'

How such 'lively movement' is conveyed by a written character, or by a painting or a piece of sculpture or pottery, is a mystery that we cannot completely analyse—it is an instinc-tive co-ordination of the artist's mental image and the muscular stroke with which he 'expresses' or 'projects' that image. It is, at any rate, a very personal faculty, achieved by continuous practice and meditation, by a discipline that is spiritual rather than physical. Only a few great masters attain perfection.

What specially interested me when I first read Mr. Chiang's book was the analogy between this aesthetic and the aesthetic of modern 'abstract' art. I use the word 'analogy' because modern artists in general have not made their principles suffi-ciently clear (by the perfection of their works), and as a result the public is still confused and even antagonized by such art.

[viii]

PREFACE

I believe that the best of the Western abstract artists are groping in the right direction, and a great painter like Paul Klee had certainly found the illumination that comes from a perfect understanding of abstract beauty. But so many abstract paintings are 'designed and motionless shapes'; of how few could one say, as Mr. Chiang says of a Chinese character, that if any part had been wrongly placed the whole would appear to totter?

In the last few years a new movement of painting has grown up which is at least in part directly inspired by Chinese calligraphy—it is sometimes called 'organic abstraction', even sometimes 'calligraphic painting'. Soulages, Mathieu, Hartung, Michaux—these artists are certainly not unaware of the principles of Chinese calligraphy, and they try to achieve 'the first two essentials of good calligraphy' which are also the first two essentials of good Chinese painting—'a simulation of life in the strokes and a dynamic equilibrium in the design'. Sometimes they succeed, but more often they seem to me to be hampered by the relatively coarse and heavy materials of Western painting. Nor, perhaps, have they that intimate relationship to nature which, however hidden, lies behind every Chinese character.

Chiang Yee writes simply and clearly about matters which are subtle and difficult to understand. Not the least valuable aspect of his book is the charm of its style. Mr. Chiang has written many books since this one was first published, and has greatly extended our knowledge, not only of Chinese art and civilization, but also of art and civilization in general. He is one of those rare foreigners who help us to understand ourselves.

HERBERT READ

CONTENTS

PLATES

PLATES

Plates (continued)

PLATES

Plates (continued)

AUTHOR'S NOTE

APART of the text of this book was originally delivered in the form of lectures, mostly at the School of Oriental Studies, London University, during the time of the International Exhibition of Chinese Art in London, 1935–6, and to the China Society in London. I wish to express my obligation to my audiences, whose interest in Chinese calligraphy has impelled me to put my views on the subject together into book form. Mr. Cyril Goldie, of the L.C.C. Central School of Arts and Crafts, and Miss V. E. Hawkes, a teacher of the Royal College of Art, in particular assured me of the demand for such a book as this. Miss Hawkes, who teaches English calligraphy, suggested to me many important points on which English people interested in Chinese art would be glad of information. I am very grateful to her.

To Mr. Alan White, whose encouragement induced me to bring out my first book, *The Chinese Eye*, and who arranged for the publication of this one, it is impossible for me to express my gratitude. He has spent much time in rectifying my expressions, helping me to assemble the illustrations, and checking the proof. I owe him a particular debt.

I have also to thank several of my fellow-countrymen who have helped me in various ways. Mr. Yeh Kung-Ch'o, ex-minister of Finance in the Chinese Government, who is a well-known living calligrapher, has kindly contributed a piece of his own calligraphy to the illustrations. Mr. Ts'ai Yü-Ting, a well-known collector of stone-rubbings and writings, has lent many of his valuable treasures for reproduction. Mr. Ou-Yang Fu, a well-known critic of calligraphy and the author of a widely read book on the subject, ' *Chi-Ku-Ch'iu-Chên* ', has given me some valuable ideas towards the explanation of the beauties of Chinese calligraphy.

[xvii]

Mr. Chang Lai-Kung, a calligrapher renowned as a faithful follower of Chang Yü-Chao's style, has supplied me from China with Chinese books of reference on the subject, books which were essential to me and which are very difficult to obtain in London. Mr. Tai Liang-Mo, Professor Liu Hai-Su, Mr. Ch'ên Tzü-Ming and my elder brother Chiang Ta-Ch'uan have all helped me by supplying either materials or examples from their own collections.

Although I have not been able in this book to go into as great detail or cover as much ground as I could have wished, I think that what I have done will serve the purpose of those who wish for a general outline of the subject. The book may also perhaps prove helpful to collectors of Chinese paintings, the inscriptions on which, putatively written by famous calligraphers, may be compared with reproductions in this book and their authenticity, if not proved, at least supported.

C. Y.

October 1937

ACKNOWLEDGMENT TO THE SECOND EDITION

THE AUTHOR desires to acknowledge especially his indebtedness to Sir Herbert Read, who kindly contributes a Preface to the second edition of this work. The analogy Sir Herbert draws between the aesthetic of Chinese calligraphy and new trends in modern art is full of insight and stimulation.

C. Y.

June 1954

NOTE TO THE THIRD ENLARGED EDITION

Chinese calligraphy was first published in London in October 1938. After the considerable success of my first book, *The Chinese Eye*—an interpretation of Chinese painting—I thought I should write on Chinese calligraphy in order to introduce its aesthetic and technique, which form the backbone of Chinese painting. But calligraphy is derived from ancient

Chinese scripts and most Westerners shrank from the subject, thinking they would not understand it if they did not know the language. Each time I tried to interest a publisher in the subject it was brushed aside for that very reason. A year later, however, Mr. J. Alan White, Chairman of Methuen & Company, decided to publish it. Though *The Chinese Eye* had met with success, Mr. White warned me not to expect much from the *Calligraphy* book.

Being a good friend, he showed much interest in the manuscript and took pains to go page by page through the text with me. When the book was eventually brought out, his prediction proved correct: its sale was almost nil. Unhappily it came out at the wrong time, when the Munich crisis had just developed. In an atmosphere filled with war rumors, no one desired to read a book not easy to understand. The war began in September 1939, and the sale of *Chinese Calligraphy* completely stopped.

When the United States entered the war in 1942 many American troops were stationed in England. All English efforts had been concentrated for three years on war production, leaving neither material nor time for manufacturing toys and gifts; as Christmas approached, the American G.I.s started to buy copies of *Chinese Calligraphy* to send home as Christmas gifts. By the end of 1942 the entire edition, though small, had gone to America. Is it not curious that a work on such an esoteric subject turned out to be a Christmas giftbook? I can still recall those difficult days in England with glee, for it was an unbelievable result!

After World War II the world's attention focused increasingly on Far Eastern Asia. Many more people became interested in things Chinese, not just casually and superficially, but with a true desire for understanding. Many more books of Chinese studies were being published, and museum exhibitions of Chinese art, particularly pictorial art, were continually held. Up to 1971 *Chinese Calligraphy* has been reprinted eight times: in a second edition (1954) with a preface by Sir Herbert Read, and in a third edition (1961), both unrevised, owing to the demand for saleable copies. Chinese calligraphy has long since ceased to be a recondite subject.

At the end of 1969, with the stock of the book near exhaustion, I was asked to do a revised edition. This new edition is the result. It is satisfy-

ing to know that there is still a demand for the book, but I am particularly glad to have found time at last to read the whole text through, and to correct a number of minor misprints and occasional English misspellings of Chinese characters. The introduction, which was written in 1937, contains many passages expressing my thoughts on what was then an unfamiliar subject. Though it is so no longer, these passages still have value for those unacquainted with Chinese calligraphy; I therefore prefer to keep them as they are, and have made no attempt to bring them up to date,

Two new chapters have been added to complete my treatment of the subject. As Chinese painting is very closely related to calligraphy, those with an interest in the former inevitably begin to wish to study the latter, and even try to practice it; ' Calligraphy and Painting ' describes their relationship more fully. ' Aesthetic Principles ' explores concepts essential to a complete understanding of the artistic expression of the Chinese mind. These chapters have a number of new illustrations. Let me say again that as the book is intended for the general reader, I have not dealt in detail with the historical background of Chinese calligraphy, and have avoided burdening the reader with the unfamiliar names of many noted calligraphers.

I should like to take the opportunity to express my thanks to my good friend, Professor Fang Chao-ying, who has not only carefully proofread the whole manuscript, but has also contributed many good suggestions for the new chapters.

C. Y.

March, 1971

CHINESE CALLIGRAPHY

I

INTRODUCTION

CALLIGRAPHY as a general term simply means groups of words, in any language, conveying human thought and written by hand. It is very rarely considered, as in China, to be an art; indeed, I do not know of any other country where it is still practised and generally recognized as such. That, perhaps, is why the word 'calligraphy' is now seldom used to describe any but Chinese handwriting.

The history of Chinese calligraphy is believed to be as long as that of China herself. But its nature has always been a source of mystery and perplexity to Westerners, many of whom have understood well enough painting and other forms of Chinese art. Yet calligraphy, it can be affirmed, besides being itself one of the highest forms of Chinese art, is in a sense the chief and most fundamental element in every branch of it. Unfortunately, however, except for those brought up in the artistic traditions of the country, its aesthetic significance seems to be very difficult to grasp.

In studying the calligraphy of China one must learn something of the origins of her language, of the sources which gave rise to the characters, and of how they were originally written. For in their written form Chinese characters not only serve the purpose of conveying thought but also express in a peculiar visual way the beauty of the thought.

In my first book, *The Chinese Eye*, which was an interpretation of Chinese painting, I should have achieved one of my objects—the explanation of the aesthetic elements of brushwork—to a far greater extent had our calligraphy been more familiar to Westerners. The exposition of such a subject as calligraphy is really a considerable task, and I do not hope to cover all the ground in this one short book. But I can at least give in outline all the main facts. This book is not written for the benefit of those already knowledgeable on the subject, nor is it meant for any Chinese public. It is intended as a simple guide to those who wish to discover the fundamental principles. And it is therefore furnished with as many examples, illustrations and figurative interpretations as I have been able to think of. I shall be satisfied if it leads some people to appreciate one more form of our art, and helps them to understand more deeply the painting and other forms of our art which they already love.

Being myself profoundly interested in Chinese art, especially in its painting, I was anxious, when I came to England, to learn the Westerner's attitude towards it, and accordingly I read a number of Western books on the subject. Quite often I came across wondering comments or mistaken conceptions which, without a doubt, were entirely due to the fact that some branches of our art, especially calligraphy, have never been adequately interpreted. I have listened to the comments of many Westerners upon our handwriting. I have heard scores of people say : ' I like the appearance of Chinese characters, but I can't discriminate between good and bad.' Or, ' What exactly constitutes good writing ? ' Or, ' How is a beautiful character made ? ' And so on. Evidently there is a demand for knowledge. The

[2]

success of the Exhibition held in London in 1935–6, showed that a widespread desire exists to investigate intelligently the significance of Chinese art. One small room in the Exhibition was given over entirely to calligraphy, and I always saw numbers of people looking at the pieces with keen interest. Presumably they could not interpret them, but I imagine they must have been impressed by their decorative qualities—strokes, splashes and blobs woven together to form the happiest patterns.

One of my incentives in writing this book is to help such people to an enjoyment of our calligraphy without putting them to the labour of learning the language. If the student can understand the literal meaning of the words, so much the better : for an aesthetic appreciation it is not essential. You will understand my meaning if you think of a landscape painting in which the familiar forms of the scenery of your native land touch a chord of memory. You have a different and more pleasurable sensation from such a picture than from a painting of an unfamiliar scene. But I do feel that, without this sense of recognition, it is possible, provided one has a sense of line-movement and a knowledge of the frame structure of the matter, to appreciate the beauty of lines.

Before I go on to a summary discussion of our language in general, let me mention two things which touch my subject only indirectly, but which should, I think, prove illuminating. The first is a comparison of Chinese with Western calligraphy. I have paid many visits to the Department of Manuscripts and the Grenville Library at the British Museum and examined the old manuscripts from Bacchylides to the Articles of Magna Carta. Each piece has its own elegant arrangement of letters and words, but the effect of the whole seems to me to lack

variety. The cause of this is, I suppose, the restricted nature of the alphabetical forms. All twenty-six letters are composed of circles, curves, and straight and inclined lines, and this severely limits the forms of the various words. Looking at a manuscript as a whole I see only repeated circles, curves and perpendicular and horizontal lines, all with similar movements in relation to each other (though I must admit that the Magna Carta MS. shows some development of the inclined lines). Some of the initial letters at the opening of paragraphs are decorated with flowers or ornamental lines, but these embellishments are not part of the lettering, and are, moreover, painted, not written. Chinese characters, on the other hand, display a handsome variety in the shapes of the strokes, and each stroke may contain an individual variation of form, passing from the slender to the bold. English words, again, are limited mechanically as to length by the number of letters, and all must be written regularly from left to right; whereas every Chinese character is constructed in an imaginary square, which it can fill in a variety of beautiful ways. This is a matter which I shall discuss in a later chapter.

My second point is the close connexion of Chinese calligraphy with the daily life of Chinese people. I walk the London streets without any sensation of surprise at the shop-signs or advertisements in the windows, for they are almost all stylistically identical. They are neat, regular and symmetrical, but they are collections of lifeless letters—a criticism we have always applied to the printed forms of our own characters. Calligraphy is everywhere evident in China. The streets are hung with hand-written shop-signs and banners, done with the brush or painted on boards in large characters. Every establishment

bears the name of the owner and his wares. Nearly every restaurant, office or shop, and most private houses, bear also hanging quotations from the poets or philosophers, or lines from the ' Thirteen Classics ', eulogizing the appetizing quality of the food provided or offering established moral sentiments or poetic feelings. These signs have a threefold use : as decoration, as advertisement, and as an attraction to people of taste. Many a calligraphy-lover has been seen wandering the streets of a Chinese town, finding entertainment and pleasure in these humble examples of the writer's art. They are, it is true, as art, only decorative, and have therefore a shallower charm than those pieces of pure writing which are the product of real artistic feeling—their beauty is a beauty of the surface only ; but they are at least an improvement on the dead symmetry of printed characters.

Affection for the written word is instilled from childhood in the Chinese heart. We are taught never to tear up a sheet of writing, nor to misuse any paper with writing upon it, even if it is of no further practical use. In every district of a Chinese city, and even in the smallest village, there is a little pagoda built for the burning of waste paper bearing writing. This we call *Hsi-Tzŭ-T'a* (習字塔)—Pagoda of Compassionating the Characters. For we respect characters so highly that we cannot bear them to be trampled under foot or thrown away into some distasteful place. It is a common sight to see old men with baskets of plaited bamboo on their backs, gathering up this kind of waste paper from the streets and roads for burning in the *Hsi-Tzŭ-T'a.* You may be sure these old men do not act only on an impulse of tidiness ! There may be people nowadays who think them foolish ; but we cannot bring ourselves to abandon

our deep-rooted traditional habits. Newspapers, books, every kind of printed matter are poured out on all sides and in increasing quantity, but still the old reverence for the written word prevails.

The majority of our business men believe that a piece of good writing on their shop-sign and banner will bring good fortune, and they do their best to find competent calligraphers to write for them. For this service they are willing to pay almost any sum that the calligrapher may demand ! After the characters have been written or painted on the board, incense is burned in front of them, and before the board is hung up a celebration is held. This is surely sufficient evidence of the care and respect in which these written signs are held and of how much they mean to the merchants.

Many of my countrymen, knowing how great a part calligraphy plays in the daily life of the people, devote all their spare time to the cultivation of a good ' hand '. Do not make the mistake of thinking that calligraphers have to vary their style, like window-dressers who, lest their goods pall on the eyes of onlookers, have to be constantly changing the arrangement of them. Chinese calligraphy never satiates the eye or mind, and does not require to be continually rearranged. A good hand is the result of years of diligent and constant practice. Travelling from town to town, one can easily recognize the work of the most reputed calligraphers of a district, simply from the shop-signs they have written.

In England I have seen many fine statues in cathedrals and churches, and many large monuments standing in some of the most beautiful spots in the country, and I have been struck very forcibly by their contrast with the memorials of my own

country. The inscriptions on them are very unobtrusive. For us the inscription is often the most important part. We hang examples of tasteful writing painted on boards, or else we engrave beautiful characters upon stones. These writings may be quotations from well-known sayings, or admonitions of an older generation to a younger, or essays extolling the beauties of a particular spot, or a description of the building itself— when and how it was constructed, for example. By the side of ancestral tombs there generally stands a tablet on which is written, for the edification of those who come after, accounts of the dead person's character and deeds. Whatever the inscriptions may be they are always written in a good hand.

Our houses are usually of one storey, with rather lofty rooms. In the central hall there are always some pieces of calligraphy ; generally there are paintings as well, but some houses have calligraphy only. There is a fairly common traditional plan for houses in China. Looking in from the entrance door one gains an impression of depth and spaciousness. At the end of the hall, hanging in the centre, will be a large painting or a few huge written characters, on either side of which will hang a pair of scrolls bearing writing, very often a couplet from a poem, to which we give the name of *Tui-Tzŭ* (對 子), Parallel Sentences. On the left-hand wall we commonly find four paintings representing the scenery or typical flowers of the four seasons of the year. On the opposite wall will be four strips of calligraphy constituting either a well-known essay written out in four parts by one calligrapher or four separate poems written by different hands. This, as I have said, is merely one typical arrangement ; considerable variation is practised. In the room set apart for study at least one painting and one piece of calligraphy are

[7]

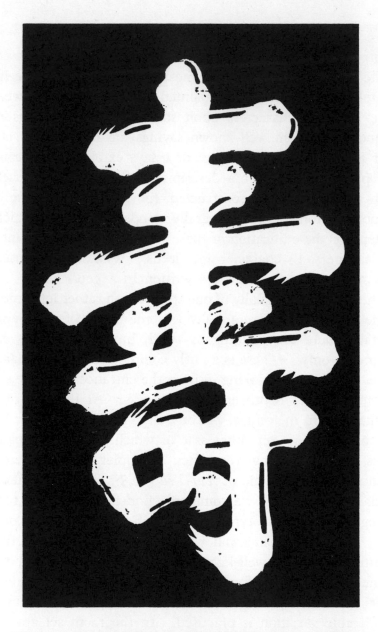

FIG. 1.—A STONE-RUBBING OF THE CHARACTER *SHOU*, LONGEVITY
By Chu Hsi, a great scholar and calligrapher of the Sung dynasty
Approximate size of the original : 2 ft. 9½ in. × 1 ft. 7½ in.
(*Collection of Tsai Yü-Ting, Nanchang*)

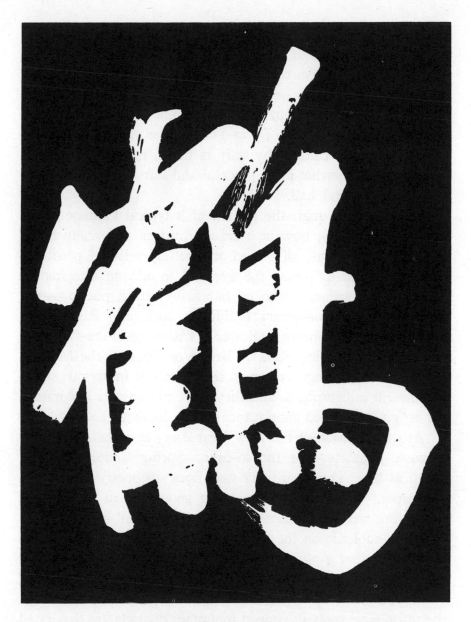

FIG. 2.—A STONE-RUBBING OF THE CHARACTER *HO*, STORK
By Hung Tsê-Chou of the Ch'ing dynasty. The stone is at Nanking
Approximate size of the original : **2** ft. 3½ in. × **1** ft. 9½ in.
(Collection of Yen Shou-Ch'ien, Nanking)

[9]

usually to be found, and quite often there is calligraphy alone. The position is always carefully chosen to exhibit the beauties of the writing to the best advantage. In the young ladies' apartments four small paintings are generally hung on the central wall, and a pair of *Tui-Tzŭ* on the side walls. Here too, occasionally, calligraphy only is hung, but then the style of writing is somewhat more graceful and soft—less virile—than that in the central hall.

Wandering through the garden of a typical Chinese home one finds paviiions, bowers, terraces, bridges and many kinds of artificial erections, all placed at carefully selected points of vantage, chosen to please the eye and to add an imaginative variety to the scene. Scholars habitually attach poetic names to these small ornamental buildings, such as 'Pavilion of Searching-for-the-Spring', 'Bower of Listening-to-the-Orioles', 'Terrace of Gathering-Stars', 'Bridge of Clasping-the-Moon'. These names are engraved upon the buildings in various styles by eminent calligraphers, and they serve not only as decoration but to give an added significance to the locality.

At the approach of the New Year every household prepares to paste upon its door the so-called Spring Couplet (*Ch'un-Lien* : 春 聯). This is usually two lines of poetry written on red paper. It is supposed to bring good luck in the coming year. For wedding or birthday presents, as well as when conveying condolence on the death of a relative, we Chinese send, not flowers, but a piece of written poetry, an essay or distich. We consider this the best way to show joy or grief.

If you travel about in China you will notice that most of the impressive spots in rugged mountain districts are decorated with engravings of two or four characters, their huge proportions

standing out on the rocks. Sometimes you will also see the lines of an appropriate poem. Far from detracting from the beauty of the scene, these characters are chosen and placed with such taste that the onlooker will view the scene with an added insight, comparing his own impression of it with that of the poet or scholar who has scanned it before him. Afterwards, perhaps, the visitor may be inspired to add a comment of his own upon another rock, thus leaving not merely a record of a casual visit, which would be meaningless and vulgar, but the token of a nature-lover's mind. The most splendid sites on Chinese mountains are often occupied by monasteries, and these always have a book specially prepared for the inscriptions of visitors, who are expected to write in it some lines of poetry or a few sentences praising the loveliness of nature. One would not dare to make one's contribution in a poor handwriting, however gracefully composed might be the verses or sentences written!

It is commonly believed in China that calligraphy expresses the personality of the writer. An individual's character, disposition, and propensities, as well as his good or bad fortune, are said to be accurately ascertainable from his handwriting. I am aware that the art of interpreting the handwriting of Western countries has become almost a science, but in my opinion the variety of construction and the arrangement and form of the strokes make Chinese even more susceptible to this form of analysis. Let me give instances. The Sung dynasty (A.D. 960–1276) is very far removed from the present day, and yet from examples of the Emperor Hui-Tsung's writing, executed in the style peculiar to him and termed Slender Gold (Fig. 47), we can infer that he was a person of handsome appearance, tall

and slim, meticulous as to detail, with a somewhat effeminate temperament ; we can even affirm that he was slow and measured of speech. Again, if we study the writing of Mi Fei (Fig. 46), the somewhat colloquial English word ' tubby ' springs to the mind as a good description of the artist's general appearance. I imagine him walking with amused deliberation, head erect, alert and whimsical—the sort of man who would kneel down to worship a grotesque rock as his beloved brother [1] and paint misty mountains with the bold and humorous ' *Mi* dot '. The writing of Su Tung-P'o suggests to me a man fatter, shorter, more careless in nature than Mi Fei, but broad-minded, vigorous, a great laughter-maker and a great laugher (Fig. 40). The writing of Huang T'ing-Chien, on the other hand, tells a different story. I should say he was a tall man, lean but strong, firm of will, obstinate even, but generous-hearted in his actions to others (Fig. 38). These are rough judgements only : many finer points could be deduced from more careful study of the written characters.

In former times the ability to write well was the passport to a successful official career, a good handwriting being one of the highest desiderata in the Civil Service examinations. All through the long period from the T'ang dynasty (A.D. 618–905) to the Ch'ing (A.D. 1644–1911) the examination system for officials was arranged in three stages—District, Provincial, and Palace,—and at each, the handwriting of the candidates came in for the most careful scrutiny, success being withheld, no matter how brilliant the composition, if the characters were poorly formed. It may safely be said that all those who achieved the distinction of passing the Palace Examination were notable calligraphers.

[1] Cf. *The Chinese Eye*, page 158.

Even at the present time a good hand is a social asset. As I have said, we tend to judge a person's character from his handwriting, and many a friendship has been made or strengthened by admirably written letters. Such is our respect for a scholarly and cultured calligraphy! We believe even that we can test a person's learning from his hand, for writing needs not only persistent practice and disciplined training, but an extensive background of knowledge as well. Without the ability to write a good letter, a Chinese would find it hard to secure any kind of appointment. We have now, it is true, invented a Chinese typewriter, and have also become accustomed to writing with foreign pens and pencils, but we still give little weight to printed or typewritten matter or to the products of the fountain-pen. We treasure, on the other hand, the manuscript letters of our friends, even mounting them for the sake of their pleasing appearance, instead of merely keeping them as souvenirs. And importance is attached not only to the style but to the arrangement of the characters on the note-paper.

From these remarks you will gather that our calligraphy is very closely bound up with our social habits; indeed, it is used in every sphere of our life. In this respect it is more important than painting. And it cannot be denied that it has, through long usage, reached a very high state of development, and is fully entitled to its status as the basic element in all forms of our art.

Speech and writing are two organs of the same human impulse—the conveyance of thought: the one operating through hearing, the other through sight; the one by sound from mouth to ear, the other by form or image from hand to eye. But each can do something besides convey thought. Spoken words

can be arranged to discharge aesthetic 'musical' significances, as in much Western poetry. Written words can be formed to liberate visual beauties; and this is possible with Chinese characters in a greater degree, it is safe to say, than with the script of any other language, because *art*, not science or religion, was the prime end of those responsible for their development. A good Chinese character *is* an artistic thought.

Chinese characters are monosyllabic and pictographic. They are not made up from an alphabet, but stand alone, each ideogram throwing on the mind an isolated picture. This is a different system from that of any Western language. European words are sound symbols intended for pronunciation and containing no visual idea. Some of our characters too, I must admit, are only sound symbols, having no 'written' meaning, but these derive chiefly from our comparatively recent attempts to translate by their sounds the words of foreign languages into our own. Chinese characters comprise three elements, thought, sound, and form, and thus are able to fulfil both the uses of daily life and the exacting requirements of an artistic medium.

I doubt if, as a step to the full appreciation of Chinese calligraphy, I can persuade my readers to learn the Chinese language, in spite of the assurances of many of my countrymen that it is an easy language to acquire; but I should at least like them to realize the simplicity and clarity of its appeal to the memory. It is these qualities that have caused Chinese writing to be so widely used throughout our vast country. Chinese is in nature and origin entirely different from any other language. It is perhaps the only *pure* language in the world. Thoroughly to understand a single Western tongue one must know several others. English, to take one example—an extreme one, it is

true,—contains more than seventy per cent of words derived from at least ten different languages. Again, Chinese has only monosyllabic words, in which respect it is simpler than German or English, which have words of fifteen or more letters and nine or ten syllables, difficult both to write and to pronounce. And there are other points. Chinese has no such element as accent, a part of the English language which strangers find extremely difficult to learn ; nor has it grammatical inflection—no difference in number, gender, case, person, voice, mood, tense, or degree of comparison—not even prefix and suffix. Surely these are advantages ? The ordinary affairs of life are complicated enough ; most of us wish that we could stretch time to twice its length : if, therefore, we can simplify language to its basic elements, so much, surely, the better for us ! Chinese has had simplicity of form from its earliest days. The style of the classical literary language is condensed to the extreme of significant brevity, though from the richness of its content and the grace of its manner we must infer that it passed through a period of purgation (as it might be called) before reaching its present form.

The characters and the construction of the Chinese language are unchanging ; time has scarcely affected them. We can read one of the most ancient of all books, ' *The Book of Changes* ' *I-Ching* (易 經), written in Chinese about three thousand years ago, and then turn to a daily newspaper, and although we certainly find a considerable change in the terms, phrases, facts and ideas, the characters, grammar, and that to which we may give the general term of ' style ', do not appear strange. How different is the situation of an Englishman of to-day attempting to read one of the Anglo-Saxon poets or the writings

3 [15]

of Chaucer! It is not an exaggeration to assert that a Chinese child of seven or eight years can read the ' *Four Books* ', *Szu-shu* (經書)—the Confucian Classics—though these were printed about 1,000 years ago.

For purposes of learning, Chinese characters can be simply divided into six categories, one of which is so large that three-quarters of the characters fall into it. The structure very often gives a clue to the meaning, while a part of the character generally indicates the sound. With a knowledge of the basic elements of structure and of a few phonetic groups one has a very good chance of deciphering both the approximate meaning and the approximate sound of a great number of characters. If you know thoroughly the components of a hundred characters, you will probably be able to read and use a thousand! The best method of memorizing is to learn to write : for writing is simpler than conning. Once you can analyse the structure, and at the same time appreciate the beauty of the lines, you will have come to a real love of Chinese calligraphy for its own sake ; for the more you study the appearance of Chinese characters, the more you will enjoy writing them, and the more quickly you will remember their meaning and shape.

As I have already said, this book is not for sinologists but for readers who cannot interpret a single Chinese character. I hope to bring them into a simple appreciation of the beauty in the movement of strokes and the patterns of structures. I write also to help those who already love our painting to a better understanding of brush-work, to something more than the general feeling of a picture. I shall try to explain the aesthetics of calligraphy as fully as possible, for that is the root

of the matter. But I shall not neglect technique : there will be chapters on training and practice for the assistance of those who wish to make the venture even though they know nothing of the language.

In China calligraphy is the most popular of the arts. It is a national taste, a common aesthetic instinct nourished in every Chinese from childhood up. There are many more scholars who are ' crazy ' over it than over painting. Good paintings, songs and poems are not common, but good calligraphy is to be found everywhere in China and at every period of history. The majority of Chinese people—like the majority of any other nation—understand almost nothing of art and literature, yet all of them can gaze at a piece of calligraphy with pleasure simply for its familiar shapes and composition. Families which are too poor to afford ancient paintings will possess rubbings of characters taken from engravings on bronze and stone objects.

Great numbers of Chinese people look upon calligraphy as one of the most delectable of hobbies and pastimes. The art is easier than painting in that far less preliminary thought is required. For a painting one must wait upon mood and inspiration—if one is ever granted these gifts !—whereas in an instant one can write a character, a series of beautifully proportioned curves and strokes that can be looked upon with pleasure. Why not try ?

II

THE ORIGIN AND CONSTRUCTION OF
CHINESE CHARACTERS

IT is impossible to speak with certainty about events of four thousand or more years ago, and in tracing the origins of Chinese characters we can only draw rough conclusions. Although there are no authentic records of the very early stages of the written symbols, it is evident that there must have been some primitive aids to memory before the invention of the picture-character *Hui-T'u-Wên-Tzŭ* (繪圖文字), which we call *Piao-Shih* (標識), sign or symbol.

The first stage, as far as is known, was that of knotted strings or cords—*Ch'ieh-Shêng* (結繩) in Chinese. Before the time of Fu-Hsi (伏羲) (28th century B.C.) those in charge of the administration used these knotted strings to remind themselves of matters which had already been dealt with and to remember those which had still to be done. Anything particularly important was indicated by a large knot, something less important by a small one.

Second in order of time, according to tradition, we have Fu-Hsi's *Pa-Kua* (八卦), which I described briefly in my earlier book, *The Chinese Eye*. This is a much more advanced system, covering all natural phenomena. The Emperor Fu-Hsi, in whose reign it was propounded, tried to bring all things

in heaven and earth into a simple system of notation. With the two signs — and --, corresponding to the positive and negative principles of the Universe—*Yang* (陽) and *Yin* (陰) as they are called in Chinese—as a basis, Fu-Hsi evolved

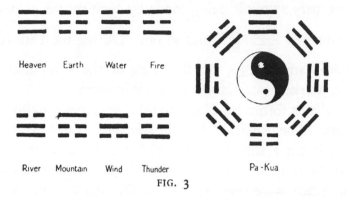

Heaven Earth Water Fire

River Mountain Wind Thunder Pa-Kua

FIG. 3

eight combinations, representing heaven, earth, thunder, wind, water, fire, mountains, and rivers. This list is instructive as showing what things seemed of most importance to the human mind at that early stage of development. It is interesting to note that though rain, hail, and snow are all included in water, rivers are separated from it, and mountains distinguished from earth. Mountains and rivers still hold a high place in the Chinese heart. Probably Fu-Hsi developed a system of grouping all the observed objects and phenomena of his universe under these primary symbols. For instance, ☰ would represent heaven, emperor, father, gold, head, horse, and so on ; and ☷ would represent earth, mother, cloth, breast, cow, etc. All the items under one head will be seen to have some quality in common : those in the first list, for example, share an element of strength and hardness ; those in the second, one of weakness and softness. Of course, Fu-Hsi's universe was

[19]

considerably less complex than ours : its outstanding features were the facts of nature, such as climate, warmth and cold, flood and drought, or personal property—horses, cows, dogs, pigs. Later the system was elaborated, further combinations of the primary symbols being made by such means as doubling the groups ☲ ☳ ☴, and so on. During the 12th century B.C. Wên-Wang (文王), the first king of the Hsi-Chou (西周) dynasty, worked out sixty-four combinations.

In its later forms *Pa-Kua* provides very deep philosophical problems. The classical ' *Book of Changes* ' is devoted to them. But that is not a subject with which we are concerned in this book ; what has to be noticed is the advance made from knotted strings, which were only an aid to the memorizing of events and could be easily confused, to a method of directly representing human thought.

The first kind of picture-writing is traditionally ascribed to the invention of Ts'ang-Chieh (倉頡), official recorder to the semi-mythical Yellow Emperor, Huang-Ti (黄帝) (2898–2679 B.C.). Obviously neither sources nor dates can be relied upon ; we can only say that, whether or not Ts'ang-Chieh was responsible for them, they were definitely established in his time. Ts'ang-Chieh is said to have devised a primitive form of deed, which was used for official counting, simple business transactions, and affairs of like nature. The object he invented was something like the English tally, and was called *Shu-Ch'i* (書契), Notched-stick. It consisted of a piece of wood engraved with a symbol. The two people or parties concerned in the transaction would divide it between them. Ts'ang-Chieh, if certain ancient books are to be believed, observed the marks of birds' claws and

animals' foot-prints upon the ground, the shapes of shadows cast by trees, and so on, and engraved rough representations of their forms upon the sticks. Gradually these pictures came to be recognized as elementary characters.

When first picture-characters came into use, human affairs were comparatively simple. Hunting and fighting occupied a large part of men's lives, and in such events one either lost or won the battle, shot or missed the bird. As life became more complicated, additional characters were invented to meet the new needs of society. Examples of very early picture-writing are not easy to find in existing records. But recently a great many tortoiseshell and animal bones of the Shang-Yin (商 殷) dynasty (18th century B.C.) were found, bearing picture-characters engraved to form records. We can also get some idea of what early characters looked like from bronzes of the same dynasty and of the Chou (周) dynasty (1122–249 B.C.). Here are some examples:

Jih (日), Sun : ☆ ▢ ☉ ◔ ℮. Notice how these symbols pick out the solar attributes of roundness and radiating beams.

Yüeh (月), Moon : 〕 ⟨ ⌣ ⌣ 〉 ⟍ 〗 𝒟. A crescent, a form in which the moon sometimes appears in the sky, and in which it clearly differs from the sun. The character is engraved sometimes as a combination of two lines, sometimes as a single heavy line.

Hsing (星) Star : ⚇ ⚇ ९९९ ⚬⚬ ⚬⚬ ⟨. Constellations in the sky have this appearance.

Yün (雲), Cloud : ？. A symbol conveying the sinuous or curved shape of clouds.

[21]

Yü (雨), **Rain** : ▦ ▥ ▨ . Water falling down from the sky.

Shan (山), Mountain : ▲ ▲ ▲ ▲ ▲ ▲ ▲ . A range of mountain peaks.

Shui (水), Water : ﾟ ﾟ ﾟ ﾟ ﾟ 川 . Ripples on the surface of moving water.

Shou (足), Hand and *Tsu* foot : ✲ ✲ ✲ and ⌇ ⌇ ↓· (手),

Mo (目), Eye and *K'ou* (口), Mouth : ◉ ◔ ◑ ◑ and ⌣ ⌣ ⌣ .

Niu (牛), Cow or ox : ✲ ✲ ✲ . A composite character in which ∪ ∪ represent two horns, and ┤ ┼ │ represent head and neck.

Yang (羊), Sheep : ☙ . Here we have the whole animal, but

sometimes sheep is written ♈ ♈ ♈ ♈ ⌣ ♈

with two horns and the head only.

Chu (豬), Pig : ﾟ ﾟ . The whole body of the animal.

Yü (魚), Fish : ⟨fish⟩ ⟨fish⟩ ⟨fish⟩ ⟨fish⟩ ⟨fish⟩ ⟨fish⟩

The fish complete with fins and tail.

Fu (斧), Axe : ⊤ ⊤ ⊤ ↑ .

Chou (舟), Ship or boat :

Hu (壺),
Pot, jug, or
tankard :

Shih (室),
House :

Ch'iu (囚), Prisoner : . A man in jail.

Ch'i (祈), Worship : . A man kneeling in prayer.

Chieh (街), Street : . A foot walking in the street or by the side of the road.

These few examples of ancient Chinese characters are simply pictures or images of things. In the etymological study of them it is usual to look for three elements : image, sound, and meaning. But the meaning is derived from the other two : if you know exactly the image and sound, the meaning is necessarily plain. In the course of time both sound and image became considerably modified. It sometimes happens when comparing the ancient and modern forms of the same character that the reason for the meaning of the latter is not immediately obvious, because there seems to be no connexion with the original image. In these cases it is necessary to discover how the character was constructed and formalized.

As I have said, the invention of the notched stick is dated at about the 27th century B.C., and picture-characters were drawn up into some sort of rough system at the same time. Some thousand years later, about the 18th century B.C., during the Shang-Yin dynasty, most of these picture characters were engraved upon tortoiseshell or animal bones. These we call

Chia-Ku-Wên (甲骨文), Shell-and-Bone Script. About 800 B.C. an Imperial Recorder named Chou (籀) drew up a system of characters which was called *Chou-Wên* (籀文) or *Ku-Wên* (古文) and was usually engraved on bronze. Later these characters came to be known by philologists as *Ta-Chuan* (大篆), Great Seal. About 213 B.C., under the famous Ch'in Shih-Huang-Ti (秦始皇帝), who perpetrated the 'burning of the books', the Prime Minister Li Szu (李斯) drew up an official index of characters and unified the written form for the use of scholars. This, which was known as the *Hsiao-Chuan* (小篆), Small Seal, contained more than 3,000 characters. It was an extremely important step in the history of our calligraphy. Li Szu led the way to the easy method of character-formation by phonetic combination, for in all cases he merely combined an earlier picture-character with a phonetic. As the need arose for new characters, scholars added to Li Szu's list by the method he had invented, with the result that by A.D. 200 the number had increased to over 10,000. At the present day it has reached half-a-million.[1] And while increasing in number, the characters underwent many changes of form, some of which were for the sake of higher speed of execution, some for aesthetic reasons, some through the improvement in writing materials.

The first standard work on Chinese etymology, the '*Shuo-Wên-Chieh-Tzŭ*' (說文解字), was the work of a scholar named Hsü Shen (許慎) who was born about 86 B.C. It was not printed until about A.D. 120. This contains the first classification by radicals, radicals being the modern forms of the primitive

[1] The reader must not, however, be deterred by this from learning Chinese. In order to read and speak with facility one need remember only about 4,000 or even less.

picture-symbols. Most later scholars have based their work upon the ' *Shuo-Wên* ' (說文). Hsü Shen classified the ancient characters under six heads, showing how they were constructed and how new ones based upon them could be formed.

The characters are divided, in the first place, into *Wen* (文), Simple Figures, and *Tzǔ* (字), Compounds. These two classes are in turn subdivided. The simple figures may be either (1) Images, *Hsiang* (象), or Imitative Symbols, *Hsiang-Hsing*, (象 形), or (2) Indicative Symbols—symbols indicating an action, quality, event, &c.—*Chih-Shih* (指 事).[1] The compound characters are also subdivided into two : (3) Phonetic Compounds, *Hsing-Sheng* (形 聲), in which one part stands for the meaning and the other for the sound, and (4) Logical Combinations, *Hui-I* (會 意), in which each part of the character contributes to the meaning of the whole. The ' *Shuo-Wên* ' gives two more classes of characters, (5) *Chuan-Chu* (轉 注) and (6) *Chia-Chieh* (假 借), both of which must be mentioned, though neither has ever gained the universal acceptation of the other four.

Now let me restate these categories, with a few details and examples, one by one.

(1) FIRST CATEGORY : *Hsiang* and *Hsiang-Hsing*, Imitative Symbols or Images, sketches representing an object. I have given some examples already ; here I will give further details. The image can be divided into four kinds—single, double, combined and complex.

(i) Single figures :

 Ch'ê 車 , cart, .

 Yen (燕), swallow, .

 [1] Literally, ' a pointing at something '.

(ii) Double figures :

 Chü (甽), looking at both sides, .

 Ping (並), standing together, .

(iii) Combined figures :

 Fu (箙), quiver, , two or three arrows in the quiver.

 Shê (射), to shoot, , an arrow, a bow and a hand.

(iv) Complex figures :

 Chiang (疆), boundary or border, , two fields with a stream or sand-hill between.

 Ch'i (其), corn-flail or winnower, , a corn-flail set on a stand.

Simple figures are easy to detect from the pen-strokes, position and outline. They are constructed upon the characteristic shape of the object, such as :

 Hsiang (象),
 elephant,

 Lu (鹿), deer,

 Hu (虎), tiger,

 Ch'üan (犬), dog,

In these four figures it is possible to distinguish the animals from the characters. There are very many characters like these. I have already mentioned the sun, always round, and the moon, which appears sometimes as a crescent.

(2) SECOND CATEGORY: *Chih-Shih*, Indicative Symbols, figures which suggest the meaning, often by the idea of some motion:

Tan (旦), dawn or day-break, ♀ ♀ ♀ ☉. The sun rising above the horizon.

Ming (明), bright or clear, ☽ ☽ ☽. A combination of sun and moon, which have in common the attribute of luminosity.

Li (立), to stand, 夽 夵 夵. The upper element represents a man, the lower the earth; i.e. a man standing firmly on the ground.

Chih (至), to reach or go to, 至. The upper part indicates a bird, and the lower, land: a bird flying down to land.

The characters listed in this category by the 'Shuo-Wên' are comparatively few. In form they are similar to those in the first category; in function they differ in being used exclusively for abstract description and the expression of imaginative ideas. They depict objects not according to their intrinsic visual characteristics but as imaginative symbols.

(3) THIRD CATEGORY: *Hsing-Sheng*, Phonetic Compounds. One element indicates the meaning, the other the pronunciation. We are able to trace the way in which this type of character came into being. Primitive man could imitate sounds before he could write. His first attempts at writing were done with simple figures. Then he found that there were some

[27]

things which he could not express by this means, and he devised a clever expedient. He set beside the simple figure indicating the main attribute of his meaning a second element having the *sound* of what he wished to express. This extension of the written language considerably enlarged its field of expression.

So now we have not one character only for such a thing as water, of which there are many forms—rivers, lakes, seas, oceans, &c.—but several, each describing a different form of water, down to distinctions between great and small rivers, calm and rough seas. The characters for river are examples of such Phonetic Compounds. There is 河, *Ho*, of which the left-hand element, 川, *Shui*, signifies simply water, and the right-hand element, 可, *K'ê*, the sound of water flowing. That would be a very wide river. *Chiang*, 江, of which the left side also stands for water and the right, 工, *Kung*, for the sound of water flowing, would designate a rather narrower river. For *Kung* is a higher pitched sound, as of water flowing from a height, than *Ho*, which is the sound of a broad mass of water flowing more slowly.[1] These are by no means the only characters for river.

Here are some further examples of Phonetic Compounds. *Hu*, 湖, lake : the left side, 川, means water and the right, 胡, *Hu*, conveys the sound. *Ya*, 鴉, crow : the left side, 牙, gives the sound (we imitate the crow's harsh call by ' Ya-Ya '

[1] To appreciate the onomatopoeic quality of *Ho* and *Kung* it is necessary to speak the first in a whisper and to sing softly the second.

instead of ' Caw-caw ' as in the West) and the right side, 𝄢, is the sign for bird. *Wen*, 問, to ask : 門, *Men*, door, is the phonetic, and ▽, *K'ou*, means mouth—a mouth in a doorway suggests asking. *Wên*, 聞, to hear (when spoken, a different ' tone ' distinguishes this character from the previous one) : an ear, 耳, *êrh*, to a crack in the door.

(4) FOURTH CATEGORY : *Hui-I*, Logical Combinations. The meaning of each part of these characters, as with the characters in the Third Category, contributes to the meaning of the whole, but here the signification of the whole is a synthesis, not a joining, of the meanings of the components. *Hui-I* characters were created, like *Hsing-Sheng*, to meet the needs of a social life growing more complex, and they constitute a very subtle development. They are something more than two simple figures placed side by side, the one qualifying the other : their meaning is ' metaphorical ' ; it is a new thing, not logically contained in the parts. Here are some :

Ch'ung (衆), 𖣘 or 𑀫, means ' all ', ' multitude ', ' many ', or ' majority '. Originally it was a symbol composed of three men, because in number at least one more than two is considered many.

Ch'ou 讎, 𗈓 or 𗀊, means ' to be similar ', ' enemy ', or ' to answer '. Originally it was 𗈓 or 𗀊, two birds, sometimes fighting, sometimes answering each other.

Nung 農 , 𗈋, means farm, agriculture. Originally it was written 𗈋. You can see ⊕ representing ' field ' or ' land ',

and � symbols or 〱 a 'plough'. To plough the land is symbolical of agriculture. In the second character there is in addition the sign 〱 representing the human foot.

Fu (婦) means woman, lady, matron. Originally it was 〱 or 〱. It is based upon the characters 〱 and 〱, symbols for a girl, and 〱 and 〱, the simple forms for a broom. A girl holds a broom to do housework, which is the duty of a married woman.

Fa (伐) means to invade, attack. Originally it was written 〱 〱 〱 and 〱 〱 〱. The shapes of a lance or spear (held by a man) can be discerned in 〱 〱 〱 〱 〱 〱 〱. The forms of the characters are different, but in each the inference to be drawn from a soldier about to fight is expressed.

The principle of combining characters is not confined to the uniting of two simple figures : it is possible to combine two compound characters. The method by which this is accomplished is explained in the diagram on the opposite page (Fig. 4).

I could give examples of very many characters constructed in this way, but to do so would be to overburden this book with examples and lead us away from our general purpose.

It might be supposed that provision had now been made for every type of character which could be needed ; but, as we know, the Chinese language is monosyllabic, with fewer sounds

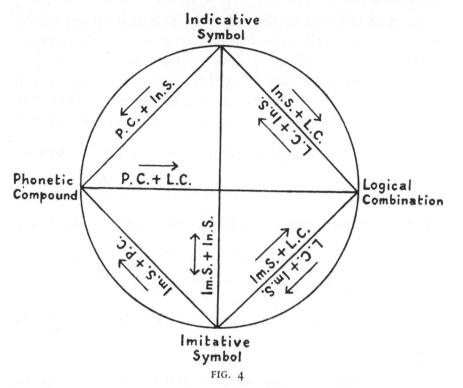

FIG. 4

than other languages, and this circumstance necessitated further elaboration of the characters. So two more categories came into being: *Chuan-Chu* and *Chia-Chieh*. They consist of characters constructed in the ways we have already seen, but used to signify different meanings. The two categories have never had universally accepted meanings and even to-day are still the subject of controversy in China. The following are examples:

(5) FIFTH CATEGORY: *Chuan-Chu*. Characters of this type are likened to water poured from one bottle into another—the water is the same but the bottle different. Their meanings are under-

[31]

stood in an extended or derived sense, sometimes metaphorical or figurative, occasionally inverted or even directly opposite to the original. *Chuan* means to turn or transmit, *Chu* means to explain or note: together they signify 'to explain by turning' or 'to express by reciprocation'. Thus two or more characters are constructed to explain one another.

For example: *Lao* (老), meaning 'old', if the final upward stroke is turned downward, becomes *K'ao* (考), meaning 'to examine' (youngsters are generally examined by their elders).

T'so and *Yu* (左 and 右) mean left and right respectively; the ancient characters are ﬤ and ﬤ, the second being formed by reversing the first. The characters 上 and 下 (⼀ and ⼀ in ancient writing) mean 'up' and 'down'; but by extension they also stand for above and below, superior and inferior, &c. There are many possible ways of interpreting the characters in this category and the best method is still in dispute. No new words can be added to it except for the purpose of explaining those already in existence. It can be seen, however, how complicated the Chinese character has become in the process of time, and how wide its scope.

(6) SIXTH CATEGORY : *Chia-Chieh*, Borrowed Characters. To this category belong characters used in senses not originally their own, either by reason of their sound or through association or derived meaning. For instance, *Ling* (令) originally meant 'an order', and it has been 'borrowed' for the mean-

ings ' to give an order ' or ' a person giving an order '. *Chang*
(長) means ' long ' as opposed to ' short ', and has been ' bor-
rowed ' to represent an adult, because he is taller than a child ;
or an aged person, because he is older than a youngster ; or
an officer or governor, because he is a leader of others. *Hsi*

(西) was in ancient writing and , originally constructed
out of the bird returning to its nest at sunset ; but as the
sun sets towards the West, this character has been permanently
borrowed for the meaning ' west '. *P'êng* (朋), in ancient

writing , was originally the image of the phoenix, and has
been permanently borrowed for the meaning ' friend ', because
in our imagination this bird is always followed by a score of
other birds while flying.

To sum up : The Chinese written language has definitely
overcome the difficulties which arose in the course of its develop-
ment and, still alive, preserves its independent tradition. It is
true that some of the present styles of the Chinese written
character, with which I shall deal in the next chapter, have so
far deviated from their original forms that there seems to be
no connexion between image and meaning ;—thus all the
advantage of *Hsiang-Hsing* has been lost ;—but a connexion
nevertheless exists, and a study of the accompanying chart
detailing the changes of Chinese written characters from the
28th century B.C. to the Han (漢) dynasty (206 B.C.–A.D. 219),
taken from the large chart prepared by Mr. Hua Shih-Fu
(華石斧), will reveal this. After Han times there are few
changes in stroke-making, but the evolution of different *styles*
of calligraphy brought changes in the shaping of the strokes.

The difference between the ancient script and the method

	Happiness	Myriad	Upright	Eye	to defend	Heaven	Uniform	Corn	to obtain	Tiger	Moon	Sun

FIG. 5.—TABLE OF HISTORICAL CHANGES OF CHINESE CHARACTERS

[34]

of writing after Han times is manifest, but there is not much change in construction and shape. Clearly the first glyph of a character—the original reduction of a concrete object to a few simply written lines—must have been a task of great difficulty. The ancient script has no consistent form, no definite sound, no recognized position, and it could not have had any great use because the number of its characters was so limited. And yet the same idea remains evident in a character through all the variations, without any confusion resulting. The first image is a solid representation of the object; double lines are then substituted for this; then a single simplified line; and then different shapes of stroke come into being. The varying methods of construction to convey the same meaning must have been inconvenient for daily use, for character-formation under-went systematization and unification many times before the Han dynasty; but although nearly two thousand years have passed since Han, no further radical change has occurred. Evidently China reached the peak of her culture before the end of the Han dynasty. And whatever limitations there may have been to the practical uses of this Chinese ancient script, one cannot but admire, from an artistic standpoint, its simple beauty.

In the present-day style of writing, though the original image has in many cases been lost, there is still a vivid enough image to move the reader's feeling and stir associations with other characters. These images are complicated and the characters include many elements. Just as a good picture may send a man's thought beyond the bounds of the frame, so a character can move his imagination beyond itself. This is what we mean when we say that ' to look at the figure engenders thoughts '. A character, being evolved from a picture, displays

its meaning clearly through its appearance, even if it has no sound.

It has been said that Chinese characters were derived from ancient Babylonian and Egyptian. We can easily pass a judgement on the first of these propositions by examining the following comparisons [1] :

sun house hand comb bird

Ancient Babylonian :

sun house hand broom swallow

Ancient Chinese :

Between the first two pairs of characters there is a difference in the way of imaging the object. Both of the fourth pair have a connexion with ladies, but in Babylonian the object is a comb while in Chinese it is a broom. The similarity of construction in the fifth pair is only very approximate.

Now let us compare the ancient Egyptian script with the Chinese. For convenience I will divide my comparisons into four groups :

(1) Similar in form and meaning :

Ancient Egyptian :

sun moon mountain water eagle silk eye knife

Ancient Chinese :

sun moon mountain water eagle silk eye knife

[1] I take these comparisons from ' *Kuo-Wen-T'an-So-I-Pan* ', by Hua Shih-Fu.

[36]

(2) Similar in form but different in meaning :

	throne	parallel line	sieve
Ancient Egyptian :			

	hundred	rosy (彤 *T'ung*)	a conical cap
Ancient Chinese :			

(3) Different in form but similar in meaning :

Ancient Egyptian :

leg	stone	window	basket	garden	grass	worship

Ancient Chinese :

leg	stone	window	basket	garden	grass	worship

(4) Both form and meaning different :

	bottle	lamp
Ancient Egyptian :		

	mortar	chief or master
Ancient Chinese :		

The above tables suggest that the processes of human thought are probably very similar all over the world. It must be the processes of expression which differ. Here, the method of constructing a character in Chinese is seen to be ' sketchy ', while in Egyptian it is elaborate and exact. The one has strong simplified lines, and is ' idealistic ' ; the other is ' photographic ', a kind of painting—' realistic '. By the time that the Egyptian

script had reached its greatest refinement, it had become inconvenient for writing, and, incapable of modification to meet the requirements of daily use, it fell away. But the Chinese preserved a great capacity for development, and so it keeps its life, yet without ever losing touch with its very ancient origins.

The most marked difference between a Western language and the Chinese is that the former is written horizontally from left to right and the latter vertically from right to left. Aesthetically it makes no difference whether Chinese is written vertically or from the right or left, but to write horizontally with a Chinese brush is not convenient because every Chinese character is constructed in a square and is always written from the top downwards.

Now let me draw some comparisons between Chinese and those languages, such as Korean, Japanese and Hsi-Hsia (西夏), which are derived from it :

Korean writing Chinese translation

에 正 게 드 랐 大 至 德 大
正 흠 흠 힘 은 學 善 在 學
흠 에 에 에 德 의 親 之
에 잇 잇 잇 을 道 民 道
잇 느 며 며 시 는 在 在
느 니 지 民 름 밝 正 明
니 라 구 을 은 於 明
라 흘 흘 德

FIG. 6

Japanese writing　　　　Chinese translation

舟求曰兆不說子〻道
力不足也子曰力不
足者中道而廢今
汝畫

FIG. 7

Hsi-Hsia writing　　　　Chinese translation

過去有佛號威音王
神智無量好道于一切
天人龍神皆共供養

FIG. 8

It can be seen that Korean, Japanese, and Hsi-Hsia are written in the same manner as Chinese: with a brush, from right to left, and from the top of the page downwards. In Korean the nouns and verbs are preserved exactly as in Chinese

[39]

in regard to their form and meaning, but many of the other words have circles and vertical lines which give a monotonous appearance to the writing. In Japanese most of the Chinese characters are employed without change in form or meaning, only they are pronounced differently ; but the fact that the forms of many of the subsidiary words are taken from Chinese Grass or Regular writing and mixed with the native style upsets the aesthetic balance of the whole. In the Hsi-Hsia example, not a single character is exactly the same as its Chinese counterpart, but their sounds and meanings are the same, and, taking the pieces of writing as wholes, the type of stroke and method of construction are similar. Hsi-Hsia, however, is poor aesthetically ; the strokes are mechanical and crowd the imaginary squares they fill. Hsi-Hsia writing is only employed in a small area, a part of the Kansu province of China, and it has no great importance. Koreans and Japanese are very fond of hanging calligraphy in their houses, but, significantly enough, not usually their own calligraphy but Chinese.

III

THE STYLES

I DO not propose to burden the reader with a detailed description of the historical development of the various styles in Chinese calligraphy; I am anxious to avoid boring him with dates and unfamiliar names. What I wish him to understand are the aesthetic and technical matters essential to appreciation. But some general sketch of the principal styles in the order of their creation is necessary, and this I shall give in the fewest possible words.

Between the original invention of written characters, ascribed to Ts'ang-Chieh (25th century B.C.), and the Shell-and-Bone characters of the Shang-Yin dynasty (18th century B.C.), variations and new forms were doubtless devised, but there exists no record of them. After Shell-and-Bone comes *Ku-Wên*, a style of character used for the inscriptions engraved on the bronze vessels and objects of the Chou (周) dynasty (12th century B.C.). No standardization was achieved in this style, the different bronzes showing a great variety of forms of the same character. Later in the dynasty, Chou (籀), a Recorder at the Court of the King Hsüan (宣), invented a new style called *Ta-Chuan*, Great Seal, which he described in a book entitled '*Fifteen Essays on the Great Seal*'. This new style seems to have been adopted and, with slight local variations, widely used

until the Ch'in dynasty (246–207 B.C.), when the separate feudal
states of China became united under one Emperor and the
Prime Minister Li Szu decided to unify the scripts of the various
states, and to this end devised the style now called *Hsiao-Chüan*,
Small Seal. This style, which was based on the one used in
the Ch'in state, was a modification of the Great Seal Style and
was more suitable for universal use. Next, in the period from
Ch'in to Han (the Han dynasty lasted from 206 B.C. to A.D. 219),
there gradually developed, through many processes of change
and simplification, the *Li* or Official Style. The invention of
the final form of *Li-Shu* (隸 書) is attributed to a certain Ch'êng
Miao (程 邈). The *Pa-Fen* (八 分) Style, which was also devised
during the Han period, is closely related to *Li-Shu*. After
Han, as a consequence of improvement in the writing instru-
ments, three further styles were produced which quickly gained
acceptance and have remained to this day the most widely
used of all the styles : *K'ai-Shu* (楷 書), *Hsing-Shu* (行 書)
and *Ts'ao-Shu* (草 書) Regular, Running, and Grass. Though
not actually simpler than *Li-Shu*, these three styles are quicker
to write and offer a wider range of stroke and construction,
besides being generally more convenient in practice.

But while, for general use, *K'ai-Shu*, *Hsing-Shu* and *Ts'ao-
Shu* became permanently established, the older styles continued
to be practised by calligraphers. For artistic purposes no dis-
tinction was—or is—made between the ancient and the later
scripts. Calligraphers practised them all, though they might
specialize in any one of their preference. With the passage of
centuries an almost unimaginable variety of styles has been
evolved. And still there is room for novelty ! Every new
style has, however, derived—as, I am convinced, every new

style must in future derive—from the ancient foundations. That is why budding calligraphers still dutifully study the old styles and techniques.

Neglecting the minor styles, I will now deal briefly with the five principal ones only : *Chüan-Shu, Li-Shu, K'ai-Shu, Hsing-Shu* and *Ts'ao-Shu*. Only the most general forms of each will be considered, though it should be understood that each is susceptible of considerable individual variation.

CHÜAN-SHU OR SEAL STYLE

Under this general heading I am including Shell-and-Bone writing, *Ku-Wên* or Ancient Script, Great Seal and Small Seal.

The recent excavations in Honan province have brought to light many interesting examples of the most ancient Chinese script. Bones of animals and tortoiseshells, of considerable archaeological value, have been dug up and found to bear characters engraved upon them. The well-composed patterns and linear qualities of these characters have suggested new methods of treatment to calligraphers. But so far few have distinguished themselves by their inventions. The only important names in this field are Lo Chên-Yü (羅振玉) and Yeh Yü-Shen (葉玉森) (Fig. 10).

The *Ku-Wên* Style occurs in the characters inscribed on bronzes in the period before the invention of *Ta-Chüan* (Great Seal). The arrangement and interrelation of the lines of the characters differ in every example, but each has its own value and beauty. The ancient bronzes were used in important national ceremonies and at the services of ancestor worship. As is to be expected, therefore, the characters are dignified and sublime, and designed to endure for many generations. The

FIG. 9.—A SPECIMEN OF CHARACTERS FROM SHANG-YIN TORTOISESHELL AND
ANIMAL BONES
(*Collection of Chin-Shou Hall, Shanghai*)

FIG. 10.—TWO POEMS

By Yeh Yü-Shen (1878–1939). Mr. Yeh, a poet, painter, and calligrapher, wrote many books on the study of Bone characters. He was the author's predecessor in the local government of the Tang-T'u district. The example is two poems which he presented to the author on his departure for England and which are still hanging in his room. Mr. Yeh died two years ago

most talented calligraphers of the day were doubtless employed to engrave them, but unfortunately no trace of their names and careers remains. The process of engraving upon bronze and stone is an art in itself. In Chinese it is termed *Chin-Shih-Hsüeh* (金石學), the Study of Metal and Stone. All through the centuries Chinese scholars have made it a subject of study and discussion.

Many later calligraphers have imitated the *Ku-Wên* Style in order to train their eyes to well-balanced construction and their hands to strength of stroke. Down to the last dynasty, writers have been in the habit of refreshing their minds and technique by practising *Ku-Wên*, and all the most renowned exponents have distinguished themselves in this style.

Ta-Chuan (Great Seal) is not very different from *Ku-Wên* (Ancient Script): it is a synthesis of the variants of that style. The most famous and admired examples of it, the 'Stone Drum Inscriptions', have for centuries been the subject of enthusiastic comment by scholars. The prominent T'ang dynasty writer, Han Yü (韓愈), composed a long poetic eulogy in praise of these characters. His fine poem makes us vividly aware of their firmly patterned strength. The drums were discovered in the Pao-Ch'i district of Shensi, and are treasures for both calligrapher and archaeologist. Copies of them are now kept in the gateway to the Temple of Confucius in Peip'ing. Unfortunately only two hundred characters remain, and the numberless rubbings of them taken by scholars has left even these in a very worn condition (Fig. 16). Wu Ta-Ch'êng (吳大澂) and Wu Ch'ang-Shih (吳昌碩) are famous exponents of *Ta-Chüan*.

As has already been explained, previous to the unification of China under the first Emperor of Ch'in, each of the feudal

[46]

 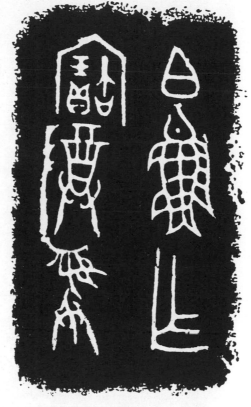

FIG. 11.—INSCRIPTION ON A BRONZE BELL OF A DUKE OF CHÜ, HSI CHOU

(朱公鐘)

(*National Museum, Peip'ing*)

FIG. 12.—INSCRIPTION ON A COVER OF PEI-YÜ TUN (BRONZE BOWL) OF CHOU

(白魚敦)

(*National Museum, Peip'ing*)

FIG. 13.—INSCRIPTION ON A *P'AN* (BIG VASE) OF THE SAN FAMILY OF CHOU
(散氏盤銘)

(Collection of Ch'in Ch'ing-Tsêng, Soochow)

[48]

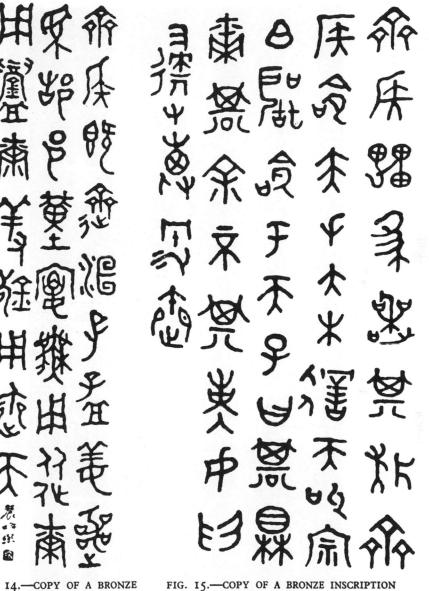

FIG. 14.—COPY OF A BRONZE
INSCRIPTION

By Tsêng Hsi (曾 熙), grandson
of Tseng Kuo-Fan, a well-known
calligrapher. His work is especi-
ally admired for the power of the
twisted strokes

(*Collection of the Tsêng family,
Hu-Nan*)

FIG. 15.—COPY OF A BRONZE INSCRIPTION

By Li Chien (李 健). Another example of *Ku-Wen*
by a living calligrapher

(*Collection of the calligrapher, Shanghai*)

[49]

FIG. 16.—PART OF THE INSCRIPTION ON THE STONE DRUMS
(*Collection of Ch'in Ch'ing-Tsêng, Soochow*)

[50]

FIG. 17.—COPY OF PART OF A STONE INSCRIPTION

By Wu Ch'ang-Shih, one of the most prominent painters and calligraphers of the last fifty years. He was especially noted for his Stone-Drum-Inscription style. Our art critics are of the opinion that Wu Ch'ang-Shih's talent in painting, as shown in both the pattern and the shape of his strokes, is due to his training in handling the brush for *Ta-Chuan* characters

(Collection of P'ing Tên-Kê, Shanghai)

[51]

states used its own form of the Great Seal Style. Then the Prime Minister, Li Szu, with the help of some of his subordinates, unified the various modes into the Small Seal Style. He also, incidentally, added a number of new characters to meet the demands of the increasingly complex society he governed. This Small Seal Style (*Hsiao-Chüan*) has a standard character for each object and action, and does not confuse the mind with a variety of forms as does the Great Seal.[1] This was an important stage in the development of Chinese culture, affecting not only etymology but calligraphy and painting as well. Learning could be more easily disseminated with a standard script. All the irregularities of the ancient writing were dropped, and each character was made to 'occupy' an imaginary square. On this basis were built all the later styles of writing.

There is a record that the first Emperor of Ch'in, on his visit to the east of his kingdom, made six stone engravings recording his victories and distinctions. Unfortunately only two still exist: one on the Lang-Ya Terrace (琅 邪 臺), the other on T'ai Shan; and in the course of the centuries even these have been badly damaged. The famous *I-Shan Pei* (嶧 山 碑), a memorial on I-Mountain in the Province of Shantung, is not the original written in Ch'in times but a copy made by Hsü Hsüan (徐 鉉) of the Southern T'ang dynasty. It cannot be claimed that this *Pei* (碑) faithfully reproduces the original Small Seal Style as devised by Li Szu, but it is considered by students of this style to be of considerable merit, and it cannot be overlooked.

[1] Many writers translate *Hsiao-Chüan* as 'Lesser Seal'. I consider this misleading. It suggests that the style was throughout simpler than the Great Seal and that its characters had a smaller number of strokes, whereas although this was true of some of the characters it was not true of all.

In the reproduction of it (Fig. 18), it will be seen that the characters are of uniform size, and every line is of equal thickness, smoothly curved and well balanced. The style has two other names: *Yü-Ching-Chuan* (玉筋篆), which means Jade Muscle Seal Writing, and *T'ieh-Hsien-Chuan* (鐵線篆) or Iron Wire Seal Writing (the last a term also used in figure painting). It is a style much practised by calligraphers and painters with the object of acquiring assurance of stroke and mastery of pattern. Li Yang-Ping (李陽冰) of T'ang dynasty, uncle of the famous poet Li Po (李白), was a devoted follower of Li Szu, and a pioneer of this style; later calligraphers adopted his work as a model. Succeeding generations of Small Seal writers blended elements from other styles with the original, in this way giving play to their individual taste. Of these numerous modifications I can give only a few examples here, but they will be sufficient to show how much variation within the bounds of a single style is possible in Chinese calligraphy.

Although seal writing had originally no connexion with the engraving of seals, it is nevertheless always used for that purpose. The designing and carving of seals, itself a form of art, developed independently. But without a thorough acquaintance with the ancient Seal writing, it is very difficult to appreciate the beauty of seals.

FIG. 18.—A MEMORIAL ON I-MOUNTAIN
A copy of Li Szu's, by Hsü Hsüan of South
T'ang
(*Collection of Ts'ai Yü-Ting, Nanchang*)

FIG. 19.—A DESCRIPTION OF SAN-FEN
By Li Yang-Ping, a famous calligrapher of T'ang
who specialized in *Hsiao-Chuan*

(*Collection of Ts'ai Yü-Ting, Nanchang*)

[54]

FIG. 20.—PART OF AN ESSAY

By Têng Shih-Ju (鄧石如),
a calligrapher of Ch'ing, well
known for his work in every style
and famous as the great reviver of
the old calligraphy. In this ex-
ample his great talent is apparent
in the design of each character
and the evenness of the strokes

(Collection of P'ing-Têng-Kê,
Shanghai)

FIG. 21.—A LINE OF POETRY

By Wu Ch'ang-Shih (cf. Fig. 17)

(Collection of P'ing-Têng-Kê, Shanghai)

FIG. 22.—SOME CHARACTERS FROM AN ESSAY

By Chao Chih-Ch'ien (趙 之 謙), a statesman, calligrapher, painter and seal-engraver of Ch'ing. The design of his characters has peculiar charm and his strokes are very graceful. We consider, however, that his work shows feminine characteristics, and though undoubtedly good, is not so fine as the powerful work of Têng Shih-Ju

(Collection of Chiang Ta-Ch'uan, Kiu-Kiang)

FIG. 23.—A COUPLET

By Ho Shao-Chi (何紹基), a learned scholar and historian of Ch'ing dynasty.
As a calligrapher, he is particularly remarkable for his *K'ai-Shu* or Regular Style.
In this example it will be noticed that the number and arrangement of strokes of *Hsiao-Chüan* is adopted, though the pattern is different. The strokes have a free appearance.
One can almost feel the writer letting his brush turn in his hand, following the curves of the characters

(Collection of Cathay Publishers, Shanghai)

[57]

FIG. 24.—A POEM

By Yang Fa (楊 法), a specialist in *Ku-Wên* writing. In this example the squared circles of *Li-Shu* have been blended with many elements of *Ku-Wên*. The rippling or quivering movement of the strokes is very charming to the eye. It is by no means an easy style to write unless one has thoroughly mastered the *Chüan-Shu*

(*Collection of Cathay Publishers, Shanghai*)

FIG. 25.—A POEM

By Yi Li-Hsün (伊 立 勳), a living calligrapher

(*Collection of Ta-Ch'uan Hall, Kiu-Kiang*)

[58]

LI-SHU OR OFFICIAL STYLE

Li-Shu is said to be the invention of a certain Ch'êng Miao of Ch'in dynasty (246–207 B.C.). Ch'êng Miao had the misfortune to offend the first Emperor of Ch'in and was thrown into the prison of Yün-Yang (雲陽), where he lay for ten years, brooding over a new style of writing. Ultimately he produced about three thousand characters in the style we now call *Li-Shu*, and, in consideration of this amazing achievement, was set free and promoted to a high position in the government. His style was adopted almost universally for official purposes, for which it was much more convenient than Seal writing, which the clerks found slow and laborious. At first *Li-Shu* was regarded as a kind of shorthand, and was used only by clerks and officials. Indeed, *Li* in Chinese means ' clerk ', and the style is sometimes called Clerical Style. It is also called *Tso-Shu* (佐書), ' *Tso* ' meaning ' to help '—a help to quicker and easier writing. Later, the Emperor's orders, the government proclamations, and the in-scriptions on ceremonial vessels used at public services all came to be written in *Li-Shu*. No authentic record exists to prove whether the original examples of this style were beautiful in appearance or merely serviceable, but it is clear that later developers of it have adopted beauty rather than convenience as their standard. By the Han period *Li-Shu* was established as one of the standard styles and used, probably, more exten-sively than any other. All kinds of stone monuments and public documents were written in it. Unfortunately most of the Han writings are unsigned, so we shall never know the names of the great *Li-Shu* stylists of those times. But this does not pre-vent us from appreciating the style itself : the firm, decorative

characters, and the varied shapes of stroke (Figs. 26 and 27) which transformed the circular, curved and rounded lines of Small Seal into the square, the polyangular and the straight.

Strictly speaking, there are three forms of *Li-Shu* : the *Li-Shu* of Ch'in, the *Li-Shu* of Early Han and the *Li-Shu* of Later Han. The last is often termed *Pa-Fen*, and has somewhat the same relation to earlier forms of *Li-Shu* that *Hsiao-Chüan* has to *Ta-Chüan*. A vast amount of discussion has taken place as to the origin and significance of the name *Pa-Fen*. But the question is one for archaeologists, and we can content ourselves here with noting the change from rugged uneven strokes to smooth, even, decorative, and regularly incised ones.

The Later Han period saw a sudden leap forward in the art of calligraphy, mainly due, no doubt, to the improvement of the writing instruments. It became possible for calligraphers to express their talents freely, shaping their strokes with varied thickness and rendering them steady or hasty, heavy or light, dry or wet, square or circular as taste demanded. These facilities were denied to the earlier writers, who worked upon bronze and stone with knives that could not be turned with any ease. Henceforward the possibilities of calligraphy as an art were developed to an astounding degree. The designing of the characters had been regarded as a fine art even in the days when the symbols were almost wholly pictorial ; but now the technique was developed till calligraphy could rank, as a means of expression, with any other of the fine arts. It is a tragedy that of the writings of T'sai Yung (蔡邕), who was considered the finest calligrapher of Han times, and who specialized in *Pa-Fen* Style, no authentic examples remain ; we have only records of the opinions of his contemporaries.

FIG. 26.—AN EPITAPH OF TS‘AO-CH‘ÜAN OF HAN (曹全碑)

A good example of *Pa-Fen*. The strokes are shaped very beautifully. Thousands
of calligraphers have been inspired by this specimen to practise sedulously, and some
of them have produced fine work

(*Collection of Ch‘in Ch‘ing-Tsêng, Soochow*)

FIG. 27.—THE HSI-P'ING
（ 鄭燮 ）EULOGY OF
HAN

(Collection of Chiang Ta-Ch'uan,
Kiu-Kiang)

FIG. 28.—THE BROKEN EPITAPH OF
WEI TS'AO-CHÊN (魏曹貞碑)

(Collection of Chiang Ta-Ch'uan,
Kiu-Kiang)

FIG. 29.—THE CHIN-KAN DIAMOND
SUTRA ON TAI-SHAN

（　泰山金剛經　）

The most famous stone engraving that
ever existed. 980 characters, each nearly
two feet square, still remain undamaged.
They are considered to be an excellent
model for big poster characters

(*Collection of C. Y. Tseng, Nanking*)

FIG. 30.—A STONE INSCRIPTION OF TS'UAN-PAO-TZŬ
(爨寶子碑) OF THE CHIN PERIOD

In this style, the shaping of the strokes and the making of
the patterns are done in a peculiar, almost geometrical way.
Some elements of *K'ai-Shu* are incorporated

(*Collection of Ts'ai Yü-Ting, Nanchang*)

6

為雖此圖美：皆向左番風之夕

滿前呈爛熳晴烟低葉紛婀娜燃

柔初觀賦目若零瓢諦視凝神還

衣磐薄裸但覺書紙如書空帷知

變化縱橫無不可他人之弌弍已云

雖不能知蘭之颯亦頗二戴觀品

氣嚴人肌骨寒手必不置行與坐

FIG. 31.—PART OF AN ESSAY

By Chu I-Tsun (朱彝尊), a well-known scholar and a great writer and calligrapher, who specialized in the *Pa-Fen* style. Notice how skilfully he handles his brush, and how scrupulous is his perception of nature

(Collection of Cathay Publishers, Shanghai)

PLATE II

An example of *Li-Shu*, by Shih-T'ao (石濤), the most brilliant painter of the early Ch'ing period. Shih-T'ao has exercised a dominating influence on all subsequent Chinese art. As a calligrapher he specialized in *Chuan-Shu* and *Li-Shu*. But his strokes and patterns are designed according to his own particular taste

(Collection of Cathay Publishers, Shanghai)

FIG. 32.—*HSÜ TA-FU CHIH* (許大夫誌)

By Ch'ên Man-Shêng (陳曼生), a calligrapher of the Ming period. The derivation of his style from the *Li-Shu* of the Northern Wei period is observable. The pattern is very pleasing

(Collection of Chang Lai-Kung, Nanking)

FIG. 33.—A SHORT ESSAY

By Chin Tung-Hsin (金冬心), one of the so-called ' eight queer painters ' of Ch'ing. His calligraphy is distinguished by the square ends of the strokes. Obviously the brush was held in a slanting position, like that of a varnish-painter, and his writing is accordingly called *Chi-Shu* or Varnish Style. It is a mixture of *Li-Shu* and *K'ai-Shu*, and testifies to an undoubted queerness in the calligrapher's nature

(*Collection of Cathay Publishers, Shanghai*)

I have been able to give only a few of the most famous examples of *Li-Shu*. The innumerable variations which were evolved must be left to the reader's imagination.

K'AI-SHU OR REGULAR STYLE

Chronologically, *K'ai-Shu* does not, strictly speaking, follow *Li-Shu*. A style known as *Chang-Ts'ao*—a rapid, abbreviated style—came between. But this I shall deal with later, under the heading of *Ts'ao-Shu*.

The Regular Style is a combination of the modified *Li* Style, of which it preserved the essential characteristics of squareness and precision, and the *Chang-Ts'ao* mentioned above, the features of which are simplicity and speed. At one time the *Li* Style was sometimes called *K'ai-Shu*, a name descriptive of its contrasting elements—*K'ai* meaning 'model' and *Ts'ao* meaning 'grass', the whole signifying 'rough' or 'care-free'. In practice, both *Li-Shu* and *Chüan-Shu* always tended towards *Ts'ao-Shu*, but in *K'ai-Shu* there was an inflexible regularity of design that earned for it the additional name of *Chêng-Shu* (正書) or Regular.

It is impossible to say exactly who originated this style. We have seen that by the end of the Han period many individual variations of *Li-Shu* had been developed: the elements of the future Regular Style are to be found among these variations. But in the four hundred years from Han to T'ang so many scores of scholars of the utmost importance in the history of Chinese calligraphy lived and worked that it is very difficult to particularize at all. Some of their stone inscriptions, particularly those of the Northern Wei period (A.D. 220–64), have roused the enthusiasm of Ch'ing-dynasty and present-day scholars to lyricism.

Popularly, Chung Yu (鍾繇) is considered to be the patriarch of *K'ai-Shu*, on account of his stone inscription *Ho-K'ê-Chieh-Piao* (賀克捷表). The most famous of all Chinese calligraphers, Wang Hsi-Chih (王羲之) of the Chin (晉) dynasty, was chiefly distinguished for his *K'ai-Shu*. He was fortunate in being highly favoured by the second Emperor of T'ang, the great T'ai Tsung (唐太宗), who was himself no mean calligrapher. This Emperor was devoted to Wang's writing and took the utmost pains to collect examples of it, for which he paid very high prices. The court officials were commanded to imitate them, and a fashion was thus started which has prevailed to the present day. Young writers still like to model their style on that of Wang Hsi-Chih.

Other well-known calligraphers who have developed individual types of *K'ai-Shu* include Ou-Yang Hsün (歐陽詢), Yü Shih-Nan (虞世南) and Ch'u Sui-Liang (褚遂良).

In mid-T'ang, during the period which we regard as the Golden Age of Chinese culture, the writer Yen-Chen-Ch'ing (顏真卿) made a drastic change from the elegant slender stroke created by Wang, to a broad, muscular, rigid one (Fig. 39). Another master, Liu Kung-Ch'üan (柳公權), made the framework of his characters even more 'bony' (Fig. 37). By the beginning of Sung times (A.D. 960–1279), the possibilities of *K'ai-Shu* seemed to have been exhausted, for the style had come to a standstill; but once again the impact of new personalities refreshed it, and we have the writings of Su Tung-P'o (蘇東坡), Huang T'ing-Chien (黃庭堅), Mi Fei (米芾) and T'sai Hsiang (蔡襄). In the Yüan (元) dynasty (A.D. 1279–1368) Chao Meng-Fu (趙孟頫) evolved a style of his own, and his work is probably the best *K'ai-Shu* written at that period.

FIG. 34.—PART OF A LETTER

By Chung Yu, of Wei. This shows the true beginning of *K'ai-Shu*

(*Collection of Tai Liang-Mo, Peip'ing*)

[69]

遊德園積精香潔玉女

存作道憂柔身獨居

狀養性命守虛無恬

惔無為何思慮羽翼以

FIG. 35.—HUANG T'ING-CHING

By Wang Hsi-Chih, of Chin. The inscription being written on a small scale, the
original force has unfortunately been lost in repeated rubbing and engraving

(*Collection of Chên Tzŭ-Ming, Shanghai*)

[70]

FIG. 36.—CHIU-CH'ENG-KUNG (九成宮)

By Ou-Yang Hsün (歐陽詢), a scholar and calligrapher of T'ang dynasty. Each character is strongly constructed and designed and the strokes are sharp and powerful. One imagines the artist to have been a well-built man with a fine, handsome appearance

(*Collection of San-Ching Hall, Kiu-Kiang*)

[71]

FIG. 37.—HSUAN-PI PAGODA

By Liu Kung-Ch'üan (柳公權), a scholar and calligrapher. His style might at first glance be mistaken for that of Ou-Yang Hsün. But Liu's strokes have greater 'boniness' and the construction of the character is more elongated. The inscription suggests a slender but well-covered figure belonging to a man careful in carrying out a thing from start to finish

(Collection of Tsai Yü-Ting, Nanchang)

FIG. 38.—PART OF AN ESSAY

By Huang T'ing-Chien, a writer, poet and calligrapher. The sharp, stiff strokes of his style indicate his obstinate character and determination to work out his own ideas

(Collection of Chên Tzŭ-Ming, Shanghai)

[73]

道法先生

辂以足疾

FIG. 39.—AN EPITAPH ON MAO-SHAN

By Yen Chen-Ch'ing (頼真卿), a high official in the army, a statesman and cal-
ligrapher. The chief characteristic is the heavy structure with the 'flesh' of the strokes
tightly bound on to the 'bones'. One can feel the artist pouring the energy of his
whole body into his writing, which is full of indications of his strong character and
sincerity in affairs

(Collection of Chiang Ta-Ch'uan, Kiu-Kiang)

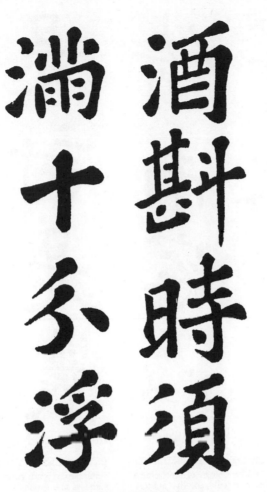

FIG. 40.—HSIAO-YAO-FU

By Su Tung-P'o (蘇東坡), statesman, writer, poet, painter and calligrapher of the Sung dynasty. In his style one can discern the loose flesh and easy manner of a fat person. Su Tung-P'o's reputation as a happy humorist has engendered the saying that one will live longer if one practises Su Tung-P'o's style

(Collection of Chiang Ta-Ch'uan, Kiu-Kiang)

[75]

整我六師

是討是震

倚南窻以

寄傲審容

FIG. 41.—KWEI-CHU-LAI-TZŬ

By Prince Ch'êng (成親王) of the
Ch'ing dynasty. The charm of stroke and
pattern resembles, one feels, the shy glances
of a young girl

(Collection of Chang Lai-Kung, Nanking)

FIG. 42.—PART OF AN ESSAY

By Chang Yü-Chao (張裕釗),
statesman and calligrapher. His style
shows the great influence of Wei stone-
rubbings. He has only a few followers,
because his brush-work is very difficult
to achieve.

*(Collection of Chang Lai-Kung,
Nanking)*

[76]

繞坐於石盤蔬

器瑤琴芭蕉圍

大石案陳設古

FIG. 43.—PART OF AN ESSAY

By Ho Shao-Chi (何紹基), whom we have already seen as a Seal writer. Here
we see his special way of shaping the strokes and making the patterns. The effect is by
no means soft if you compare it with the work of Yen Chen-Ch'ing. It is very difficult to
copy, and beginners are advised not to attempt it

(Collection of the Author)

[77]

7

板橋自幼窶不喜人過目不忘而四書五經自家又未嘗時刻而背忘然他當忘者不窶而忘不當忘者不窶而忘百兩午歲讀書天寧寺帖嘩之眼戲同友人賽正種生亂市坊中印精日默三五希蘇

FIG. 44.—A PART OF AN ESSAY

By Chêng Hsieh (鄭燮), one of the 'eight eccentric painters' (Chin Tung-Hsin (金冬心) was another) of Ch'ing times, and a distinguished calligrapher. His style contains *Chuan* and *Li* qualities and a stroke which resembles a painter's brushwork. The result has a very special flavor

(Collection of the Author)

妃　嫛　萇
夬　渚　固
戡　陔　饌
梁　邱　謐
凫　戀　原
鷖　佚　隰

FIG. 45.—PART OF AN ESSAY

By Chao Chih-Ch'ien (趙之謙), an example of whose writing we have seen in the Seal Style. Here he follows the style of the stone inscriptions of Southern T'ang. A different way of shaping the strokes is apparent, and an individual mode of constructing the characters

(Collection of Chang Lai-Kung, Nanking)

Of the Ming (明) dynasty writers (A.D. 1368–1644) Tung Ch'i-Ch'ang (董其昌) is the most notable exponent. From the Ch'ing (清) dynasty to the present time, writers have tried to put new blood into their imitations of the old masters by incorporating elements from ancient stone inscriptions. I have given (pages 69–79) a few examples of the many variations of *K'ai-Shu* that have been created.

It can safely be said that *K'ai-Shu* is the most typical style of Chinese calligraphy. Though strongly differentiated from both *Li-Shu* and *Chüan-Shu*, it holds an uncontested place both as a practical medium for daily use and as a graphic art. Each individual variant has, as we shall see later, its corresponding version in *Hsing-Shu* and *Ts'ao-Shu*.

HSING-SHU OR RUNNING STYLE

Hsing-Shu or Running Style was the invention of Liu Tê-Sheng (劉德升), of the Later Han period. In its most highly developed form it departs from the strict formality of *Li-Shu*. The angles of *Li-Shu* are softened and a great deal of movement and ease added. Both this style and *Chang-Ts'ao* (章草) were created before the real *K'ai-Shu* was established. *Hsing-Shu* cannot therefore be said to have derived from *K'ai-Shu*; it is a parallel style which prevailed at the same time. As the Regular Style developed and ramified it was inevitable that one variation should be a combination of *K'ai-Shu* and *Hsing-Shu*. The two found each other good companions, and became, indeed, inseparable; every type of *K'ai-Shu* came to have a corresponding type of *Hsing-Shu*. Running hand, as its name suggests, allows of freer handling and more vivid movement.

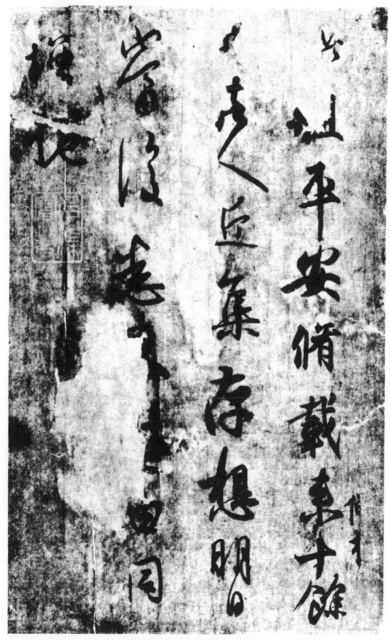

PLATE III

Fêng-Chü-T‘ieh (奉橘帖), by Wang Hsi-Chih (王羲之). This, the only piece
of Wang's writing which has survived, was done in the fourth century A.D. It is a very
pleasing specimen of *Hsing-Shu*

(*Palace Museum, Peip‘ing*)

日月轉雙轂古今同一丘惟此

鶴骨老凛然不知秋去住雨

無礙天人爭挽留去如龍出

雷雨卷潭湫來如珠還浦奥

It has usurped the old position of *K'ai-Shu* as the most popular style for daily use, besides achieving recognition as one of the most artistic styles. *K'ai-Shu* now occupies a subordinate place in the training of calligraphers.

The *Lan-Ting-Hsü* (蘭亭序) of Wang Hsi-Chih is considered to be the best work ever done in *Hsing-Shu*. Unfortunately most of the rubbings of it found in China nowadays are taken from copies made in the T'ang period which have probably lost the quality of the original.

The strokes and patterns of *Hsing-Shu* are designed and executed every bit as carefully as those of *K'ai-Shu*, only they are written in a quicker way. The strokes and dots which in *K'ai-Shu* are separate are usually joined in *Hsing-Shu*, and, in the piece, *Hsing-Shu* has a fluency not possessed by the more formal style. Though closely related to *K'ai-Shu*, *Hsing-Shu* can also manifest the influence of *Li-Shu* and *Pa-Fen*.

In the following examples the reader will be able to make his own comparisons between the various modes of the style. Most of the pieces are by artists famous for their painting as well as for their calligraphy, and should therefore, incidentally, serve the purpose of collectors wishing to identify paintings by one or other artist. It is worth while also to compare them with the K'ai-Shu examples on pages 69 to 79, especially those by the same calligraphers (e.g. Figs. 43 and 52 by Ho Shao-Chi). It is even more worth while to compare them with the examples of *Ts'ao-Shu* later on (pages 94 to 104).

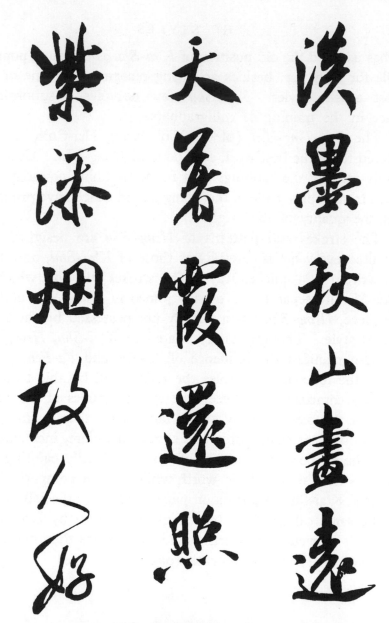

FIG. 46.—PART OF A POEM

By Mi Fei (米芾). One thinks of a striking tubby figure walking along a road, unaware, apparently, of any one but himself. The style is very different from both Wang's and Yen's

(Palace Museum, Peip'ing)

[82]

異品殊葩共翠柯嫩紅拂拂
醉金荷春羅幾疊疊丹陛雲
繚重縈沿絳河玉鑑和鳴鸞
對舞寶枝連理錦成棄束
君造化勝前歲吟繞清香故
琢磨

FIG. 47.—A POEM

By the Emperor Hui Tsung (徽宗), of Sung (宋), a gifted scholar, painter and calligrapher. He distinguished himself in calligraphy by a special style to which he gave the name of Slender Gold. The above is an example. His writing shows the emperor to have been a well-built, handsome figure.

(Palace Museum, Peip'ing)

余酷嗜苦笋諫者至十人戲作苦笋賦其詞

曰僰道苦笋冠冕兩川甘脆愜當小苦而及

成味溫潤縝密多啗而不疾人蓋苦而有味

如忠諫之可活國多而不害如舉士而皆得賢

是其鍾江山之秀氣故能深雨露而避風

FIG. 48.—PART OF AN ESSAY

By Huang T'ing-Chien. The same characteristics are displayed as in this calligrapher's Regular Style writings

(*Palace Museum, Peip'ing*)

FIG. 49.—PART OF A LETTER

By Chao Meng-Fu, a descendant of a Sung emperor and a scholar, painter, and calligrapher. Some qualities from Wang's writing are traceable, but the style stands by itself in its soft undulating movement and charming pattern

(Palace Museum, Peip'ing)

[85]

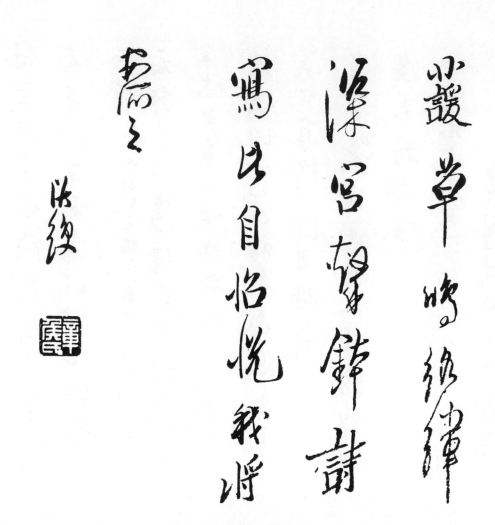

FIG. 50.—A POEM

By ' Old Lotus ' Ch'ên Lao-Lien (陳老蓮), a great painter and calligrapher of the
Ch'ing period. He has a highly individual way of shaping his strokes and constructing his
characters. He has absorbed some qualities from Wang and Huang

(*Palace Museum, Peip'ing*)

使劍以術鑄刀若為筆鈍猶楚溪水庙

瀘淬柔列今當雜涪川元乙迺刀劃期水

一劃故此以开益昔去阮神解（去声）閣群哥

濟北雅樂玩以當抓之氣與刀元乙本無

刀銅鐵斷空廊

世況二十首之二率錄并重言

八大山人

FIG. 51.—A POEM

By Pa-Ta Shan-Jen (八大山人), another great painter and calligrapher of the early Ch'ing period. He has a peculiar stroke. His pattern is derived from Wei-dynasty stone rubbings

(Collection of Cathay Publishers, Shanghai)

[87]

FIG. 52.—PART OF AN ESSAY

By Ho Shao-Chi. (Cf. Figs. 23 and 43.) Notice the marked variation in the ' weight ' and size of some of the characters. This has definite relation to the pattern.

(Collection of Tsai Yü-Ting, Nanchang)

[88]

其精華故得碑意之厚而善

變沸之迎追以駕北碑侔者

趙搗牀陶心雲烝誤法龍門

故板批搗牀晚ム駕鄭文之乃

FIG. 53.—A POEM

By K'ang Yu-Wei (康有為), a widely read scholar, statesman, and calligrapher. His style shows many elements found in Wei rubbings. He has taken the lead in the new era of calligraphy begun in modern times

(*Collection of Chiang Ta-Ch'uan, Kiu-Kiang*)

勝日登臨輕一醉

治耆騰踊躍雙流

仲揆先生正之

譚延闓

FIG. 54.—A COUPLET

By T'an Yen-K'ai (**譚延闓**), late President and late Premier of the Chinese
Republic. He was a faithful follower of Yen Chen-Ch'ing's Style. This couplet was
written specially for the author

(Collection of the Author)

[90]

FIG. 55.—A POEM

By Yü Yu-Jên (于右任),
(1878–1964), a widely known
twentieth-century calligraph-
er. His style shows him to
possess a cultured and care-
free personality with the
tastes of an antiquarian

(Collection of Chang Lai-
Kung, Nanking)

FIG. 56.—PART OF A POEM
By Chêng Hsieh. (Cf. Fig. 44.)
(Collection of the Author)

8

歐明三德于天下者先治其國欲
治其國者先齊其家欲齊其
家者先脩其身欲脩其身者
先正其心欲正其心者先誠其
意欲誠其意者先致其知致
知在格物
大學一章為最高政治哲學
錄似
仲雅先生
葉恭綽 丑年十二月

FIG. 57.—AN EXTRACT FROM THE *CONDUCT OF LIFE* OF CONFUCIUS

By Yeh Kunh-Ch'o (葉恭綽) (1880–1965), one of the outstanding calligraphers of the twentieth century. This was written specially for the author

(Collection of the Author)

[92]

TS'AO-SHU OR GRASS STYLE

As I have already explained, the variety of *Ts'ao-Shu* known as *Chang Ts'ao* was in existence before *K'ai-Shu*. Controversies still rage as to the identity of the inventor. Some records propose the Han Emperor Chang, arguing from the name; others prefer Ts'ao Yung (蔡邕) or Tu Ts'ao (杜草). The meaning of the word *chang* is 'essay' or 'chapter'; *ts'ao* signifies 'grass' and has besides the adjectival sense of 'rough'. The two words combined give us the expression 'rough essay' or 'rough draft', something written quickly and perhaps carelessly. *Ts'ao-Shu* may be supposed to have been written, in the first instance, in a hurried, sketchy manner, for the sake of convenience; but, later, scholars found a certain beauty in it and an interest in practising and perfecting it. Each character in the *Chang-Ts'ao* Style is written separately and the style thus differs from the later *Ts'ao-Shu*. The undulating movement of the strokes was doubtless derived from *Li-Shu*, especially from the *Pa-Fen* variety.

The later *Ts'ao-Shu*, developing simultaneously with *K'ai-Shu* and *Hsing-Shu*, grew more and more care-free and 'grassy', as the following examples show. The uncurbed force and rapidity of the style causes every character in a complete piece to have both an inherent and a visible link with the rest. For this reason many descriptive names have been given to special variations of *Ts'ao-Shu*, such as Flying Grass, Scattered Grass, Twining Silk Grass.

Generally speaking, *Chuan-Shu* and *Li-Shu* are the most decorative styles, and are used on important occasions for the sake of their beauty and dignity. For practical use their incon-

FIG. 58.—PART OF AN ESSAY

By Chang Chih (張 芝) of the later Han period. His style retains something of the quality of *Li-Shu*

(*Collection of Tsai Yü-Ting, Nanchang*)

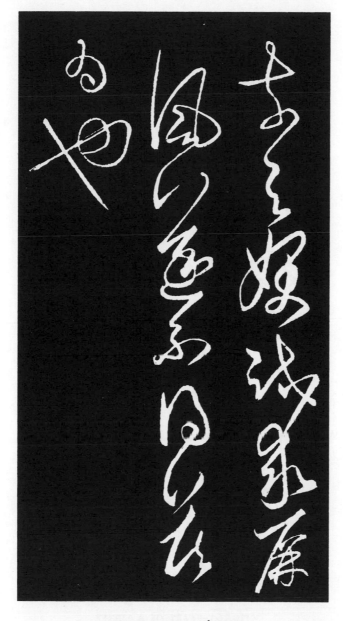

FIG. 59.—SHIH-CH'I-TIEH

By Wang Hsi-Chih, whose graceful and fluent *Ts'ao-Shu* has dominated the minds of all Chinese scholars through the centuries. The stone engraving from which this rubbing is taken is probably not the original, much of the quality of which has been lost

(*Collection of the Shanghai Commercial Press*)

[95]

FIG. 60.—PART OF A LETTER

By an unknown calligrapher of the T'ang period who was evidently influenced for the good by Wang Hsi-Chih's style

(*Palace Museum, Peip'ing*)

[96]

FIG. 61.—A PART OF AN AUTOBIOGRAPHY

By a monk, Huai Su (懷素), of the T'ang period, a calligrapher who specialized in
Ts'ao-Shu. He was very fond of wine, and wrote quickly and beautifully whilst he was
drunk. Being very poor, and lacking money to buy paper, he planted many banana
trees in his native home and used the leaves for writing. He called his writing ' The
calligraphy of an intoxicated immortal '. From his style one can imagine his appearance

(Palace Museum, Peip'ing)

[97]

FIG. 62.—PART OF A LETTER

By Ts'ai Hsiang, of the Sung period, a statesman and calligrapher. His *Ts'ao-Shu* was described by Su Tung-P'o as showing the changes and movements of winds, clouds, dragons, and snakes

(Palace Museum, Peip'ing)

[98]

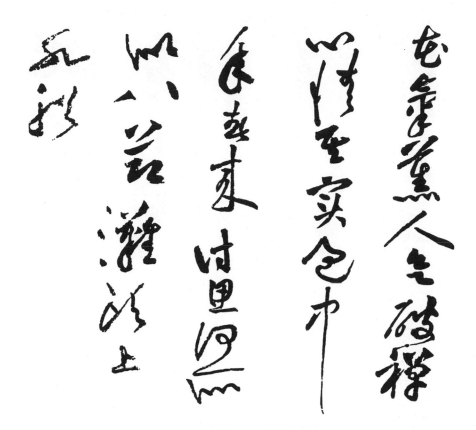

FIG. 63.—A POEM

By Huang T'ing Chien. This example shows Huang's character more clearly than his *K'ai-Shu* and *Hsing-Shu*. It is considered to be his best work

(*Palace Museum, Peip'ing*)

FIG. 64.—PART OF AN ESSAY

By Chu Yün-Ming (祝允明). It displays the same character as his *Hsing-Shu*
(*Collection of Chiang Ta-Ch'uan, Kiu-Kiang*)

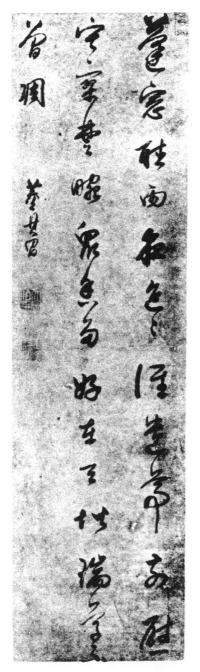

PLATE V

By Tung Ch'i-Ch'ang (董其昌), a learned scholar, statesman, painter, and calligrapher. He has combined most of the well-known styles and created one of his own. This piece of *Ts'ao-Shu* shows a tendency towards *Hsing-Shu* (*Collection of Cathay Publishers, Shanghai*

FIG. 65.—A POEM

By Ch'ên Ts'an (沈 粲), of the Ming period, a statesman and calligrapher. His style gives one the impression of a man standing with uplifted head

(*Palace Museum, Peip'ing*)

FIG. 66.—PART OF A POEM

By Chen Tao-Fu (陳道復), of the Ming period, a well-known flower-painter and
calligrapher. His style is a kind of combination of Mi's and Chu's

(Collection of Cathay Publishers, Shanghai)

FIG. 67.—PART OF AN ESSAY

By Wang Tso-Ling (王作霖), a statesman of the Ch'ing period, who later became a monk under the name of Hung Yü (弘瑜). He was a painter and calligrapher. From his emphatically individual style one can imagine how he forced his whole being into his work and movements. Few could have dared to approach him when he was seriously occupied

(Collection of Cathay Publishers, Shanghai)

[103]

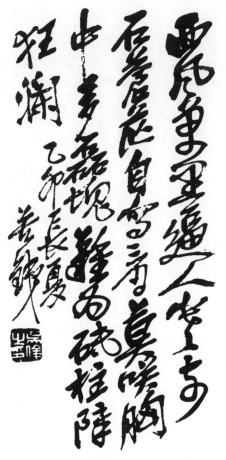

FIG. 68.—A POEM

By Wu Ch'ang-Shih. We have already seen an example of his *Ta-Chuan* Style.
From that basis we can trace the source of his strength in the strokes of his *Ts'ao-Shu*
(*Collection of P'ing-Tên-Kê, Shanghai*)

venience in writing forces them to yield place to *K'ai-Shu*, *Hsing-Shu*, and *Ts'ao-Shu*. They are used occasionally, however, even to the present day, but only by trained calligraphers. The three simpler forms have really dominated calligraphic practice ever since their establishment.

The elements of the characters in all styles were fixed in the Han period and no changes have since been made in their formation, all the attention of subsequent writers having been turned to the shaping of the strokes and the arrangement of them in patterns. When beginning to learn calligraphy, *K'ai-Shu* should be practised first, then the other styles in the order of the learner's preference.

I recommend the reader not to proceed to Chapter IV until he has looked again at the examples given in this chapter, examining them attentively and deciding for himself what constitute the essential differences between the various styles.

IV

THE ABSTRACT BEAUTY OF CHINESE CALLIGRAPHY

BEAUTY is a difficult word to define, especially as applied to Chinese calligraphy.

There is a beauty which appeals immediately to the heart—in natural scenery, for instance, and in some pictures. There is also a beauty which more than half conceals itself within or behind Form and is revealed only to the 'informed' and searching eye. The first we can trace to its origin and analyse. The second is generated neither by powerful thought nor reason, nor has it any particular source : it is the 'abstract' beauty of line.

The word 'line' suggests certain general shapes—straight and curved, thick and thin. The medium of all the graphic arts is line—straight and curved or in combinations of straight and curved. Straight lines give the impression of solidity, strength, severity, immobility. Curves engender feelings of motion, buoyancy, suavity, and delicacy ; they also tend towards the negative and effeminate. The beauty of handwriting in any language is the product of combinations of these two linear movements. But whereas calligraphers of Western languages are confined within the range of straight and curved lines, Chinese calligraphers have additional scope for individuality in

variations of the separate strokes. All this constitutes what I have termed the 'abstract beauty' of line. But definition is difficult and not always very helpful; my meaning may be clearer after I have given some examples and analogies.

To the Chinese themselves, calligraphy is the most fundamental artistic manifestation of the national mind. Rhythm, line, and structure are more perfectly embodied in calligraphy than in painting or sculpture, and even form and movement appear in it in at least equal measure. Every Chinese character, built up in its own square, presents to the calligrapher an almost infinite variety of problems of structure and composition; and when executed it presents to the reader a formal design the abstract beauty of which is capable of drawing the mind away from the literal meaning of the characters. Many of our scholars have confessed that they have almost lost their minds in contemplating the miraculous lines and structures of some of our characters—characters so combined as to introduce indirectly to the thought aesthetically satisfying equilibria of visual forces and movements. For there is in every piece of fine Chinese writing a harmony which is a source of pleasure over and above the pleasure of apprehending the thought. To those who lack the sense of abstract visual beauty, or are unable to experience it from Chinese characters, the enthusiasm of those Chinese connoisseurs who lose their heads over a single line or group of lines that have no apparent logical meaning, will seem little short of madness; but such enthusiasm is not misplaced, and it is my aim in this book to explain whence this joy is derived.

I cannot write of the abstract beauty of Chinese calligraphy without mentioning some of the most vital movements in con-

temporary Western art, such as Surrealism. A section of the general public appreciates the productions of the Surrealists, partly no doubt on account of their novelty, but partly also from genuine insight into the ideals and intentions of the artists. The rest pooh-pooh the whole movement, which gives too severe a shock to their conventional ideas of beauty or is incomprehensible to them. Yet there is, after all, nothing essentially new in Surrealism; to the Chinese mind, accustomed through many centuries to an attitude of receptivity towards purely linear beauty, its principles cause no shock. A piece of our most ancient script, composed perhaps five thousand years ago, and a Surrealist drawing of the 20th century produce very similar aesthetic emotions. Compare, for example,

the Chinese word *Fu* 尗⺆ in the ancient script with this draw-

ing by Hans Arp 𝄞. Viewed as realistic representations, both appear strange, but viewed as abstract designs they are extremely fascinating.

Until recently Europeans tended to think of the Chinese mind as something highly mysterious. The Chinese, of course, never thought of themselves in this way, and the mystery must therefore have been the result of misunderstanding. Most of the obstacles to a right understanding of the Chinese are removed by a comprehension of the extent to which artistic emotion is indulged in by them for its own sake, and how largely they sacrifice realism to aesthetic satisfaction.

In ancient China the men of artistic genius perceived the beauty in the real and tried to represent it by simplifying the outline, in order to capture the essential shape of the object

and at the same time to form an aesthetically pleasing composition. Compare, for example, the hieroglyph for 'worship' in ancient Egyptian script, ⚏, with the ancient Chinese character for the same concept, ⚏. The Egyptian is a 'straight' picture of a kneeling person. The Chinese, though it captures the attitude and essential shape of a kneeling person, is not an exact imitation of it. We claim that it is 'above the real'. But obviously many more primitive and hesitating forms of the character, of which we have no record, must have preceded the one shown, which is the product of a long evolution. Thus the deliberate neglect of realistic representation is in no way strange to the Chinese. The 'line' of the ancient character for 'worship' is, to us, as powerful and beautiful as any linear form can be.

The Surrealists—to return to our rather illuminating comparison—have expressed the desire 'to deepen the foundations of the real, to bring about an ever clearer and at the same time ever more passionate consciousness of the world perceived by the sense'.[1] I think it is just this which the Chinese, in their ancient script, accomplished. They perceived reality with clear eyes, and, in simplified and astonishingly significant forms, rendered the essentials visible and memorable.

The Surrealists are also said to 'have attempted to present interior reality and exterior reality as two elements in process of unification'.[1] This, too, I think, is sometimes achieved in the composition of Chinese characters, especially those in the category called Logical Combinations: complex characters compounded of two or more simpler characters, each of which

[1] '*What is Surrealism?*' by André Breton.

has a *visual* significance of its own and contributes in addition to the *meaning* of the whole.

The Chinese value calligraphy, as I have already said, purely for the sake of the satisfactory nature of its lines and groups of lines ; they acknowledge no necessity for the thought expressed to be beautiful. The aesthetic of Chinese calligraphy is simply this : that a beautiful form should be beautifully executed. A piece of writing lacking the second factor would be merely vulgar. An identical series of characters can be written by two hands, and though the lines described are precisely the same, with no difference at all between the curves and the structures, the work of the one hand will be an object of joyful contemplation while the work of the other appears so common that the untutored onlooker feels he could do as well himself ! A fine stroke by a good calligrapher (examples of which are given in the previous chapter) is not easy to analyse, still less to imitate. Its aesthetic quality does not vary with the changes of fashion ; many other styles may—and always do— succeed it, but it remains as satisfying and admirable as when it was first conceived.

The power to distinguish good strokes from bad depends upon taste and experience. In an ordinary decorative design, provided the curves and straight lines are of even breadth and consistent movement, two different hands can sketch it equally well ; slight differences which may appear in the sketches can be adjusted subsequently. But a line in Chinese calligraphy is executed with a single stroke of the brush ; it is not possible to touch it up afterwards ; the writer's skill, or lack of it, are always only too apparent. Perfect co-operation between mind and hand, such as can only be achieved by years of practice,—

co-operation vitalized by the emotional energy of the artist at the moment of writing—is required for Chinese calligraphy, and it results in forms of unique individuality. One master's work is inimitable even by another master. A fairly exact likeness is possible, but such a copy invariably looks laboured and lacks vitality, for no other hand than that of the creator can imbue the strokes with spontaneous and unconscious spirit.

It is told of Chung Yu of the Wei dynasty that after failing to get any instruction from Wei Tan (韋 誕) about T'sai Yung's stroke he nearly died of disappointment. But after Wei Tan's death he rescued a specimen of the wonderful stroke from the calligrapher's tomb and, making this his model, evolved what came to be called the Regular Style, of which he is now regarded as the ' Father '.

The fundamental inspiration of calligraphy, as of all the arts in China, is nature. As I have said in my book, ' *The Chinese Eye* ', our love of nature is characterized by a desire to identify our minds with her and so enjoy her as she is. In calligraphy we are drawn to nature in the same irresistible way : every stroke, every dot suggests the form of a natural object. And, in turn, natural objects become in many instances prototypes of calligraphic styles. Many expressive names drawn from nature have been coined by great writers in the past to describe different kinds of stroke : ' falling stone ', ' sheep's leg ', ' the ruggedness of a plum branch ', ' decayed trunk of an old tree ', ' the muscles, bones, and sinews of an animal's limbs ', are examples.

It follows that our appreciation of calligraphic strokes is in proportion to our feeling for nature. Just as in the process of writing we install this sensuous perception within the frame-

work of the characters, so afterwards in contemplation we experience an emotional pleasure akin to that of direct contact with natural beauty. Every twig of a living tree is alive; and every tiny stroke of a piece of fine calligraphy, inspired by some natural object, has the energy of a living thing. The strokes of a printed character are very different; they are inspired only by draughtsmanship, and can be copied by the most insensitive. So, too, with a stroke which is 'painted', i.e. deliberately formed in direct imitation of a natural object; its superficial verisimilitude prevents it having the true vitality of art. Nor can a good stroke be made with any kind of pen or pencil. The brush alone—the same brush as the painter uses—can effectively reproduce the movements of clouds and trees.

In modern Chinese calligraphy certain types of stroke have become standardized. Their ideal forms are called the 'Seven Mysteries', *Ch'i-Miao* (七 妙). A writer who can achieve all seven of them may rest assured of winning lasting fame. They are as follows:

(1) A horizontal line or *Heng* (橫) ➖ , so written as to seem like a formation of cloud stretching from a thousand miles away and abruptly terminating.

(2) A dot or *Tien* (點) • , giving the impression of a rock falling with all its force from a high cliff.

(3) A *P'ieh* (撇) or sweeping downward stroke, written from right to left ╱, so that it has the sharp edges of a sword, or looks like the gleaming horn of a rhinoceros.

(4) A vertical line or *Chih* (直) ❘, like a vine stem thousands of years old but still stout and full of strength.

(5) A *Wan* (彎), a sharp curve, ⟩ and ⟨, like the sinews and joints of a strong crossbow, pliable in appearance but in reality tough.

(6) A *Na* (捺) or downward stroke ⟍, made from left to right—the opposite of *Pieh*—like a wave suddenly rolling up or a flying cloud emitting growls of thunder!

(7) A *T'i* (趯), a downward stroke ⟍, moving from left to right, but straighter and stiffer than *Na*, and made to appear like a drooping pine-tree with firm roots.

To those not versed in the technique of calligraphy, and particularly in the handling of the brush, these terms, for all their vividness, will seem remote from the actual practice of writing. All the necessary information on technical matters is given in the next chapter; but I think that even without this information the 'Seven Mysteries' are illuminating as giving some idea of the beauty and movement which Chinese people *expect* to find in the strokes of a good 'hand'.

But we claim that not only the separate strokes but the structures of the complete characters are basically inspired by Nature. During the long course of our artistic history innumerable writers have made exhaustive researches into the possible variations of stroke and structural form, with the result that there is now hardly an organic shape or a movement of a living thing that has not been assimilated into our calligraphy. The great masters of the past set themselves to absorb natural beauties and to translate them into the strokes and structures of characters, and their successors have classified their achievements. In the previous chapter you will find examples of strokes inspired by the brittleness of the sheep's

leg, by the massive paw of the tiger, the rugged face of a rock, the heavy tread of the elephant, the twisted shape of the pine branch, the firmness and straightness of the chestnut trunk, the elegance of the orchid's leaves, the intractability of an old rattan, the creeping movement of the snake, and so on. Every stroke must, as I explained earlier, be well shaped and beautiful in itself, and form, in combination with other strokes, a satisfying pattern. But our judgement of a character's excellence depends largely upon the degree to which it possesses the vitality of a particular natural object.

There are in drawing only three basic forms : the circle, the triangle, and the square. If you fill each of these with pattern, you find that the last is the one which provides the greatest scope ; the circle and the triangle will satisfactorily contain only curved patterns. Every Chinese character roughly fills a square, and for this reason its exponents have unusual freedom for composition and attitude. But this freedom has its laws. For each character there is a definite number of strokes and appointed positions for them in relation to the whole, the shape differing with the different styles. No stroke may be added or deleted for the sake of decorative effect. Chinese characters were evolved by a process of artistic simplification from observed objects, and it would be a travesty of this origin were unnecessary parts to be added or necessary parts omitted in the interests of some impulse towards ' beautification '.

The definite and well-knit strokes of a Chinese character can be composed into many individual patterns according to the talent of the calligrapher. Thus :

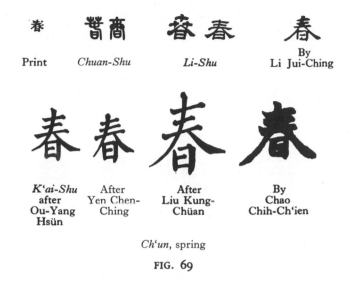

| Print | Chuan-Shu | Li-Shu | By
Li Jui-Ching |

K'ai-Shu After After By
after Yen Chen- Liu Kung- Chao
Ou-Yang Ching Chüan Chih-Ch'ien
Hsün

Ch'un, spring

FIG. 69

Each of these examples, with the exception of the printed type, has its own pattern distinguished by sharply individualized shape of stroke and the arrangement of the strokes in the character. Strict regularity is not required; the writer has only to consult his taste and establish a general balance. The essential thing is that the pattern should have a living movement.

It is not difficult to differentiate the qualities of printed characters from those of good handwriting. In a printed character the strokes are of fixed length, thickness, position, and so on; printing does not allow of variation in these respects. As for the style—any one can copy that, for it is bound to be common and entirely lacking in individuality. We call such strokes ' dead '. And the arrangement of them in the character is ' dead ' too, for it is done simply to fill up the square symmetrically. The result is neat, clear, and legible, but quite without aesthetic significance.

[115]

Another type of 'dead' character—though this kind is executed by hand—is the 'decorative' one (Fig. 70) widely used nowadays in advertisements. Superficially, this 'style' is not without attraction; but on examination each stroke is seen to have been *painted*,—not executed with a single stroke of the brush,—and the product is accordingly wooden.

FIG. 70

I give below (Fig. 71) some experimental diagrams which I think will enable the reader to compare the aesthetic response in himself to printed and well-written strokes. I have deliberately refrained from forming the strokes into actual characters in order not to distract the reader's attention with an invitation to discover some possible meaning. The first two examples represent the printed character, the other three represent various lively movements such as are to be found in different styles of calligraphy.

FIG. 71

If these simple lines can produce such markedly different visual impressions, how much more must be possible with the complex shapes and contours of actual characters!

Although, except in our most ancient script, which is some-times termed picture-writing, no Chinese character exactly represents a living thing, yet the main principle of composition is in every case a balance and poise similar to that of a figure standing, walking, dancing, or executing some other lively movement. In criticizing a piece of calligraphy, the first desideratum is that the thing should be living; the next, to discover where the life lies. The beauty of Chinese calligraphy is essentially the beauty of plastic movement, not of designed and motionless shape. A finished piece of it is not a sym-metrical arrangement of conventional shapes, but something like the co-ordinated movements of a skilfully composed dance —impulse, momentum, momentary poise, and the interplay of active forces combining to form a balanced whole. Neatness, regularity, and exactitude of outline, such as are found in English or Chinese printing types, are not desirable qualities in Chinese calligraphy.

The principles on which the strokes are balanced into a beautiful pattern are not those of symmetry, but depend upon a kind of inherent tendency in the writer. The balance is achieved by instinct, and derives from the writer's aesthetic vision. However, although our ancient masters doubtless had no knowledge of mechanics, most of their characters succeed in obeying its laws! The centre of gravity, for instance, is always rightly placed. In the examples below (Fig. 72), each character has a stable stance, with a gesture of movement, and the centre of gravity falls upon the base. If any part of any character had been wrongly placed, the whole would have appeared to totter.

The construction of a good character presents a further

problem in the spacing of the parts. One side of the character may be much larger or denser than the other side, but the whole still must not overbalance. We Chinese *prefer* asymmetrical

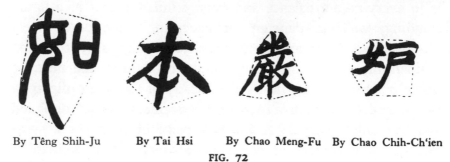

By Têng Shih-Ju By Tai Hsi By Chao Meng-Fu By Chao Chih-Ch'ien

FIG. 72

balance, for the reason that it seems to us to possess more movement.

In the following sketches two pairs of birds are perched upon a branch, but in (*a*), where the postures of the pair differ

(*a*) (*b*)

FIG. 73

slightly, the eye is stimulated, while in (*b*) the eye has an impression of decorative effect only, a static impression. Similarly with characters. There is a very marked difference in the pleasure derived from the standard proportions of the printed words *Ping* and *Lin* and the well-placed irregularities of their written

立立 竝 林 林

Ping *Lin*

FIG. 74

[118]

forms. The word 'three' provides an even better illustration. The character is composed of three horizontal lines. In printing, these lines are equidistant, parallel, and of equal length;

三 三 三 三

FIG. 75

in the Seal Style a larger space is left between the second and third lines than between the first and second; while in *K'ai-Shu* and *Hsing-Shu* the length differs and the shape of the lines varies more or less in accordance with the taste of the writer at the moment.

We try to avoid using similarly shaped strokes in the same character or forming similarly designed characters in the same piece of calligraphy. This point I shall deal with more fully in the chapter on composition.

It is of especial significance that the arrangement of the different parts of a character to form an organic whole can be done only with the subtlest appreciation of artistic values. Firstly, all the strokes of a character must be grouped so that they not only balance perfectly with each other but together form a unit which is complete in itself and which would be upset if any stroke were to be taken away. Finally, the whole character must have, not static symmetry, but a dynamic posture, the attitude of a moving figure in momentary equilibrium.

In the following illustrations, characters by eminent calligraphers are accompanied by sketches by myself, illustrating how much of art and how little of mechanical design there is in Chinese script. In Fig. 76, the character *Yu* (有), 'to have', which is by Têng Shih-Yü, was written in *Chüan-Shu* at a time

when little progress had been made beyond the most primitive form of the style (*Ku-Wên*), yet it has a very emphatic movement as well as stability. In the accompanying sketch, the left hand of the figure largely supports the body and is balanced by the left foot ; while the slight lifting of the right hand and the slight downward inclination of the right foot, which is held close to the left, assist in creating the impression of a temporary equilibrium achieved in the act of moving.

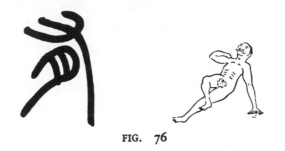

FIG. 76

The character *Hsin* (心) in Fig. 77, which means ' heart ', is considered difficult to form well, because the three dots and the single curve are not easily arranged into a satisfying pattern. This particular example is taken from a *Li-Shu* memorial of

FIG. 77

the Wei dynasty. Comparing it with the accompanying picture, the three dots are seen to occupy corresponding positions to the man, the oar, and the awning, while the elongated curve has the semblance of the boat. The whole character seems to be proceeding serenely down a river.

Fig. 78 is another example of Yen's style, of which we

have already learned something (page 74) : it is strong, firm, sincere. The character *Ts'ou* (足) means 'foot', and, appropriately, it compares with a dignified bishop stepping ceremoniously down, perhaps, the aisle of Westminster Abbey!

FIG. 78

In Fig. 79 the character *Chieh* (界), 'boundary', well formed by Chao Chih-Ch'ien, has the motion of an owl in flight when about to soar upward. The two strokes of the lower half, stretching out in divergent directions, seem to support the body of the character like the wings of a bird.

FIG. 79

Fig. 80 comprises the character *I* (意) for 'thought' written by Su Tung-P'o and the figure of a person seated at ease. There is no suggestion of a wooden image in the character, but the imaginary person, from the inward movement of the strokes, seems to have a pensive demeanour.

FIG. 80

[121]

10

Fig. 81 shows the character *Sui* (遂), 'to follow', in the Grass Style of Wang Hsi-Chih. The movement of the strokes suggests speed, but a dancing rather than a racing speed. The formation of the character is amazingly good, every stroke joined to the next in a continuous mobile line, like the contours of a dancing girl with her floating draperies.

FIG. 81

Finally, Fig. 82, *Yee*, the author's signature (舞), which means ' a constant rule ', has the shape of a stork standing on one leg—stable but poised for movement.

FIG. 82

It would not be possible to find pictures to correspond as closely as this with every character, but the principle holds good for all : the character must have the balance of a human being or natural or other object caught in the act of moving.

In the writing of an inferior calligrapher either asymmetrical balance, or momentum, or both, will be lacking. Good writing always has both qualities, and the achievement of them often draws a character into unexpected shapes. This unexpected quality is one of the greatest attributes of Chinese calligraphy. The flexibility of construction which is possible enables the practised calligrapher to choose his own forms as he works. The choice and construction require, of course, good taste, and good taste has to be cultivated, and this is done by observing beautiful forms in nature and studying beautiful forms in art. Those unaccustomed to these practices are usually uncertain in their judgements of calligraphy. Some characters are satisfying to every eye, but many more can be appreciated only by those who have taken the pains resolutely to train themselves.

Beauty is, of course, not an absolute quality ; there are many kinds of it which appeal to one in different moods. The Chinese have names for a number of the types of beauty to be found in good calligraphy. They distinguish ' perfect beauty ', ' virile beauty ', ' elegant beauty ', ' limpid beauty ', and ' strange beauty ', for example. Some of the established styles of callig-raphy mentioned in the last chapter fall in these categories. Wang Hsi-Chih's hand (Figs. 35 and 59) certainly has ' perfect beauty '; Yen Chen-Ching's (Fig. 39) has ' virile beauty '; the Sung Emperor Hui Tsung's (Fig. 47) has ' elegant beauty '; Mi Fei's (Fig. 46) and Chao Meng-Fu's (Fig. 49) are possessed of ' limpid beauty '; Su Tung-P'o's (Fig. 40) and Chêng Hsieh's (Fig. 44) have ' strange beauty '.

It has already been explained that Chinese characters originate in nature. Now, no completely natural thing is ever quite regular : consequently Chinese characters usually display

small unevennesses, in addition to the deliberate asymmetry of their pattern. Every stroke, after it has fallen from the brush of the writer, has to lie on the paper without correction ; ' touch-

FIG. 83
By the Monk Huai-Su
(*Palace Museum, Peip'ing*)

FIG. 84
By Feng Hung-Chang
(*Collection of Cathay Publishers, Shanghai*)

ing up ' would destroy its life. Hence, when a partially dry brush is used, and ' hollow ' strokes described, as in Figs. 83 and 84, this is deliberate. Such strokes show more clearly than solid ones the movement, direction and speed of the brush

[124]

itself. The colour and thickness of the ink enable us to detect whether any retouching has been attempted.

Individual inspiration is as necessary to the creation of brilliant calligraphy as to any of the more familiar forms of art. It is easy to copy the composition and pattern of a good style, but the movement of the strokes is not so simple to imitate. The story of the calligrapher Wang Hsien-Chih (王獻之), who was the son of Wang Hsi-Chih, himself a famous calligrapher, illustrates this. When Hsien-Chih was a boy he was confident that he could write as well as his father. One day he saw a piece of his father's writing hanging on the wall and sat down to imitate it exactly. Then he secretly substituted his work for his father's. In due course Wang Hsi-Chih came in, and noticing the inferior writing hanging on the wall, muttered to himself : ' I must have been drunk when I wrote that abomin- able stuff ! ' Hsien-Chih heard this and it made him feel so ashamed that he never repeated such a trick again. Another story tells how Sung Yi (宋翼), a pupil of Chung Yu, perhaps the greatest writer of the Wei period, turned all his mind to forming characters which were models of neatness and correct- ness, thinking thus to please his master. But Chung Yu reproved him so severely that Sung dared not show his face before him again for three years. These stories testify to the value the Chinese attach to good brushwork as compared with mere exactitude.

Movement, as I have said, is the very breath of Chinese calligraphy. Two kinds of this movement are distinguished : the first may be called ' activity in stillness ', the second ' activity in action '. The two are not strictly separable, but grow out of each other. The first manifests itself in the direction, shape,

pattern, and grouping of the component strokes of the characters : places where, offhand, one would not expect to find motion, but where, after a discerning analysis, the irregularity, asymmetry and proportion appear to obey some law of organic growth. The second kind of movement lies in the motion of the brush as it travels.

A good English handwriter wields a firm pen-nib and balances his hand in such a way that the nib travels lightly over the paper with the minimum of effort. The flexibility of the Chinese brush-pen, which can twist and curve in every direction, makes it possible for the sense of impetus and potential movement *to emerge in the written character*. The ' push-off ' of a stroke provides the impetus, as with a skater, and the hand follows through and governs the movement exactly as the skater controls his ' figure '. And just as a skater who loses control of his body either falls or is thrown into an awkward posture, so bad handwriting is the result of a failure of the writer to find an equilibrium between himself and his brush. The brush may be badly balanced and so unable to acquire any impetus, causing it to drag heavily and produce lifeless strokes, without rhythm and movement. There is a long and important essay by Wang Hsi-Ch'ih on the subject of *Pi-Shih* (筆 勢), ' the posture for brush-handling ', dealing with this question of balance and impetus.

It is not unprofitable to compare calligraphy with dancing. The calligraphy of a great master is not the piecing together and lining up of certain written symbols to convey meaning, but an adventure in movement very similar to good dancing. A skater, preoccupied with the evolutions of his legs and feet, will sometimes forget to balance his arms and hands, but a

dancer's whole body and all his limbs must be woven into a harmonious rhythmic movement. The pleasure derived from looking at good calligraphy, or felt in practising it, is exactly this delight of watching a beautiful dancer. We are told that the writing of Chang Hsü (張 旭), a calligrapher highly esteemed for his Grass Style characters, was suddenly improved and inspired after he had watched the Lady Kung-Sun (公 孫) perform the 'Dance of the Two-Edged Sword'.

Blasis Carlo says in ' *The Code of Terpsichore* ' (1830) :

When the arms accompany each movement of the body with exactitude, they may be compared to the frame that sets off a picture. But if the frame is so constructed as not to suit the painting, however well executed the latter may be, its whole effect is unquestionably destroyed. So it is with the dancer ; for whatever gracefulness he may display in the performance of his steps, unless his arms be lithesome and in strict harmony with his legs, his dance can have no spirit nor liveliness, and he presents the same insipid appearance as a painting out of its frame or in one not adapted to it ' (page 28).

A dancer has to pay particular attention to the logical and harmonious co-ordination of feet and arms. As a rule the two run in fairly obvious concord ; with a wide movement of the feet the action of the arms is likewise large. In the following characters a similar correspondence is displayed.

A B C D

FIG. 85

[127]

In Figs. 85 A, B, C, D, you will notice particularly how all the strokes are formed in logical co-ordination with each other; the direction and movement of certain of the leading ones influence the remainder. Fig. 86A shows the character *Huang* (黃), 'yellow', written in two styles: in the first the poise of the character is towards the left; in the second it is to the right. Fig. 86B, the character *Huan* (寰), 'vast', has its 'head' tilted to one side and its 'arms' slightly higher on one side than the other. This slight tilting of the left upper corner serves to create a feeling of tension against the lower

FIG. 86

Adopted from the article by Lin Yü-Tang

right-hand corner. As a result the outline of the character has something of the posture of a tap-dancer.

In dancing there are certain recognized positions for hands, feet and head. They are not symmetrical postures, but points of equilibrium, variable with the figure of the dancer, which occur in the course of the movements. In calligraphy there are similar conventional positions for the strokes, but it is rare to find any two strokes in a single character alike. Obviously every position in dancing varies with the slightest displacement of foot or arm; in calligraphy, corresponding minute variations on a set design effect the development of an individual style. A dancer has first to master the mechanical pattern of a step

and then to develop his individual method of presenting it. Calligraphy is in no different case.

During the three years I have spent in England, I have heard a good deal of the Russian Ballet, and have myself seen several of its performances. The kind of pleasure I personally derived from watching it closely resembled, I found, the aesthetic emotion involved in calligraphy. After some experience of writing one begins to feel a movement springing to life under the brush which is, as it were, spontaneous. It is present in even a single stroke or dot. The brush acts rhythmically, stretching to the left, drawing away to the right, turning, pirouetting, poising. The stroke responds to the slightest movement of the wrist and fingers or of the right elbow and arm. The sensation is really very like that aroused by a ballerina balancing upon one toe, revolving, leaping, and poising on the other toe. She has to possess perfect control of her movements and amazing suppleness. The same qualities are demanded of the writer. A dancer's movements follow the rhythm of the accompanying music : a writer's movements depend upon the length and shape of stroke of the style he is practising, which may thus be said to correspond to the music. When I see a dancer executing a ' stilted ' step, I am reminded of the Regular Style of handwriting ; when she changes to a flowing movement I think of the Running Style ; and when she breaks into a light, rapid step, I think of the Grass Style. And conversely, I believe one can derive more pleasure from contemplating a piece of Running or Grass Style calligraphy if one holds in mind the image of a dancer. Particularly is this the case with the Grass hand, in which all the strokes of the characters are joined in a continuous line like the pattern of a dancer's

feet. Mi Fei's Running Style is like the smooth motions of a ballroom dancer; Wang Tso-Ling's Grass Style is like the dancing of the *corps de ballet*.

I conclude that the beauty of Chinese calligraphy is of the same nature as the beauty of painting and dancing. A calligrapher's aim is not merely legibility and the making of a page pleasant to look at—the desiderata, I believe, of good Western manuscripts, but the expression of thought, personality, and design together. For us, it is not a purely decorative art. A satisfying piece of it can be executed only by a scholar of marked personality, and preferably one with poetical, literary and musical tastes. One could practise writing for years and still fail to achieve a good hand if one did not at the same time cultivate one's personality. Accomplished vulgarity in writing is unfortunately only too common.

Many examples of the handwriting of the Ch'ing Emperor Ch'ien Lung were exhibited at the International Exhibition of Chinese Art held in London in 1935–6. Fig. 87 is a specimen of his work in which he is supposedly following the style of Yen Chen-Ching.

FIG. 87
(*Palace Museum, Peip'ing*)

A glance at Yen's own work (Fig. 39) is sufficient to show how far short the Emperor fell of his model. None of his strokes is well made and the pattern is ill formed. The first character on the left—*Yi*, ' art '—has too small a base for its upper

[130]

structure, with the result that the character appears to totter.
In the second character from the right, *Ts'ai*, ' style ', the left
lower corner is too small for the rest and the character only
just maintains its balance. After a study of the Emperor's
Running and Grass writing one is at a loss to find any move-
ment as graceful even as the gestures of a street dancer ! The
writing of the Sung Emperor Hui Tsung (Fig. 47), on the other
hand, is worthy of the highest praise. Social rank, it is certain,

FIG. 88 FIG. 89

does not make an artist. When I first came to London I
rather liked the handwriting of some of the post-office officials
who wrote out receipts for registered packages. Later I dis-
covered that there was no difference between their writing and
that of most other clerks and secretaries. Neatness without
individuality is not hard to attain. I imagine that people un-
acquainted with Chinese characters may easily fall into the same
temporary error about them as I did with English writing.

But to achieve individuality it is not necessary to be eccentric.
Strokes and compositions must follow general rules, otherwise

the results would be fantastic. In Figs. 88 and 89, each character is deliberately distorted in shape and pattern. In Fig. 88 the shape of the stroke itself is grotesque, while in Fig. 89 the composition is over-fanciful. Both testify unmistakably to lack of taste and training in the writer.

Chinese calligraphy—a lively conception of some equilibrium of forces—can only be achieved by concentrated and unremitting scholarly study.

V

TECHNIQUE

TO its very roots, our technique of writing differs from that of the West. It is our custom to write from the right side of the page to the left and with the brush held vertically instead of obliquely like the pen. The tools and materials are also different. We can write, it is true, on

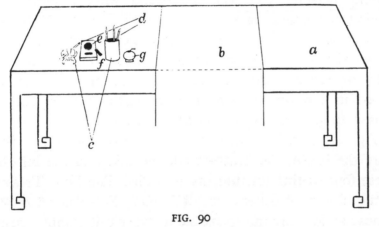

FIG. 90

a, Table. *b*, Paper. *c*, Brush Stand. *d*, Brush. *e*, Ink-stone. *f*, Ink. *g*, Water-pot

any ordinary desk or table, but the table we customarily use, which is called *Ch'ang-T'iao-Cho* (長條桌) (Rectangular Table), is a longer rectangle than most tables seen in the West. It is shown in Fig. 90.

We do not need a drawing-board to be hinged to the edge of the table so that it can be inclined at any desired angle. We simply place the paper on the flat surface. The table sketched in Fig. 90 is higher than the tables we use for other purposes, because, for the sake of greater freedom of movement, we prefer to stand when writing a large piece of calligraphy. When we sit to write we like to have the chair of such a height that the waist is just below the level of the table.

We use the same paper for writing as for painting : coarse in weave and more porous than that with which you are familiar in the West. It is specially suited to our method of handling the brush, with its rapid, lively and balanced alternation of light and heavy strokes. If you examine carefully any well-written character you will understand what I mean.[1] For learning and practising we use a cheaper paper. Unbleached and yellowish in colour, it has nevertheless the same general characteristics as the more expensive kind. For formal calligraphy we use as a rule a well-ripened paper which has been dipped in a warm solution after the initial process and then pressed to give an extra fineness of texture.

Fig. 90 shows how the paper is placed on the table. Beside it are the brush, the brush-stand, the ink, and the ink-stone. These four writing instruments are called The Four Treasures, of the Room of Literature, *Wên-Fang-Szu-Pao* (文房四寶), because all four are indispensable to every calligrapher, painter, and scholar. I will not go into the history of their evolution, but content myself with explaining how they are used.

Chinese ink, the most characteristic medium for calligraphy

[1] For a more detailed discussion of the instruments used in Chinese painting and writing I refer the reader to *The Chinese Eye*, pages 192–212.

and painting, is different from that used in the West. It is black and not made in liquid form. The soot of burnt pine-wood or of oil smoke (lamp-black) is collected and mixed with a kind of gum, warmed and left to solidify. It is then moulded into small flat or round sticks, often decorated with carved designs and characters which make them beautiful objects in themselves. When about to write, the calligrapher grinds this stick upon the ink-stone with a little water.

The Chinese ink-stone is an unfamiliar object in the West. It is a flat stone with a hollow scooped out in the middle in which the ink is ground and mixed. One end is rather more deeply gouged than the other to enable the water to flow into it. Inkstones are generally made of a special rock called 'red-stone', which can be cut and highly polished. The surface cannot be made as smooth as glass or jade, but more so than ordinary limestone. Bricks and roof-tiles have also been used on occasion. The brick-makers of the Han dynasty were particularly successful in compounding bricks of harmonious colour and shape.

When grinding the ink on the ink-stone, we hold the stick perpendicular to the surface of the stone and work it slowly but firmly, using the left hand, so that the right hand is kept

FIG. 91

(a) ink, (b) ink-stone, (c) good models of masterpieces

free for writing. As we grind we meditate, making our minds as calm as possible. An amateur about to make a copy should spend this time studying the model carefully to find out which points are particularly beautiful. A more accomplished calligrapher about to write a piece of his own composition would devote himself to visualizing his characters—their special beauty of stroke or structure. The amount of ink required to complete a piece of writing should be estimated at the outset. To be on the safe side we usually grind a little more than we expect to use. To be obliged to grind more than one lot of ink for the same piece of writing usually results in a noticeable variation of colour and thickness. Moreover, if a considerable pause has to be made, a change in the whole feeling of the writing is likely to become apparent. If the ink is ground too thickly it will not run freely on the paper; if it is too thin it will blot and expand into lines thicker than you intend, for the paper is very absorbent, somewhat like blotting-paper. In general it can be said that the ink is ready for use when the surface of the stone emerges through the liquid. It is best to test it at this point with your brush on the paper. If your ink-stone is not large enough to grind all the ink required at one time, it is necessary to grind two or three lots and pour the extra fluid into a cup, dish or other receptacle in which it will not easily evaporate. It is always wise to make fresh ink for each piece of writing. Left on the stone, especially during our hot Chinese springs and summers, the gum becomes affected and the ink flows harshly and unevenly over the paper. Old ink is also apt to turn an unpleasant brownish colour.

I have described the character of our paper and how we lay it on the table; but I have not told you that we always put

a second sheet of paper beneath the one on which we are going to write, in order to prevent the ink from running through on to the surface of the table. The calligrapher has to be very careful to move this backing sheet whenever he moves the writing sheet, otherwise the wet spots on the underside will make blotches on the calligraphy. Generally we write on scrolls of paper, and when these are longer than the width of the table, we like to get some one to hold the top end and move the paper and lining together as we write. When writing very large characters we lay the whole sheet upon the floor and write there, kneeling down or bending over.

The Chinese brush is made of animal hair, tied together in small bunches and fixed into a hollow reed or very thin bamboo stem. Usually the handle is mounted with a small tip of gold, silver, jade, ivory, or crystal. The brush is stiffer than that used in the West for water-colour painting. The tips of the hairs form a very fine point which is extremely sensitive and pliable in use. The hair of many different animals is employed : sheep, deer, fox, wolf, mouse, or rabbit, according to the taste of the writer or the requirements of a particular style. For small, delicate characters, rabbit's hair is the most popular ; for bold characters, sheep's hair is the best. As we write principally with the tip of the brush, it is important that every hair should be of even length, smooth, and straight. A single curly or irregular hair would destroy the appearance of strength in the stroke. Every calligrapher should possess his own brushes and condition them to his habits until they respond to his slightest movement. Many famous writers, indeed, have made their own tools, just as in the past Westerners have cut their own pens from reeds or cane. But the possible ways of making

reed pens are limited: the nib must be finely cut and may be slanted at any angle to suit the writer's style—that is about all the maker need attend to. We cannot press our brushes on the paper as you are able to rest a good part of the weight of your hand on a nib. The play of the brush under Chinese fingers is extremely delicate, and the instrument has therefore to be more sensitively constructed.

The handling of the brush is of the utmost importance. It is said that once a calligrapher has learned to handle his brush correctly he is in a fair way to become a good writer. There is no definite method to follow. The brush may be likened to a bow and arrow. When an archer has thoroughly sighted his target, poised his body, grasped his bow firmly, and aimed accurately, the arrow will almost certainly hit the mark. So with the calligrapher: with the mind concentrated, the body upright and balanced, the brush vertical, the dot or stroke should fall exactly on the appointed place.

Every great master has his own way of handling his brush, but a beginner must first submit to some discipline. Generally

FIG. 92

the brush should be absolutely vertical, inclining neither to right nor to left. The thumb and three fingers should grasp the handle on four sides, with the little finger in support. (Fig. 92.) The upper phalange of the thumb presses on the left side of the handle, the top of the second finger on the right side; part of the handle lies on the middle phalange of the second finger. The top of the middle finger hooks round the anterior side of the brush, and the finger-nail and some of the flesh of

the fourth finger backs on to the posterior side. The little
finger is held close behind the fourth finger, supporting it
and giving added firmness to the stroke. This is called the
Five Character Method of Brush-holding, or in Chinese,
Yeh (撅), *Ya* (壓), *Kou* (鈎), *T'ieh* (貼), and *Fu* (輔), characters
which represent the five fingers of the hand in action.

The thumb and second finger are the most important
members, receiving the strength of the wrist and arm and
regulating the pressure of the stroke. The middle and fourth
fingers do the work of turning and moving, for the middle
finger can twist the handle downwards or to the right, while
the fourth lifts it upwards or to the left. When the fourth
finger is in process of lifting the brush, the middle one can
adjust it; while the middle finger is hooking the brush the
fourth one can prevent it from slipping too far. The little
finger plays the part of conductor, sometimes drawing the
fourth finger to the right and sometimes pushing it to the left.
In this way each of the five fingers plays its part. The work is
distributed, and the fingers never tire. Another name given
to this method of holding the brush is *Po-Têng* (憺 鐙), Touching
the Stirrup, the explanation being that when only part of a
rider's feet rest, lightly but firmly, in the stirrups, it is easy for
him to move and turn and control his horse, and a brush held
in the fingers, away from the palm, offers similar freedom and
control to a writer. The fingers must all co-operate. This is
an important point. Only a small part of them touches the
brush, but every part must assist if the hold is to be firm. There
is no need to handle the brush in a strange or awkward fashion.
The essential is that the strength of wrist or arm should flow
into the stroke.

The poise of the hand in relation to the brush, as well as the disposition of the fingers, must be noticed. The average length of our brushes is about six *t'sun* (寸) (a *t'sun* equals 1·3 inches). In a book called '*Pi-Chên-T'u*' (筆陣圖), '*Battle Array of the Brushes*', by the Wei Fu-Jên (衛夫人), the instructor of Wang Hsi-Chih, we read the exhortation: 'One *t'sun* for *K'ai-Shu*, two for *Hsing-Shu*, three for *Ts'ao-Shu*'. This means that when writing in the three styles, *K'ai-Shu*, *Hsing-Shu*, and *Ts'ao-Shu*, the brush should be held respectively 1·3, 2·6, and 3·9 inches from the tip. For *K'ai-Shu*, if the handle is held rather high, the stroke produced will tend to be vague and weak. For *Ts'ao-Shu*, a higher position helps the fingers to move freely. Conversely, if the brush is held too near the hair, the point is dulled, and every stroke appears heavy. In practice, every writer has to find his own position on the brush-handle, wherever he feels he can exercise most control.

When Wang Hsien-Chih, the seventh son of the famous calligrapher Wang Hsi-Chih, at the age of seven was practising writing his father crept behind him and tried to snatch away his brush, but without success. Thereupon Wang Hsi-Chih declared: 'This boy will win great fame for himself in calligraphy.' The story stresses the great importance of a firm grasp on the brush for the writing of good characters.

A very tight hold produces rugged, severe, powerful strokes; a rather looser hold results in graceful, tender, and supple ones. But it is better to err on the side of firmness, for a loose hold is apt to end in weakness instead of fluid beauty. On the other hand, it is necessary to beware of holding the handle too rigidly, and so causing the strength of wrist and arm to end with the handle and not reach the hair, the result of which is a flaccid

stroke. It is particularly important that the brush should be held in the fingers and away from the palm, otherwise, as in Fig. 93, where the palm is pressed against the handle, it is impossible to produce the stroke intended, all the strength being concentrated in the palm and never reaching the brush's tip.

There are also some points to remember about the positions of wrist, elbow, and arm. As the brush has to be exactly vertical, the wrist must be held level; that is to say, the small bone on the outer side of the wrist must not incline towards the table or support. This enables the writer to exercise control over the brush with fingers and wrist simultaneously. The effect is very remarkable. The extreme tip of the brush describes the central part of each stroke, and the

FIG. 93

stroke or character produced is 'full of blood and rigid muscles'. I shall explain such special terms as this later. For the present purpose I can think of no English equivalent that is more expressive than the literal translation. The writer Chu Chiu-Chiang is frequently quoted on the subject of brush handling. His saying: *Hsü-Ch'üan* (虛拳), *Shih-Chih* (實指), *P'ing-Wan* (平腕), *Shu-feng* (豎鋒), means roughly: 'Empty the fist, make the fingers firm, level the wrist, keep the brush upright.' These are the four fundamental rules to be observed by the student when practising.

The size of the characters to be written governs to some extent the position of the wrist. The normal position, which is called *P'ing-Wan* (平腕), Level Wrist, and is used for most practical purposes, is illustrated in Fig. 94. Greater freedom

of the brush is obtainable with the *Chên-Wan* (枕腕), Pillowed Wrist, position shown in Fig. 95, in which the right wrist rests

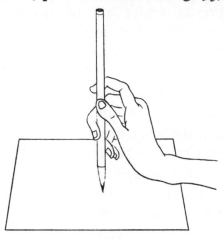

upon the left hand. This method is most convenient for writing small characters. Strokes produced in this way have a steady, firm appearance. For medium-sized characters it is better to let the elbow rest on the table and to raise the forearm at an angle of about 25 or 30 degrees. This position is

FIG. 94
(*P'ing-Wan*)

called *T'i-Wan* (提腕), Raised Wrist (Fig. 96), and allows the brush to operate over a greater ambit. For still larger characters, both wrist and elbow are held above the table (Fig. 97). *Hsüan-Wan* (懸腕), Suspended Wrist, is the name for this method, and without

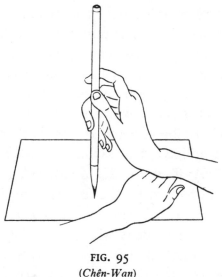

FIG. 95
(*Chên-Wan*)

doubt it is the most important position in the training of a calligrapher. If no part of the arm touches the table, the

[142]

strength of the whole body can pass through the shoulder,
arm, elbow, wrist, and fingers, into the brush-point: and the
strokes of the brush
will be correspond-
ingly vivid. The
training necessary
to attain mastery of
this method must
inevitably be long
and persistent. In-
complete control
results in shaky and
quivering strokes.
For *K'ai-Shu* the
wrist and elbow

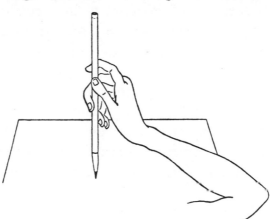

FIG. 96
(*T'i-Wan*)

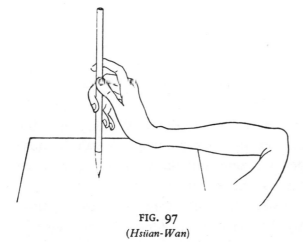

FIG. 97
(*Hsüan-Wan*)

need not be sus-
pended very high,
but for *Hsing-Shu*
and *Ts'ao-Shu* it is
as well to raise them
as high as is com-
fortable. The
largest scrolls of all
we write standing,
a position which
leaves the whole
arm and body with-

out support. This engenders in the stroke a dynamic force
as if an electric current had passed through the writer's frame

[143]

and the brush-handle had been a good conductor; no support 'short-circuits' the passage of the strength into the brush. In speaking of brush-play, the four words *Hsü* (虛), *Hsüan* (懸), *Ch'ih* (直), *Chin* (緊), are often on our lips. They mean respectively, 'Empty', 'Suspended', 'Upright', 'Tight'. They are the passwords to a good hand.

Having mastered the relations between hand and brush, we have to attack that most important problem, *Yung-Pi* (用筆), Brush Treatment (the phrase *Yün-Pi* (運筆), Brush Movement, is sometimes used). It is often maintained that the aesthetics of Chinese calligraphy are the product of *Yung-Pi*.

Breadth or slenderness of stroke depend upon the pressure of the hair of the brush upon the paper. The exercise of this pressure should be at the command of the writer. The length and thickness of the brush-hairs vary with the size of character to be written, but seldom is more than half the length of the hair used, the other half forming a reservoir of ink. Too great pressure on the brush not only renders impossible the execution of the intended stroke but damages the delicate Chinese paper. Western painters sometimes press their brushes with some force upon the canvas without disaster, and the Western writer can bear heavily upon his pen or pencil because the texture of the paper is strong, but the Chinese has to curb his strength and render its impression by ingenuity.

In every kind of stroke there are three principal brush-movements: *Tun* (頓), 'to crouch'; *T'i* (提), 'to raise'; and *Na* (捺), 'to press the hand down heavily'. Let us suppose that we wish to write a character measuring about one-and-half inches square. A medium-sized brush will be re-

quired, and we shall need to fill the whole length of the hairs with ink. Only a part of the hairs will ever touch the paper. For *Tun* seventy per cent of them; for *T'i* fifty per cent; and for *Na* ninety per cent (Fig. 98). In any particular stroke, two of these movements only may be employed, or all three. There is no hard-and-fast rule; my figures are only rough computations, and must vary with the individual manner of the calligrapher. The *T'i* movement makes thin strokes, and the *Na* movement thick; and their right alternation governs the

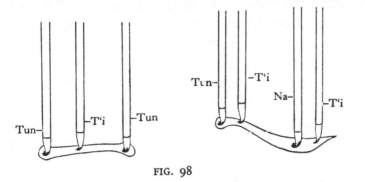

FIG. 98

composition of a character. The *Na* movement is often applied to the 'empty' part of a character where the strokes are few; *T'i* to the parts where many strokes are accumulated. In making the *T'i* movement the brush is gradually lifted, starting with about half of it on the paper and ending with the point only. *Tun* is always used for starting and ending a stroke, when turning, and at the junction of two strokes. There is a saying that a stroke should be started with a force great enough to move a mountain and end with some of it still left! Every stroke has its definite starting and ending, easily visible in *K'ai-Shu* and *Hsing-Shu*, but somewhat obscure in *Ts'ao-Shu*.

The speed of the strokes is another important factor of brushwork. Every stroke is composed of alternating quick and slow movements. Which these are can only be described in relation to a particular character.

The terms Reserved and Exposed, which describe the two ways in which the brush-tip can touch the paper, require some explanation. When the brush is filled with ink all the hairs are bound together into a fine point. A stroke is said to be Exposed when the brush—poised, as usual, vertically—is drawn along the paper *without* the tip of it being turned in, the resultant stroke having sharp outlines like a bird's beak and lacking, to our eyes, vitality. In a Reserved stroke the hair-tips *are* turned in slightly and the track of the brush's point forms a visible line down the centre of the stroke. Any good example by an old master will display Reserved brushwork. If you hold the paper up to the light you will notice—for Chinese paper is rather thin—a darker streak running down the middle of the stroke, the ink around it being lighter.

The expression *Ju-Mu-San-Fen* (入木三分) which means 'piercing into the wood three-tenths of an inch', is used to describe the impression created by a stroke of which the ink, under the force of the writer's stroke, appears to penetrate through the paper into the wood of the table beneath. This is done with an 'upright brush'. A graceful and supple stroke can be achieved by slanting the brush. Depending upon these two positions of brush are two distinct styles of writing : *Yüan-Pi* (圓筆), Round Stroke, and *Fang-Pi* (方筆), Square Stroke (literally). The first type is produced by the *T'i* movement, the second by the *Tun*. Round Stroke writing is graceful and supple, Square Stroke solid and reposed. Square Stroke is

suited to *K'ai-Shu*; Round Stroke to *Hsing-Shu* and *Ts'ao-Shu*. These, however, are not rules but merely guides: in *K'ai-Shu* the Round Stroke is sometimes employed to add a grace and ease of manner; in *Hsing-Shu* and *Ts'ao-Shu* added dignity is gained by the use of Square Strokes. The expert writer works out for himself the most suitable combinations and variations for his special style.

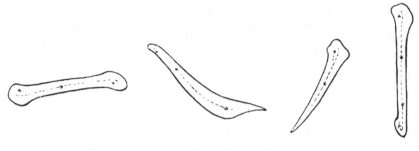

FIG. 99

Horizontal line	*Na* or Sweeping-rightward Stroke	*P'ieh* or Inclining-leftward Stroke	Vertical Stroke
(A)	(B)	(C)	(D)

Single strokes are made in accordance with a method called *San-Che-Fa* (三折法), Method of Three Folds, which is illustrated in Fig. 99, A and B. For a Horizontal, or Sweeping Stroke to the right, the brush first moves slightly to the left, then turns to the right for the main length of the stroke, and finally leftwards slightly again. For an Inclining-leftwards Stroke (Fig. 99, C), the brush first twists to the right, then sweeps down to the left, and for the third movement, pauses. For a Vertical Stroke (Fig. 99, D), the brush travels upwards first, then moves down, and ends by twisting back slightly.

One more matter must be mentioned. Every hair of the brush must be straight. If after a stroke or two one or more hairs become twisted, the point of the brush must be straightened by twisting it gently on the ink-stone, round in a circular movement for an instant, and it is then refilled with ink.

The technique of Chinese calligraphy is so fine and difficult, and so different from European methods, that the Westerner may feel discouraged from attempting to master it. But the venture is worth the trouble. In China calligraphy is looked upon as a healthy exercise, like skating or golf or tennis ! For it involves not only the movement of the fingers, wrist, and arm, but, in the case of really large pieces of writing, the whole body. Consequently we habitually practise it in the early morning, when the body is fresh. And it must have some effect, for it is remarkable how many of our good calligraphers have lived to a great age.

Our scholars practise calligraphy as a hobby. If you enter the study of one of them you will find no guns or rackets, but you will certainly see the Four Treasures, and you will find that the owner of the room practises writing for recreation. An article by Lin Yü-Tang (林語堂) in the 'Tien Hsai (天下) Monthly' for December 1935 contains the following note :

Wang Hsi-Chih and other masters of calligraphy have compared the action of writing to that of a General in the field of battle. They compare the paper to the battle-field, the brush to the fighting weapon, ink to the armour and ink-stone to the waterways. The talent or ability of the writer is the General, the artist's mind is the Chief-of-Staff, the structural form is the military plan or tactics, the incidental or momentary inspiration which come instinctively

to the writer at the moment and may make or spoil the products are fate, the main strokes which intercross or penetrate each other are the army commands, the bendings and turnings are close combats, the date and strokes are detachments, and the longer drawn-out strokes are the colours of the army.

VI

THE STROKES

I HAVE explained that the beauty of Chinese calligraphy does not lie in symmetry but in dynamic asymmetry. We do not attach much importance to printed characters, which, though they are neat and readable, are visually lifeless. Drawn figures too can be mechanical. With the help of an instrument such as a compass, or even with a hard-pointed pencil or pen used freehand, perfect straight lines and curves can be smoothly drawn; but they will necessarily be of even width and shape and will appear ' dead ' to the eye. It is not possible to vary very much the thickness of stroke when using a Western pen; the nib would scratch or tear the paper if pressed to its fullest width. The Chinese brush, on the other hand, can be made to produce strokes of widely varying thickness and depth of colour by adjustments of the amount and strength of ink with which it is filled and of the proportion of the hairs pressed on to the paper. This great flexibility makes it possible to invest the individual strokes of a Chinese character with life and movement.

We liken the irregularity of good strokes to the undulations of mountain ranges and winding streams and the knotted strength of twisted tree-branches, but we never write a stroke actually to resemble a natural object. It is the *kind of life*

inherent in mountains, streams and trees which we wish to reproduce. We strive to make our writing appear as if it had itself grown naturally.

To achieve this is a great joy, but it involves the patient assimilation of a very subtle and even esoteric technique only to be learned through actual practice.

In earlier chapters I have several times referred to the 'type of stroke' of an individual calligrapher as if there were only one stroke and various personal ways of making it. But actually Chinese characters are composed of a multitude of different strokes, each of which is executed with a different movement of the writer's hand and arm. The same stroke, too, varies according to the style employed. In general, and always for practice, we take as our standard the strokes of *K'ai-Shu* or Regular Style. We believe that a calligrapher will find it comparatively simple to make the strokes of the 'freer' styles, such as *Hsing-Shu* or *Ts'ao-Shu*, if he has first mastered those of *K'ai-Shu*, especially if he has taken as his model the work of Ou-Yang Hsün, Yen Chen-Ching, or Liu 'Kung-Ch'üan.

The Emperor Chang of the Later Han dynasty differentiated fourteen types of stroke; the Lady Wei distinguished seventy-two. The classification of the great calligrapher Wang Hsi-Chih in his book, '*The Eight Components of the Character "Yung"*',[1] has been more widely studied than any other system and is still the most generally used as the basis for practice. The eight strokes of *Yung* are: *Tse* (側), *Lê* (勒), *Nu* (努), *Yo* (趯), *Ts'ê* (策), *Liao* (掠), *Cho* (啄), and *Chieh* (磔), as in Fig. 100. Wang Hsi-Chih affirmed that one would have a good hand if, after practising these eight strokes, one could

[1] *Yung* means 'eternity'.

compose the character *Yung* well. His theory is profound and difficult. It has been well interpreted in a book entitled ' *Yüng-Tzŭ-Pa-Fa*' (永 字 八 法) by Li Fu-Kuang (李 溥 光) of Ch'ing dynasty. Mr. Li extended the eight strokes to thirty-two, most of which are dealt with in the present chapter. But *Yung* does not include all the strokes necessary for the formation of certain other important characters ; and the descriptions given

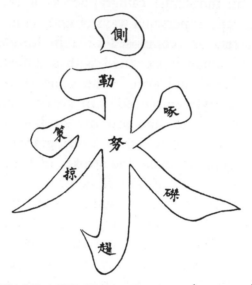

FIG. 100.—THE CHARACTER *YUNG*, ' ETERNITY '

below therefore include more strokes than Wang Hsi-Chih's eight, though fewer than Lady Wei's seventy-two.

To those who do not know the Chinese language it should be a help, I think, to see these strokes written down and described one by one. I have provided white lines down the middle of the strokes to indicate the path of the brush-tip. It must be remembered throughout that every stroke is executed

[152]

in a very short space of time and that no correction is possible. Some of the examples are in *Hsing-Shu*, most are in *K'ai-Shu*.

'*Leftward*' *Dot, Hsiang-Tso-Tien* (向左點). Like a tiger's claw descending. Written first to the left, then to the right, then to the left again.

'*Rightward*' *Dot, Hsiang-Yu-Tien* (向右點). Like a tortoise's head. Written first to the right, then to the left, then to the right again.

'*Vertical*' *Dot, Chih-Tien* (直點). Like an eagle's beak. Written first upwards, then downwards.

'*Elongated*' *Dot, Ch'ang-Tien* (長點). Written first to the left, then downwards to the right, then again to the left to form a hook.

'*Curved*' *Dot, Ch'ü-Pao-Tien* (曲抱點). Written first to the left, then round to the right, then downwards slightly to the left.

'*Two-faced*' *Dot, Liang-Hsiang-Tien* (兩向點). Written first to the left, then downwards to the right, then again to the right with a quick upward movement.

'*Left-and-right*' *Dot, Tso-Yu-Tien* (左右點). Nearly the same as the 'vertical' dot, except that it is written in a slightly horizontal direction.

'*Hooked*' *Dot, Kou-Tien* (勾點). Written like the 'elongated' dot, but with a downward direction instead of an inclination to the right, and forming a large hook at the end.

'*Level*' *Dot, P'ing-Tien* (平點). Written first to the left, then to the right. It is the shape of a bean.

[153]

'*Upward*' *Dot, Hsiang-Shang-Tien* (向上點). Like the 'vertical' dot reversed. Written first upwards, then downwards, then slightly to the left.

'*Tiny*' *Dot, Wei-Tien* (微點). Like an apricot-kernel. Written first upwards to the left, then downwards to the right.

'*Beak*' *Dot, Cho-Tien* (啄點). It differs from the vertical dot only in its position. Written first to the right, then to the left.

These two dots, joined together in the form of the Arabic numeral three, may be considered as two 'level' dots, with a light line joining them.

These three dots we call the *Water Radical*, because the meaning of any character which contains them has something to do with water. The dots are written as the arrows indicate. Notice that each influences and is influenced by the others ; they seem affiliated.

These two dots are a combination of the 'beak' dot and 'tiger-claw' dot, set closer together at the top than at the bottom.

These two dots are a combination of the 'two-faced' dot and the 'beak' dot, set rather wider apart at the top than at the bottom.

These three dots are a combination of two 'two-faced' dots and one 'tiger-claw' dot. They stand at a distance, facing one another.

These three dots are a combination of two 'two-faced' dots and one 'beak' dot. They stand rather close as if the middle dot were either being received by the outer two or thrown from the left dot to the right.

These four dots, a combination of one 'upward' dot, two 'two-faced' dots and one 'tiger-claw' dot, are called the *Fire Radical*. The meaning of any character which includes this sign has something to do with fire.

These four dots are called *Four-dots-back-to-back, Pei-Szu-Tien* (背四點) because they are not written in the same direction though they are closely related, as you can see.

These four dots we call *Four-dots-packed-together, Ho-Szu-Tien* (合四點). They are a combination of two 'two-faced' dots and two 'beak' dots.

The dot in Chinese calligraphy has very numerous varieties of shape. The examples I have given are only the most common ; there are others like willow-leaves, Chinese orchid-petals, chestnuts, &c. Dots are always written instantaneously with a very slight movement of the brush-hair.

This '*Horizontal*' *Stroke, Heng-Hua* (橫畫), is written first to the left, then to the right, then slightly to the left again. The general direction is horizontal, but the stroke rises slightly at the right end to give a touch of liveliness.

This ' *Perpendicular* ' Stroke, *Shu-Hua* (竪畫), is like a sheep's leg. It is written first upwards, then downwards, with a final turn to the left to make a hook if necessary.

This ' vertical ' stroke is called ' *Dropping-Dew* ', *Ch'ui-Lu* (垂露), because the lower part is in the form of a dew-drop and has in relation to the upper part the appearance of dropping down. It is written first upwards, then downwards, then turned slightly to the left and drawn back instantly.

This stroke is called ' *Suspended Needle* ', *Hsüan-Chen* (懸針), from its shape. It is written first upwards, then downwards.

This stroke has a *Curved-head*, *Ch'ü-T'ou* (曲頭) executed with a slight twist of the brush-hair at the start. The brush is then drawn downwards and at the end slightly turned to the left and brought back instantly.

This *Sweeping-left Stroke*, ' *P'ieh* ' (撇), is very important. It has many varieties of shape, of which this, the first, called the *Slightly Curved P'ieh*, *Ch'ü-Pao-P'ieh* (曲抱撇), is written first a little to the right, then with a sweeping movement to the left, and ends with a slight backward turn to the right.

[156]

The 'Short-straight P'ieh', Tuan-Chih-P'ieh (短直撇), is in shape like a 'beak' dot but longer. It is written in the same way: first to the right, then to the left, then slightly turned back again to the right. It should be written with a rapid hand that can control the length of the brush-hair and execute the leftward sweep at a desired length.

The 'Long-straight P'ieh', Ch'ang-Chih-P'ieh (長直撇), is written in the same way as the 'short-straight P'ieh'. But the wrist should be held suspended, or the force will be unevenly transferred to the brush and the stroke present a feeble appearance.

The 'Curling P'ieh', Chüan-P'ieh (卷撇), is shaped like a new moon, slightly elongated. It is written by laying the point of the brush as shown in the figure and then sweeping it to the left.

The 'Vertical P'ieh', Shu-P'ieh (豎撇), looks rather like a vertical stroke, except that it is slightly inclined to the left. The first part is written in the same way as the vertical stroke; then the brush-tip is raised to its point and drawn down steadily to the left.

As this stroke begins with a twist it is called a 'Curved-headed P'ieh', Ch'ü-T'ou-P'ieh (曲頭撇). It is written like the 'curved-headed vertical' stroke at the start, then sweeps to the left as if for the 'slightly-curved P'ieh'.

[157]

The ' *Long-vertical P'ieh* ', *Chang-Shu-P'ieh* (長豎撇), written in the same way as the ' vertical *P'ieh* ', but the central part of the stroke, before it swerves to the left, is longer.

The *Hui-Feng-P'ieh* (迴鋒撇), or ' *Returning-point P'ieh* ', is written in the same way as any other *P'ieh*, but is shorter and turns upwards and back at the end without leaving a sharp point. When two *P'iehs* occur in the same character one is written in this way in order to avoid repetition.

The ' *Level P'ieh* ', *P'ing-P'ieh* (平撇), is written in the normal way : first to the right, then to the left, then slightly turned back.

The ' *Orchid-leaf P'ieh* ', *Lan-Yeh-P'ieh* (蘭葉撇), so called from its shape, is written by laying the point of the brush-hair as in the figure and then sweeping it steadily to the left.

A sweeping rightward stroke is called *Na* (捺) in Chinese. This particular one, the ' *Vertical Na* ', *Shu-Na* (豎捺), sweeps rightwards with a rather steep slant. For the lower part of the stroke the *Tun* movement is used, steadily stretching towards the right. It is also · called ' *Duck's-beak Na* ', *Ya-Cho-Na* (鴨啄捺).

The ' *Level Na* ', *P'ing-Na* (平捺), is in shape and movement like a wave rising and falling. It is written first to the left, then to the right, and at the end turns back a little. It is also likened to a swimming fish.

[158]

The ' *Inclined Na* ', *Ts'ê-Na* (側捺), is less flat than the ' level *Na* ' and not so sloping as the ' vertical *Na* '. It is written in the same way as the others, only more inclined to the right.

The ' *Reversed Na* ', *Fan-Na* (反捺), differs from the ordinary *Na* in having no sharp tip. It is written in the same way as the ' tiger-claw ' dot but is a little longer. In characters which contain two *Na*, the first is always written in this way in order to avoid repetition.

The ' *Curved-head Na* ', *Ch'ü - T'ou - Na* (曲頭捺), is written in the same way as the ' vertical *Na* ', except that the head is bent down a little to the left.

The ' *Golden-knife Na* ', *Chin - Tao - Na* (金刀捺), is very similar to the ' vertical *Na* ', but without the duck's beak.

This stroke is called *T'iao* (挑) in Chinese. It is the only kind of stroke written from the lower part upwards. This first *T'iao* is called ' *Level T'iao* ', *P'ing-T'iao* (平挑), and is written first to the left, then steadily upwards to the right.

The ' *Long T'iao* ', *Chang-T'iao* (長挑), is written in the same way as the ' level *T'iao* ', but is longer and has not the angle at the left side.

The 'Long Hook', Chang-Kou (長 鉤), generally forms a triangle at the base. It is written first as if for a vertical stroke; then, near the bottom, the brush is shifted slightly to the right to make the first angle; next it moves downwards, then again upwards a little, finally it stretches out to the left.

The 'Flat Hook', P'ing-Kou (平 鉤). The first part is written like a horizontal stroke, from the left, but as the brush reaches the right extremity it is lowered down and then stretches out to the left to form the hook.

The 'Horizontal Hook', Heng-Kou (橫 鉤), is written from the left, the brush moving first to the left, then inclining to the right until the line is level as in the figure; then, after a short pause at the right extremity, the hook finishes by curving upwards to the left.

This is a 'Kê Hook', Kê-Kou (戈 鉤). A Kê is an ancient Chinese fighting weapon something like a javelin and shaped like the form in this figure. It is written first slightly upwards, then with a downward inclination to the right, and ends in an upward hook.

This is the 'Nu Hook', Nu-Kou (努 鉤). Nu is a kind of bow. The stroke is written first horizontally, then turns downwards to form a vertical stroke, and ends with a leftward hook.

The 'Phœnix-Wing Hook', Feng-Ch'ih-Kou (鳳翅鈎), is written by drawing the point of the brush from left to right, raising it slightly at the turning-point, then sweeping downwards and to the right, and finally turning upwards to form a hook.

The 'Twisted Hook', Niu-Kou (扭鈎), is so called because in writing it the brush-point is twisted from the right to the left and then to the right again; near the end the brush turns to the left once more and ends in a left upward hook.

The 'Dragon-Tail Hook', Lung-Wei-Kou (龍尾鈎), is so called because in the Chinese character for dragon the last stroke is of this shape. When written quickly in Hsing-Shu or K'ai-Shu, it is really very like the tail of a dragon. The first part of the stroke is vertical; at the base of it the brush turns to the right horizontally, and ends in an upward hook.

The 'Floating-Swan Hook', Yu-Wo-Kou (游鵝鈎), is written in nearly the same way as the last, but the stroke is undulating and the hook restrained. Indeed, the hook is hardly visible, but one has the impression that it is there.

The 'Supporting Hook, T'o-Kou (托鈎). Characters which have many strokes in the upper part are generally 'supported' by this stroke as a handle or axis. It is written by moving the brush smoothly downwards and then turning it to the left to form a rather long hook.

The ' *Round Hook* ', *Yüan-Kou* (圓鈎), is written by drawing the point of the brush rightward in a crescent, then leftward to form a hook.

The ' *Enclosing or Wrapping Hook* ', *Pao-Kou* (包鈎), is so called because in some characters many strokes are wrapped up in it. It is like a lion's mouth and is written first with a horizontal stroke; then, after a slight upward movement, the brush travels downwards as for a ' long-hook ' but inclining to the left.

The ' *Rightward Hook* ', *Hsiang-Yu-Kou* (向右鈎), is so called because the hook faces right. It is written first with a short vertical stroke slightly inclined to the right, then a movement to the left, and finally upwards to the right.

The ' *Playing-butterfly* ' *Stroke*, *Hsi-Tieh* (戲蝶), is actually a combination of a ' beak ' dot and an ' apricot-kernel ' dot. The ' beak ' is written first, then, without a break, the brush turns to the right to form the ' apricot-kernel ' dot.

The ' *Curled-up Dragon* ' *Stroke*, *P'an-Lung* (蟠龍), is a combination of two short *piehs*, two short horizontal strokes and one small dot. They are written as indicated by the arrows.

The ' *Chanting-insect* ' *Stroke*, *Yin-Ch'iung* (吟蛩), is a combination of a ' level *Tiao* ', a ' short *pieh* ' and a ' round hook '. They are written as indicated by the arrows.

[162]

Although these examples by no means comprise all the strokes of Chinese calligraphy, they are sufficient, if properly mastered, to enable the pupil to write almost any character. The fact that we are accustomed to praise a single well-executed stroke, quite apart from the meaning of the character or even the execution of the other strokes in it, testifies to the high value we place upon good brushwork.

Every character is formed, of course, by combining several strokes, and the methods by which this is accomplished are the next thing to be learnt. Here are two examples (more are

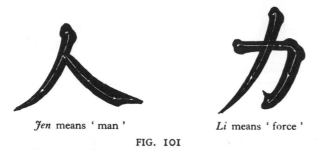

Jen means 'man' *Li* means 'force'

FIG. 101

unnecessary). The character *Jen* (人) is a combination of the 'slightly-curved *P'ieh*' and the 'duck-beak *Na*'. The character *Li* (力) is a combination of the 'wrapping-up hook' and the 'long-straight *P'ieh*'. Knowledge of the direction of particular strokes helps the writer to grasp the *order* of the strokes in a character. The dotted lines in the figures indicate this.

We have four terms to describe the quality of strokes : Bone, Flesh, Muscle, and Blood. For we look at strokes and characters from an animistic point of view. Thus Lady Wei said :

In the writing of those who are skilful in giving strength to their strokes, the characters are 'bony'; in the writing of those who are not thus skilful,

[163]

the characters are 'fleshy'. Writing that has a great deal of bone and very little meat is called 'sinewy'; and writing that is full of flesh and has weak bones is called 'piggy'. Powerful and sinewy writing is divine; writing that has neither power nor sinews is like an invalid.[1]

Thus every type of stroke should have a bone within it, formed by the strength of the writer. We criticize calligraphy according to whether it has strength—'bone'—or not. That is why the handling of the brush is of such importance and

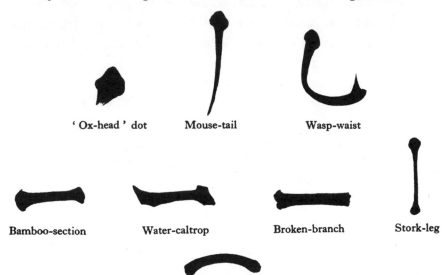

'Ox-head' dot Mouse-tail Wasp-waist

Bamboo-section Water-caltrop Broken-branch Stork-leg

A pole for carrying fuel
FIG. 102.—THE 'EIGHT DEFECTS'

the suspended wrist position the best. The flesh of the stroke depends upon the thickness of the brush-hair and the pressure or lightness of the writer's touch. It also depends upon the amount of water in the ink. The flesh will be loose if there is much water, and arid if there is too little; it will be fat if

[1] Translated by Lin Yü-Tang in *My Country and My People.*

the ink is very thick, lean if the ink is very thin. The nature of 'muscle' in a stroke can be left to the imagination; when the stroke is bony and has the right amount of flesh, muscle is sure to be there. In well-written characters there seem to be muscles joining one stroke to another, and even one character to another. The 'blood' of a stroke depends entirely upon the amount of water with which the ink is mixed—the colour. Thus it can be seen that the principle of 'life' is borne out even in the technical detail of Chinese calligraphy.

All these are illustrated in the examples (Fig. 102) which we call the 'Eight Defects,' *Pa-Ping* (八 病).

Here no flesh, no bone, no muscle, and no blood are, respectively, shown clearly. Beginners inevitably make some of their strokes like these, but the defects diminish gradually with continual practice, and ultimately the brush can be controlled with ease.

VII

COMPOSITION

THE composition of Chinese characters—proportioning of the parts, spacing within the imaginary square, poise, posture, adaptation in the interests of pattern or meaning—is not governed by inviolable laws. It issues from the calligrapher's personal aesthetic. Just as two painters will paint the same scene and produce utterly different pictures, so two calligraphers writing the same characters will produce completely different pieces of writing. There are, of course, for each of the recognized styles—*Li-Shu, K'ai-Shu, Ts'ao-Shu,* &c.—general principles of composition, and these cannot be ignored with impunity, for they are less laws than warnings against the pitfalls which await the careless or over-confident; but even within a single style a writer can—indeed, must—exercise choice.

The changes in the general style of calligraphy which took place from dynasty to dynasty were in large part changes of composition. Necessarily; for, as was remarked by the great calligrapher Chao Meng-Fu of Yüan dynasty, brushwork never changes. Modern Chinese characters are stylized ideograms (pictures of *ideas*) which have developed out of an original small number of pictograms (straightforward pictures of things). No fundamental changes of structure have taken place since

Han times, but changes in the methods of composition have been effected continuously all through the succeeding dynasties, and are still being effected. In the Chin dynasty calligraphers, following the lead of 'the two Wangs', held grace as their ideal, and the less skilful exponents tended to become facile. In T'ang times Ou-Yang Hsün, who preferred order, convention, kept writers firmly disciplined. The Sung calligraphers, led by Mi Fei, wrote with an air of thoughtfulness, strove to put their personal convictions into their characters. And so on. Every piece of writing displays not only the writer's personality but the stamp of his epoch.

The first element of composition to be considered is the 'skeleton'—that which in painting would be called the rough sketch : the plotting out of the parts in relation to one another and to the spaces left blank. The Chinese name for this is *Chien-Chia* (間架), and it is subdivided into *Fen-Chien* (分間) and *Pu-Pai* (布白).

Fen-Chien means 'relative division'. The Chinese character is always written in an imaginary square which, for the purpose of analysis, it is convenient to divide into two

or four parts. As a great many characters are composed of two or four elements, these arrangements are useful to the student. But to the calligrapher, anxious to avoid the rigid symmetry of the printed character, and striving to achieve balanced asymmetry, the nine-fold square , invented by some ingenious but anonymous writer of the T'ang dynasty, is more serviceable, and it has been very generally employed for the purpose ever since. It enables the writer to learn to make

the right and left sides of a character, and the top and bottom, asymmetrical. For example, the character *Ti*, which means ' earth ', when written in a twofold square, has a disintegrated appearance—it looks almost like two separate characters ; but when written in a ninefold square, the greater size and weight

FIG. 103.—TI, EARTH

of the right-hand side causes the two elements to lean together and form a whole. The twofold square tends always to produce the effect of falling apart. The character *Tan*, ' sunrise ', which is composed of the radical ' sun ' over a line which represents the horizon, is another instance. When written in a twofold square, the sun symbol appears to have no relation to

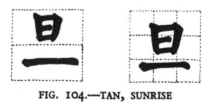

FIG. 104.—TAN, SUNRISE

the horizontal stroke ; whereas when written in a ninefold square, the character is integrated and harmonious. But let us take a more complex example : the character *Chin*, meaning ' to prohibit '. Here we have a combination of two ' wood ' symbols over the radical for ' to show ' (in ancient times public notices, which would mostly be prohibitions, were hung

[168]

on trees). Written in a fourfold square, the two upper symbols have equal value with the lower one, and though there is nothing wrong with the individual strokes, the character is top-heavy. Written in a ninefold square, the lower part becomes proportionately larger and the character is balanced.

FIG. 105.—CHIN, PROHIBIT

The second division of *Chien-Chia* is *Pu-Pai*, the 'arrangement of spaces'. It is not, as might be supposed, merely the negative aspect of *Fen-Chien*, but itself an important consideration, being intimately connected with the Chinese philosophy of art. The part played by the blank spaces in Chinese paintings is noticed by every one. These spaces are not, in the truest sense, 'blank' at all, but constitute unstated expressions of sky, land or water. In calligraphy the 'empty' portions of the imaginary character-squares are full of invisible muscles joining stroke with stroke. We expect these empty spaces to exhibit some inherent harmony with the strokes.

Space gives breadth and 'light' to a character. The strokes can be well formed and lively and yet the characters appear black and dead because cramped or disproportionately spaced. For inspiration we take, as always, Nature : the night sky. There can be no more wonderful example of beautiful spacing than the stars and planets in the firmament, filling the vast dome completely, yet irregularly and without any sense of crowding. In England the night sky is often clouded, and

[169]

there are comparatively few opportunities of studying it, but in China the moon is constantly visible, and scholars and painters and calligraphers derive continual inspiration from the contemplation of the exquisitely disposed intervals between the stars. The Chinese have always placed their faith in Nature as educator and inspirer; we think that there can be no more perfect models than hers.

So much for *Chien-Chia* as applied to individual characters : a few words must be added on its application to whole pieces of writing. The problem is really a new one, because characters which, taken separately, might appear indifferently composed and of odd sizes will, taken together, be seen to have been deliberately written thus in order to set off one another. The reader will see this clearly if he turns back to some of the examples of *Hsing-Shu* and *Ts'ao-Shu*, in which styles the characters vary considerably in size and placing. *Chüan-Shu*, *Li-Shu* and *K'ai-Shu*, which have characters of more even size and position, show it less markedly, but it is still present, and it can be detected in even the most ancient script. To describe this happy sequence of large and small characters we use the simile of the Chinese family. We say that it is like proud grandparents reviewing long lines of offspring. This simile, like many others in this book, will seem far-fetched to those wholly unfamiliar with Chinese ways of life. We live in very large families, several generations residing in different parts of the same house; sometimes as many as thirty or forty persons are sheltered by one roof. And precedence and respect are always given to elders, for we reverence age and like to ponder the long human tradition which our family system maintains. Hence there is about characters

arranged in a sequence that can be fitly likened to a fine family, an intimate relationship, a 'family likeness', and an ordered dignity.[1]

To arrive at general rules of composition is very difficult. The number of Chinese characters runs into many thousands, and although the space occupied by each is, in *K'ai-Shu* at least, roughly equal, no two are composed alike; the number of strokes varies from one to more than twenty; the general form may be dense or loose, broad or slender, heavy or light; even the component strokes have different kinds of movement —bending, stretching, covering, and so on (see Chapter VIII). Wang Hsi-Chih's '*Eight Components of the Character "Yung"*' offers reliable guidance in composition, but the instruction is too highly concentrated for any but calligraphers of some experience. Later critics, as explained on page 152, extended Wang's eight types of stroke into thirty-two 'Postures'. In the T'ang dynasty the famous calligrapher Ou-Yang Hsün devised independently a set of thirty-six rules. The Ming writer Li Ch'un (李 淳) expounded as many as eighty-four. I shall not attempt to explain all these 'laws', but in order to give the reader some idea of how to analyse and appreciate composition, I shall select arbitrarily those which in my view are most important.

The first requisite in the composition of a character is that it should stand stably on its foot (or feet) without an appearance of lameness or stumbling. Those characters which have a vertical stroke down the middle are obviously the easiest to

[1] Those desirous of pursuing the subject of composition in detail will find in the books listed in the Bibliography at the end of this volume all the main 'rules' and principles.

balance, because the centre of gravity falls at the foot of the axial stroke. Fig. 106 contains some examples:

Chung | Pi | Hsiao | Pên | P'ing
(middle) | (to finish) | (small) | (root) | (level)

FIG. 106

With characters comprising two elements the problem at once becomes more difficult; with three or four elements it may be very complex indeed. And even with simple characters like those in Fig. 106, the obligation to balance them upon the centre of gravity is, as will be seen when some of them recur as examples in the paragraphs following, not the only principle it is necessary to consider.

I have chosen fourteen rules:

(1) *P'ai-Tieh* (排疊), Arranging and Piling Up. We apply this principle to characters of particular complexity or those which have duplication and re-duplication of elements. We have to 'arrange', or space, the strokes of these characters regularly, taking care neither to overcrowd nor to leave too loose; or else we 'pile-up' the elements evenly, avoiding a crushed appearance. We try to place the strokes so that, in spite of their number, the character is still lively. Such similes as that of a mass of spring flowers or a pile of summer leaves are commonly used to convey the desired absence of either artifice or confusion. In Fig. 107 the first character, *Shou*, 'longevity', is composed of a succession of regularly-spaced horizontal strokes, one below the other; the result is neither

[172]

overcrowded nor empty. The second, *Hung*, is composed of three ‘cart’ symbols, and has the appropriate meaning, ‘the rumbling noise made by wheeled vehicles’. Notice that the character is composed by ‘piling’ one cart upon the other two in such a way that its central vertical stroke creeps down between the two lower ‘carts’, and thus avoids an ineloquent blank in the centre of the character which would cause the whole to disintegrate. Similar principles may be observed in the other examples, *Shêng* and *Ling*, both of which contain duplications. An agreeable appearance is achieved by carefully regulated spacing of the strokes and an even formation of similar forms.

| *Shou* (longevity) | *Hung* (rumbling of carriages) | *Shêng* (sound) | *Ling* (spirit) |

FIG. 107

In general, it is easier to achieve a beautiful effect with characters composed of large numbers of strokes than with simpler characters, because the writer has an abundance of material with which to fill the imaginary squares. Most painters would acknowledge that to compose a picture with a wealth of detail is actually easier than to compose one in which the effect is gained with only a few bold lines.

(2) *Pi-Chiu* (避就), Avoiding and Approaching. Some characters are of uneven density, others have too many similar strokes. With the first the calligrapher’s problem is to ‘avoid’ over-density in one part and ‘approach’ the looser part; with the second, it is to ‘avoid’ monotonous repetition and

'approach' asymmetry. The examples in Figs. 108 to 112 will clarify the implications of the terms.

P'o
(exceed-
ingly)

P'i
(skin)

Yeh
(page)

FIG. 108

The character *P'o* is a combination of *P'i* and *Yeh*. *P'i* alone is generally finished with a long sweeping stroke to the right, but when combined with *Yeh* this becomes a ' long ' dot in order to avoid cramping *Yeh* or displacing it.

The character *Su* is a combination of *Kêng* and *Shêng*. A very ugly effect would be created by making the two parts of equal size and placing them side by side : so the lower, sweeping stroke of *Kêng* is lengthened to enfold *Shêng*, which is proportionately reduced in size. This practice we call ' making the parts approach each other '.

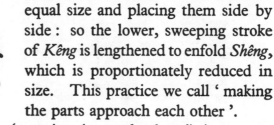

Su
(revive)

Kêng
(again)

Shêng
(born)

FIG. 109

The character *Chiu* (meaning ' a turtle dove ') is a combination of *Chiu* (meaning ' nine ') and *Niao* (meaning ' bird '). To avoid an awkward gap between the parts, *Chiu* (' nine ') is reduced in size, and shorn of its ' dragon-tail hook '.

Chiu
(turtle dove)

Chiu
(nine)

Niao
(bird)

FIG. 110

The character *Hsü* is a combination of *Chiu* (' nine ') and *Jih* (' sun '). This time the ' dragon - tail ' hook of *Chiu* is lengthened to enclose the smaller *Jih*.

Hsü
(dawn)

Chiu
(nine)

Jih
(sun)

FIG. 111

The characters *Feng* and *Tsou*

both contain two very similar sweeping strokes to the right. The procedure is to change the upper sweeping stroke of *Fêng* and the lower one of *Tsou* into dots. This obviates the effect of the characters being, as it were, on two levels.

Fêng (to meet unexpectedly)

(3) *Chu'an-Ch'a* (穿插), Piercing Through and Inserting. Some characters comprise spaces traversed or intersected by strokes. Here the problem is to knit the skeleton of the character together.

Tsou (to report)

FIG. 112

In the characters in Fig. 113, *Chung, Shen, T'sê*, and *Shuang*, the *Ch'uan* principle can be seen at work. The first two are pinioned by the vertical stroke, which must 'pierce' the remainder of the character securely. The second two have, respectively, a horizontal stroke and two curved strokes sweeping in opposite directions into which the remaining elements of the characters are 'inserted'.

| *Chung* | *Shen* | *T'sê* | *Shuang* |
| (middle) | (to extend) | (a record) | (clear) |

FIG. 113

The *Ch'a* principle can be observed in the four characters in Fig. 114: *Ch'ü, Wang, San*, and *Yü*. Two vertical strokes are 'inserted' into *Ch'ü*, two crosses into *Wang*, four *Jen* symbols into *San*, and four dots into *Yü*. The shaping and placing of piercing and inserted strokes has to be done with tact. In *Chung* and *Shen*, for example, the

| *Ch'ü* | *Wang* | *San* | *Yü* |
| (crooked) | (net) | (umbrella) | (rain) |

FIG. 114

[175]

vertical stroke should divide the oblong into two or four equal squares, but the equality should be more an optical illusion than a geometrical exactitude.

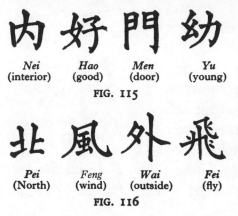

Nei
(interior)

Hao
(good)

Men
(door)

Yu
(young)

FIG. 115

北 風 外 飛

Pei
(North)

Feng
(wind)

Wai
(outside)

Fei
(fly)

FIG. 116

(4) *Hsiang - Pei* （向背）, Facing Inwards and Outwards. In certain characters the parts have the appearance of facing one another; in others, of turning their backs to each other. The four characters in Fig. 115, *Nei*, *Hao*, *Men*, and *Yu*, face inwards; the four in Fig. 116, *Pei*, *Feng*, *Wai*, and *Fei*, face outwards. These effects are the product of the general movements of the strokes. In composing inward-facing characters, the difficulty is to place the parts just far enough apart to secure the effect of 'facing'; with outward-facing characters, it is to get the parts, without cramping, close enough together to secure the effect of 'back-to-back'.

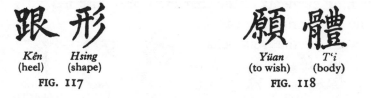

Kên
(heel)

Hsing
(shape)

FIG. 117

Yüan
(to wish)

T'i
(body)

FIG. 118

Sometimes the two parts face the same way. Both parts of the character *Kên* in Fig. 117, for example, have a rightward tendency, while both parts of *Hsing* are directed leftwards.

Hsiang-Pei is also applied to characters, such as *Yüan* and *T'i* (Fig. 118), of which neither part faces either inwards or out-

[176]

wards but both face forwards. Both parts must then be written in a similar upright manner. Before attempting to compose any character, the calligrapher must first decide what kind of character it is.

(5) *P'ien-T'se* (偏側), Aslant. Most Chinese characters have an erect posture, but a few definitely lean to one side or the other. *Chang, Hsin, Huo,* and *T'ui* (Fig. 119) lean to the left. *Hsi, Nai, Shao,* and *Li* (Fig. 120) lean to the right. Despite the slant, it is in every

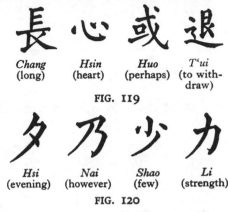

Chang
(long)

Hsin
(heart)

Huo
(perhaps)

T'ui
(to with-
draw)

FIG. 119

Hsi
(evening)

Nai
(however)

Shao
(few)

Li
(strength)

FIG. 120

case necessary that the posture should be stable. A toppling effect is aesthetically fatal. The centre of gravity must fall within the (in this case imaginary) base—like that of the Leaning Tower of Pisa. And the inclination must never be exaggerated. It is a commonplace of criticism that upright characters should be written with a suggestion of slant and slanting ones with a suggestion of uprightness.

(6) *Hsiang-Jang* (相讓), Mutual Concession. Strictly speaking, the concession is not always mutual; often one part dominates and only the other ' concedes '. The

Chu
(to help)

Yu
(young)

Chi
(imme-
diately)

Pu
(depart-
ment)

FIG. 121

concession effect is achieved by variations of the positions of the parts as well as by modifications of their size. Each of the characters in Fig. 121, *Chu, Yu, Chi,* and *Pu,* has the left side lifted

[177]

into the upper two-thirds of the ninefold square, and the right side pulled down into the lower two-thirds. Thus, dominance is given to the left-hand part of the character. Conversely, the characters *Tu, Tung, Chi,* and *I* in Fig. 122

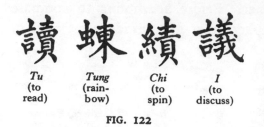

| *Tu* | *Tung* | *Chi* | *I* |
| (to read) | (rainbow) | (to spin) | (to discuss) |

FIG. 122

are composed to give prominence to the right-hand part, the left-hand part being reduced in each case to about two-thirds its normal size. In the eight characters in Figs. 123 and 124, the *Hsiang-Jang* principle operates upon

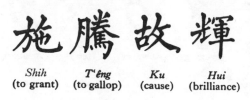

| *Shih* | *T'êng* | *Ku* | *Hui* |
| (to grant) | (to gallop) | (cause) | (brilliance) |

FIG. 123

the relative *widths* of the parts. Fig. 123 shows four characters in which only one-third of the total width is occupied by the left-hand part; Fig. 124 four in which only one-third is occupied by the right-

數獻對敬

| *Shu* | *Hsien* | *Tui* | *Ching* |
| (number) | (to offer) | (a pair) | (reverent) |

FIG. 124

hand part. In both sets of characters the length of the two parts is approximately the same. These eight characters also illustrate another aspect of *Hsiang-Jang*: that which takes account of the relative

吸呼峰峻

| *Hsi* | *Hu* | *Fêng* | *Chün* |
| (to inhale) | (to exhale) | (a lofty peak) | (steeply) |

FIG. 125

[178]

number of strokes in the parts. The characters in Fig. 123 all have fewer strokes in the left-hand part than in the right; those in Fig. 124, vice versa. In certain characters, both the length and breadth of one part are reduced in size. But notice that some of these, like those in Fig. 125, have the diminished part placed roughly on a level with the top of the dominant part, while others, like those in Fig. 126, have the diminished part placed level with the bottom of the larger. The object of all these 'concessions' is always the same—the achievement of a beautiful pattern.

(7) *Fu - Kai* (覆蓋), Covering Over. A large number of characters are subject to this principle of composition. They are all characters of which the upper element resembles a roof or shelter. The lower parts must always be brought well under the cover, like the members of a family sheltered by one roof, and arranged there in orderly fashion, each holding a proper relation to the others. Of the ten characters in Fig. 127, *Chia,*

| *Ho* (amicable) | *Chih* (to know) | *T'ien* (silver filigree) | *Hsi* (thin) |

FIG. 126

| *Chia* (home) | *Kuan* (officer) | *K'ung* (empty) | *Yu* (to pardon) |

| *Yün* (cloud) | *Lao* (to work hard) |

| *Hui* (to meet) | *Ho* (to unite) | *Chin* (gold) | *Ming* (fate) |

FIG. 127

Kuan, *K'ung* and *Yu* have a flat cover at the top, the centre of which is marked by a well-placed dot; *Yün* and *Lao* have additional strokes above the cover; *Hui*, *Ho*, *Chin* and *Ming* have obviously roof-like tops, with the lower elements so disposed as to balance the whole.

(8) *Man-Pu-Yao-Hsü* (滿不要虛), an idiomatic phrase which may be translated, ' in filling up, leave no empty space '. *Man-Pu-Yao-Hsü* is applied chiefly to characters bounded by a large outer square which the calligrapher must fill with suitably sized strokes so as to leave no ineloquent blanks. The tendencies are either to crowd the enclosed strokes or to extend them too close to the square. The square itself, incidentally, is usually more nearly a rectangle (see *Yüan*,

園	國	目	回	口
Yüan (garden)	*Kuo* (kingdom)	*Mu* (eye)	*Hui* (return)	*K'ou* (mouth)

FIG. 128

Kuo, and *Mu* in Fig. 128), and the corners are not perfect right angles but are modified in such ways as the five shown in Fig. 128. Characters like *Mu*, *Hui*, and *K'ou*, which have few or no enclosed strokes, have their whole compass diminished in order to reduce the size of the blanks.

(9) *I-Lien* (意連), Implied Connexion. Certain rather simple characters are composed of dots and strokes which have no obvious interrelation. *Hsiao*, *I*, *San*, and *Ch'uan* in Fig. 129 are examples. These touches of the brush fall, as a rule, away from one another, but they seem

小	以	三	川
Hsiao (small)	*I* (to use)	*San* (three)	*Ch'uan* (stream)

FIG. 129

nevertheless to be joined by some of those in visible muscles I described at the end of the previous chapter. In these characters the order in which the strokes and dots are written governs their direction and effects the implied connexion between them. *Hsiao* and *Ch'uan* exemplify the *I-Lien* principle particularly clearly.

(10) *Chieh-Huan* (借換), Exchange. This principle, unlike those described so far, is not for general use. The sanction of precedent—the precedent of some great scholar or calligrapher —is almost obligatory. It consists of the transposition of elements in a character for aesthetic reasons; and such a practice can obviously only be followed with caution and great skill if confusion is to be avoided.

Examples of the successful implementation of the principle are *Su, Ch'iu,* and *Ê. Su* is generally written, as in Fig. 130, A,

(A) (B) (C) (D)
Su *Ch'iu*
(to revive) (autumn)

FIG. 130

with the 魚 sign on the left, but the difficulty of arranging the right-hand side, with its rather short horizontal strokes and long sweeping rightward stroke, makes this composition awkward. So the two sides are transposed and, necessarily, the sweeping rightward stroke curtailed (Fig. 130, B). The same applies to *Ch'iu,* which is commonly written as in Fig. 130, C, with the right-hand side containing fewer strokes than the left and the character tending to sprawl. If the two sides are transposed, the long rightward-sweeping stroke of symbol 禾 abbreviated,

[181]

and that of the 㐅 symbol lengthened (Fig. 130, D), the effect is more closely knit. *Ê* has three variants. Fig. 131, A, is the regular form, but it is obvious that the long hook swinging rightward in the left-hand part of the character will tend to

(A) (B) (C)

Ê

(goose)

FIG. 131

collide with the right-hand part and give a tight appearance. Both the alternative compositions, Fig. 131, B and C, obviate this constraint. Personally I prefer C, but there is a danger in it of over-elongation.

Not much licence is permissible with the *Chieh-Huan* principle. We prefer a character to be written well in a normal form to one in which a new or eccentric composition is chosen in order to make the balance easier.

(11) *Tsêng-Chien* (增減), Increasing and Decreasing. A simple and effective way of improving the appearance of some

(A) (B) (C) (D)

Hsin *Ts'ao*

(acrid) (partly)

FIG. 132

characters is to suppress or add one stroke. Thus, in *Hsin* (Fig. 132, A), if the lower element has only two horizontal strokes the effect is top-heavy; with three it is stable (Fig. 132, B).

Contrariwise, *Ts'ao* (Fig. 132, C) is better written with one of the vertical strokes in the upper part subtracted and the other broken (Fig. 132, D).

[182]

Tsêng-Chien is another principle that must be used sparingly and as a rule only with good precedent. Its value is not realizable except by long experience, and the modifications it entails cannot be practised lightly.

(12) *Ch'êng-Chu* (撐拄), Lower Prop. Characters with a rather small base easily become weak, because the centre of gravity falls on the slightest part of the whole. *Cho, Ts'ao, Mao*, and *Ting*, for example, are supported on 'dewdrop' or 'suspended needle' vertical strokes, or 'supporting hook'. *Cho* and *Ts'ao* are easier to write than *Mao* and *Ting* : the vertical stroke at the base has the stability of a stake driven into the ground.

Cho
(eminent)

Ts'ao
(grass)

Mao
(spear)

Ting
(bower)

FIG. 133

The hook in *Mao* and *Ting* is slightly curved in the right direction—a subtle method for producing the effect of this stability.

(13) *Chao-I* (朝揖), Salutation. Characters which have two or three parts of equal value we think of imaginatively as people of equal rank meeting and acknowledging one another. Where there are only two such parts, as in *Ku, Fu*, and *Yün*, in Fig. 134, these should be of equal height and breadth. Where there are three (Fig. 135), the centre one must stand precisely

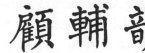

Ku
(to look
back)

Fu
(to
assist)

Yün
(rhyme)

Ch'ung
(to push
forward)

Hsieh
(to
thank)

Shu
(tree)

FIG. 134

FIG. 135

upright and the left and right flanks appear to hold it up. These effects are subtle but can usually be mastered with practice.

(14) *Hui-Pao* (回抱), and *Pao-Kuo* (包裹), Embracing and Wrapping Up. These principles apply to characters in which one or more strokes embrace or fold round the rest. There are several ways in which this can occur. In Fig. 136, *Pao,*

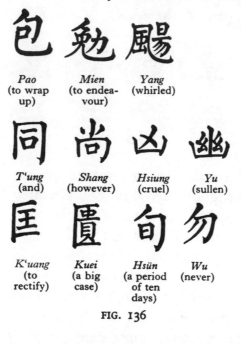

Pao
(to wrap
up)

Mien
(to endea-
vour)

Yang
(whirled)

T'ung
(and)

Shang
(however)

Hsiung
(cruel)

Yu
(sullen)

K'uang
(to
rectify)

Kuei
(a big
case)

Hsün
(a period
of ten
days)

Wu
(never)

FIG. 136

Mien, and *Yang* each have a long, curving stroke in the left-hand part that embraces the right-hand part; *T'ung* and *Shang* have three strokes which begird other characters from above; *Hsiung* and *Yu* have similar strokes begirding the characters from below; *K'uang* and *Kuei* effect the 'wrapping' in a rightward direction, *Hsün* and *Wu* in a leftward. Dangers to avoid are over-extending the embracing strokes and, in the endeavour to achieve the embracing effect, curving them round too much. Thus, if the rightward-sweeping stroke in *Pao, Mien* and *Yang* is made too long, the embraced element will not seem to fill the imaginary space enclosed; while if it is curved round too much it will cause the embraced element to look cramped. In characters in which the 'wrapping' is effected upwards or downwards, the base or top as the case may be is slightly con-

[184]

tracted. *T'ung*, however, is an exception, the outer vertical strokes being parallel. In rightward-wrapping characters like *K'uang* and *Kuei* strength is achieved by means of the *Tun* movement described in Chapter V (page 145). In leftward-wrapping characters a slight curving movement to the left of the embracing stroke supplies the necessary support and strength.

The fourteen principles of composition I have described provide an adequate foundation for those who wish to be able to discriminate good characters from bad. Serious students should consult two important books, Li Shun's '*Ta-Tzŭ-Chieh-Kou-Pa-Shih-Szu-Fa*' (大字結構八十四法) and Huang Tzû-Yüan's (黄自元) '*Lin-Chiu-Shih-Erh-Fa*' (臨九十二法), both of which can be obtained of any Chinese bookstore.

Here I will only add a few characters not directly covered by the fourteen principles, but which exemplify simple and evident modifications in the interests of pattern. *Tso* and *Tsai* in Fig. 137 have notably short horizontal strokes, and the leftward-sweeping strokes are therefore elongated. *Yu* and *Yu* have proportionately longer vertical strokes, so the sweeping stroke is shortened. Characters like *Mu* and *Chu*, containing a short horizontal stroke, a long vertical one, and sweeping strokes to right and left, are given breadth (and saved from a lean appearance) by spreading the curved strokes. If, on the other hand, the horizontal stroke of

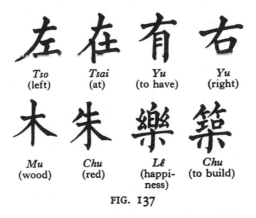

| *Tso* (left) | *Tsai* (at) | *Yu* (to have) | *Yu* (right) |

| *Mu* (wood) | *Chu* (red) | *Lê* (happiness) | *Chu* (to build) |

FIG. 137

14

a character has to be extended to support the upper elements, as in *Lê* and *Chu*, the two sweeping strokes to left and right of the vertical stroke are diminished to dots with the appearance of facing one another. In characters containing two strong horizontal strokes, like *Chêng* and *Ping* (Fig. 138), the upper of the two is made shorter than the lower. Characters with two strong vertical strokes, like *Tzŭ* and *Yin*, are made with the right-hand stroke a little longer than the left-hand. Characters which have a big 'head' and wide 'feet', such as *Ying* and *Ching*, are usually written with the central part reduced in size. Characters with long horizontal strokes in the middle and short sweeping strokes to left and right, such as *Shih* and *Ch'i*, have the right-hand sweeping stroke reduced to a dot.

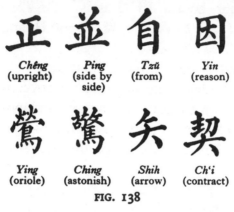

| *Chêng* (upright) | *Ping* (side by side) | *Tzŭ* (from) | *Yin* (reason) |

| *Ying* (oriole) | *Ching* (astonish) | *Shih* (arrow) | *Ch'i* (contract) |

FIG. 138

These last examples show that composition is not simply a matter of obeying rules deduced from the practices of old masters. Any writer's own experience will provide him with principles which he will not find written down anywhere as laws. All the minor principles I have described are in any case only contributory to the two fundamentals of composition, *Fen-Chien* and *Pu-Pai*, 'relative division' and 'arrangement of spaces', which together we call *Chien-Chia*. The only other generally accepted rule is that which ordains that multi-stroked characters should be written small and few-stroked ones large, lest the former should sprawl out of their imaginary squares and

the latter shrink to insignificance. After some practice the writer will find himself enlarging and contracting his characters almost unconsciously.

We call beautiful characters *Ch'üeh Hao* (卻 好), 'just right'. The reasons for the writer's success are often very difficult, if not impossible, to describe—some magical co-ordination of brush and brain seems to have been at work. Ou-Yang Hsün, the famous calligrapher of T'ang dynasty, wrote some instructions on composition which convey better than any I can write the things to be desired. I will translate his words freely in order to avoid puzzling the reader with technical terms :

Have the idea in your mind before you take up the brush. Design the composition only after you have thoroughly considered it. Be very careful with the general shape and spacing, and do not let the character tilt sideways. Too pale an ink will dim the characters' lustre, too thick a one will impede the flow of the brush. A broad fleshy stroke looks gross ; a very slim one exposes the 'bones'. Do not spoil a character by over-pliancy, nor cause discomfort by imbuing it with a quarrelsome feeling. Let all four sides be evenly proportioned and all parts co-ordinated. Short and long strokes must be calculated in relation to one another, and a compromise effected between the coarse and the fine. Mind and eye together should determine density or looseness of texture, and also inclination—whether upright or aslant. The animation and spirit of a character depend largely upon its proportioning. It is fatal to place a light head on a heavy base, or to shorten one side too much in relation to the other. The stance of a character should be like that of a well-built man. Achieve these qualities, and the atmosphere of your writing will be delightful. Only follow these instructions, and there will be no reason for failure.[1]

Trial and error is a good way of learning. Choose some printed character and try to write it as pleasingly as you can : then compare it with the same character as written by some

[1] From '*The Book of Calligraphy*', by Ou-Yang Hsün (歐 陽 詢 論 書).

acknowledged master of calligraphy. That will teach you much. Or try to write any of the characters given in this chapter, using another principle of composition than that of which it is given here as an example : then judge if your method has been justified.

VIII

TRAINING

AS I have already explained the technique of Chinese calligraphy, it may seem to the reader that a chapter on training is redundant. But actually I have not yet described how calligraphy is taught and the calligrapher systematically trained in the art.

Children are naturally unable to grasp at once all the fine points of technique—the theories of stroke-making, composition, &c. So, at the age of seven or eight, or in some cases earlier, a start is made on very simple lines. But from the outset at least one hour a day is devoted to practice. The pupils are first taught, as I have already explained, how to handle the brush and to grind the ink. They are encouraged to hold the brush very tightly. To test this, the tutor will sometimes creep up behind a pupil and try to snatch the brush out of his hand ! Next, the pupils are asked to work over in black ink a number of characters which are printed on 'practice' paper in red or other bright colour. These characters are not 'printing' characters but reproductions of hand-written ones. Children do not, of course, succeed at first in exactly covering the coloured strokes, nor can they manage the three movements of the brush necessary to the proper formation of a stroke. Frequently they only draw a line down the middle of the coloured stroke.

No objection is made to this; the tutor contents himself with explaining the positions of the various strokes in the characters and making the pupils execute them in the right order. He does, however, insist that each stroke be made in a single movement, with the brush travelling the length of it in the right direction. It is utterly contrary to the nature of Chinese calligraphy—as it is of Chinese painting—to correct or retouch a single dot. We demand that even a beginner should *write*, not fill in the coloured outlines as if he were *drawing*. Children soon get interested in writing, and strive to make their strokes resemble the model. Then the tutor shows them how to move the brush and *shape* the strokes.

The next stage consists in tracing characters. The tutor gives his pupils specimens of good calligraphy—usually written by himself—and tells them to cover them with thin paper through which the positions and constructions of the characters are partly visible. With this help, the children trace the specimen characters over and over again, and thus learn to make their own strokes and accustom their eyes to the general structure of whole characters.

Copying comes next. A model is placed in front of the pupil, slightly to the left- or right-hand side of the paper on which he is writing. The number of characters to be copied is gradually increased. The object of this exercise is to teach the pupil to understand the structure of good characters. At first he finds it very difficult to copy the model accurately, and is assisted by using a kind of ' graph ' paper divided, as described on page 167, into series of nine squares. The tutor explains which part of a character should fall within each of the squares and points out to the pupil where he is at fault.

At school, pupils over the age of ten are made to write from ten to twenty middle-sized characters and fifty or more small characters every day; under ten, the middle-sized characters are required but not the small ones. The models for the middle-sized characters are changed about every ten days.

By the time the pupil has passed the 'squared paper' stage he will have learned to raise his wrist in making a stroke, and a little later he is taught to raise the elbow also. This is very important when medium-sized or larger characters are to be written, and it has to be practised assiduously. The raising of the wrist and elbow enables the writer to achieve great swiftness and beauty of stroke. The wrist and elbow should be level with one another and maintained at a height not much below the shoulder. When a pupil has practised for some time, the tutor places on his elbow-joint a flat weight of some kind. The weight is not fastened to the elbow in any way and has to be balanced while the writing is executed. This exercise has the effect of strengthening the muscles of the arm and intensifying the writer's control over the brush, so that his hand ceases to tremble when making a stroke and his constructions become sure and steady. If he perseveres with the weight he will find that afterwards, without it, he can write much better and more fluently than he could formerly.

Our calligraphy has, as I have already shown, many styles. In practising writing we always start with *K'ai-Shu*, not merely because its characters are more 'orthodox' than those of *Hsing-Shu* and *Ts'ao-Shu*, nor wholly because it provides such fine training in the making of beautiful patterns, but primarily because it opens the door, as it were, to those later styles. Strictly speaking, *Ts'ao-Shu* was invented before *K'ai-Shu*, but

it was not established until later. *Chuan-Shu* was the ancestor of both. The need for increased speed of execution brought about the establishment of *Hsing-Shu* and *Ts'ao-Shu*, both of which grew round the basic structural shapes of *K'ai-Shu*. Hence without a thorough grounding in *K'ai-Shu* it is very difficult for any pupil to grasp the principles of strength and posture upon which good composition depends. And the freer and more rapid movements employed for the more widely used *Hsing-Shu* and *Ts'ao-Shu* result in formlessness unless the writer constantly practises the structural shapes of *K'ai-Shu*. *Chuan-Shu* and *Li-Shu* are also cultivated. Though more formal than *K'ai-Shu*, they possess a beauty and rhythm of their own, and the different ways in which their characters are arranged and spaced enlarges the writer's capacity to arrange his *K'ai-Shu* characters distinctively.

By the time a pupil has satisfactorily copied a number of good examples of *K'ai-Shu* the tutor is able to decide which manner best suits his particular talents and he then encourages him to concentrate on that manner. As a rule our first model is the writing of either Ou-Yang Hsün, or Yen Chen-Ch'ing or Liu Kung-Chüan. Subsequently we try to copy as many good examples of *K'ai-Shu* as possible, in order to gain a really comprehensive mastery of the brush and be able to shape a great variety of good strokes. Actually, the ' hand ' of a copyist is never exactly the same as the model, but he should never abate his efforts to make it so (Figs. 139 to 141). Here are some pregnant remarks on the subject by the famous calligrapher of the T'ang dynasty, Sun Kuo-Ting : (孫 過 庭).

The first lesson the beginner should learn is to look attentively at the particular traits of each style. For works of the same style by different artists

usually show marked divergencies, and different works by the same artist are by no means identical. Sometimes strength and sinuosity are coiled up in one stroke, sometimes they are bodied forth separately; an apparent smoothness may disguise the bones and sinews, or a burly vigour beat and throb upon the surface. In any case the student should delve deep into his subject; and if he starts by copying, he should copy his model without equivocation. When he fails in this—when, from absence of mind or reluctance to copy slavishly, the distribution of the strokes falls out of order and the structure of the body is loosely shaped—then, to what is splendid *and* to what are the pitfalls in this art, he is equally stranger, and such he will remain.[1]

To achieve a perfect copy would require a lifetime's practice. In time, of course, writers are able to evolve and establish new styles of their own, but their power to do so always depends upon good early training and unremitting practice. It is the same with other arts. For a dancer the road to proficiency lies equally through the sometimes tedious regions of training and practice.

Nothing is of greater importance than constant practice. In your work you will be ever confronted with difficulties, but do not despair; every obstacle can be surmounted by perseverance and assiduous practice. . . . It is only by practice that one may attain proficiency, and it is only by practice that one may preserve it.

A brief period of idleness or indifference regarding this essential of dancing causes the pupil to lose what it has cost him so much labour to acquire—his equilibrium becomes faulty . . . whereas by daily practice the pupil acquires and maintains that nice poise, facility of movement and elasticity of spring, which are a joy to the eye.[2]

To Chinese scholars calligraphy is the hobby of a lifetime. The majority of our most famous calligraphers reached the

[1] From an essay ' On the Fine Art of Chinese Calligraphy ', adapted from the translation by Sun Ta-Yü (孫 大 雨) in the ' *T'ien Hsia Monthly* ', September 1935.

[2] From ' *A Manual of the Theory and Practice of Classical Theatrical Dancing* ', by Cyril W. Beaumont and S. Idzikowski. London, 1932.

雨骸運謝星馳時流迅速

既彫桐枝復摧良木三河

奄曜以塸竃燭廌感毛羣

悲傷羽稜扁棠圭曉墳宇

FIG. 139.—AN EPITAPH, *CHIH* (誌), OF CHANG HEI-NÜ
(張黑女) MADE IN THE WEI PERIOD
(*Collection of Ch'in Ch'ing-Tsêng, Soochow*)

The object of these three figures is to exhibit the Chinese practice of 'copying'. The epitaph of Chang Hei-Nü (Fig. 139) was found by the Ching dynasty calligrapher, Ho Shao-Chi, who made the style known by the appreciations he wrote of it in his book, and by the copies he made of it. Figs. 140 and 141 are copies by two other good calligraphers of the Ching dynasty. Notice that neither even attempts to be a facsimile of the original; superficially, they differ as much from it as from one another: it is the *aesthetic* qualities only of the original that the copyists have tried to reproduce. And the copies being good, each has value in itself. The same applies to good copies of paintings.

[194]

両骸運謝星馳時流迅速
既彫桐枝復摧良木三河
奄曜以堀室燭應感毛羣
悲傷羽祿扃堂无曉墳宇

両骸運謝星馳時流迅速
既彫桐枝復摧良木三河奄
曜以堀室燭應感毛羣悲
傷羽祿扃堂无曉墳宇唯昏

FIG. 140.—THE EPITAPH COPIED BY
LI JUI-CHING (李瑞清)
(Collection of Chiang Ta-Ch'uan, Kiu-Kiang)

FIG. 141.—THE EPITAPH COPIED BY HO
SHAO-CHI
(Collection of Chiang Ta-Ch'uan Kiu-Kiang)

height of their powers only at a venerable age. No matter how long they practised they never seem to have been satisfied with their work, but always to have been finding something new in the old models and to have striven to compass it themselves. There is a Chinese proverb which says : ' *Shu-Nêng-Shêng Ch'iao* ' (熟 能 生 巧)—' good practice can produce skilfulness '. We even believe that if a writer practises perseveringly he need not worry about proficiency, for that is bound to come in time.

We distinguish three stages in the development of an apprentice calligrapher. At the first stage the writer finds that he can, perhaps after several attempts, make a copy of a character which seems to him to be nearly as good as the original. This stage is a happy one. The writer's eye is not yet sufficiently trained to enable him to perceive how far short his effort really falls of the model. Further practice brings him to the second stage, when he realizes the relative poorness of his work. This is very discouraging and sometimes a writer will give up trying further. But actually this discouragement is a sign of improvement ; it shows that the writer has begun to appreciate not merely his own defects but the excellence and beauty of his models. Those who are genuinely devoted to the art will succeed ultimately in transcending this stage. It may take a very long time, or it may be accomplished comparatively quickly. Suddenly the writer achieves a result which is really as good as the example. The wearisomeness of the endless practice falls away and he realizes that his success is due to his having at last understood the original so acutely as to be able to reproduce it. That is the third stage.

But it is by no means the last. At this point the writer

has *begun* to do good work. To become a fine calligrapher he must thenceforward steadily improve his taste and judgement; there is no stage of complete accomplishment. But now there is a far greater interest in practising, and the pupil can genuinely regard himself as a student of calligraphy. For the object of his attention has become not merely the laborious acquisition of the necessary physical proficiency but the study of the beauties of calligraphy.

All the instruction I have so far given has centred round the all-important matter of correct handling of the brush. I have explained the four essentials—*Hsü, Hsüan, Chih,* and *Chin* —which every writer must achieve. From my description it should be possible to comprehend them in the abstract, but how and why they are essential the writer must find out for himself in actual practice. The reason why the talent of some gifted writers never fully develops is often that they have not learned faithful obedience to these rules.

At this point also the shaping of strokes and the composition of pattern really begin seriously to be considered. The aspiring writer turns naturally to the acknowledged masterpieces of the past. The idea that new styles grow out of the old is one with which, as I have said in an earlier chapter, we are deeply imbued in China. A Chinese artist always masters and venerates the work of his predecessors, believing that by studying their achievements he can capture their quality and at the same time profit by their experience and avoid the pitfalls which they have uncovered. Hence we regard the devoted copying or imitation of old masterpieces as the shortest path to the production of new work of comparable merit.

Writers who have passed the third stage of development

seek to examine as many existing masterpieces of calligraphy as possible. Until recently they suffered a considerable handicap in that no means existed of reproducing calligraphy beyond that of engraving on stone and taking rubbings from the stone. The rubbings were circulated among scholars and closely studied, and the process of engraving was carried to such a pitch of excellence that it became itself an art ; in every period there were good craftsmen doing this work, though their names were not recorded and are not now known. But these rubbings had no wide circulation. Formerly, when travel in China was tiresome and inconvenient, it was often very difficult to procure good examples of them. Sometimes a scholar who possessed one would try to take a fresh engraving from it and circulate rubbings of this ; later, a third engraving might be taken from one of the second rubbings. With each transcript a part at least of the quality of the original would be lost. This necessitated a special study being made by scholars to distinguish rubbings taken from original engravings from those taken from copies. It was a delicate study, for the craftsmen who engraved the copies had necessarily to be highly skilled and they could generally write well themselves. From reading and personal experience I know that Chinese scholars have always spent a great deal of time discussing the strokes and composition of good examples of calligraphy engraved on stone. The stone may be worn with repeated rubbings ; the inscription may be partly obliterated and the meaning of the passage incomplete ; there may be nothing left but a few isolated strokes—still our scholars see beauty in these stone inscriptions and copy them as faithfully as they can.

It has always been the ambition of our scholars to collect

genuine masterpieces, but, as I have explained, it was an ambition that, until recently, was seldom realizable on any considerable scale. But during the last thirty years two new methods of reproduction have to some extent supplanted the old stone-rubbing process: lithography and collotype. And now most of the great work of the past can be purchased cheaply at any stationer's shop in China. Books of calligraphy printed by lithography or collotype, and even a kind of stone rubbing issued in book form, have a much wider sale in China than books on painting or any other subject, for calligraphy excites universal interest, whereas painting and most other subjects have only a limited appeal. We believe that every one should try to write well, for the intrinsic satisfaction it brings to the writer himself as well as the esteem it gains him among others, even those he has never met.

Despite the new methods of reproduction, original masterpieces of calligraphy are still very highly valued by Chinese art lovers, some of whom will willingly pay higher prices for a piece of it which they feel they need than for an original painting. Not a few of our scholars collect calligraphy only and have no taste for painting. A cousin of mine used, when our family assembled to enjoy the family collection of art, to pay no attention to the paintings, jade, porcelain, and so on, but when a long roll bearing the characters of a well-known calligrapher was produced he gave no one else a chance to speak. He seemed to have been born with a love of calligraphy, for from early childhood he never ceased to study and practise it. To me it is strange that this art has never really appealed to the West.

The well-known calligrapher, K'ang Yu-Wei, who died only a few years ago, once remarked: 'To learn calligraphy one

must start by imitating the old writers. Those who cannot acquire the good qualities of old writings cannot put their talents into their own. But before one can copy an old example faithfully one makes hundreds of unsuccessful attempts, for only when one has learned to make the same movements and turns of the hand as the original calligrapher will one succeed in making a perfect copy.' So, you see, the imitation and copying of good calligraphy constitutes a very important part of the training of a calligrapher, and the acquisition of good examples to copy is imperative.

The early morning has always been regarded as the best time for practice. The mind, as well as the world, is fresh at this time, and—what is almost as important—the light is clearer and stronger than it is later in the day. Artificial light of any kind is inferior to even poor daylight. This fact will seem more evident to a Chinese than to an Englishman, because in China, where the climate is by comparison with England dry, the daylight is brighter. But even allowing for the good artificial light generally available in England, I still find it is best to write by daylight as far as possible. After writing for some time by electric light my eyes get very tired and the edges of my strokes become blurred instead of sharp. This confirms the Chinese belief that lamplight not only hinders the making of beautiful strokes but impairs the eyesight.

Posture is another consideration which affects both the calligraphy produced and the writer's health. The body should be held square to the table, with the chest not more than three inches from the edge. The back should be upright—at right angles to the surface of the table ; and the shoulders level and parallel to the table. It is wrong to incline or twist the body,

or to move it about at all while writing. The slightest motion impedes the control of the arm and upsets the focus of the eye. The body should form an immobile base from which the arm can operate like the 'arm' of a crane. The left elbow is bent naturally and the left hand rests on the paper, to hold it, like a paper-weight. The right elbow is bent and the right hand holds the vertical brush, the position of the right hand and forearm being at about right angles to the left hand and fore-arm. The head, obviously, is inclined slightly towards the paper ; the neck may be stretched a little if desired. The tendency of beginners to lie forward on the table must be corrected ; nor must they be allowed to crouch down at their writing with the head tilted sideways, like cocks and hens looking for scraps of food. These faults inevitably result in bad writing and bad health.

Never try to write until you have calmed yourself completely. Any sort of rush before writing is fatal. You would not expect to be able to play the piano well immediately after running half a mile in the park! First concentrate on the characters to be written and work out patterns for them. This will induce a state of tranquillity in your mind and enable you to execute them as you wish.

For beginners, the four writing instruments need not be of specially good quality. Indeed, even accomplished writers frequently use for common purposes instruments which can be bought very cheaply of any stationer in China.[1] The ink-stick is generally made of oil-smoke and the brush of sheep's

[1] I am afraid they are not obtainable at all in Europe. But they can be had on application, in English, to The Commercial Press, Ltd., or the Chung Hua Book Company, both of Honan Road, Shanghai, China.

hair. The practice papers are called *Chu-chih* (竹紙) and *Mao-pien-chih* (毛邊紙) ('rough-edged paper'); they are made of bamboo or the stems of weeds and they have a coarse, rough surface yellowish in colour. The reader may think that this is to make things more difficult than need be for the beginner. And so it is; but we hold that it is better to start under severe conditions so that easier ones may produce better results. Let me warn you, however, not to 'make do' with such paper as is used in the West for printing newspapers and books, nor to use any stiff paper with a shiny surface. The latter papers are not absorbent and the differences of strength in the ink show in the strokes. The great drawback to them for our purpose is that the surface reacts against the force applied through the arm to the point of the brush and makes it almost impossible to get the right shape of stroke. These defects will not be fully realized except by comparison with Chinese papers. Writers who have reached the third stage of development will naturally want to try their hand with better—or even the best—instruments and materials. The best paper is called *Hsüan-Chih* (宜紙).

As this book is intended for those who know little or nothing of Chinese calligraphy, I do not feel there is any object in my going into the finer points of training and technique. The subject is inexhaustible. For centuries past thousands of our scholars have devoted their lives to the discussion of its subtleties and delicacies. But these niceties cannot be realized without a great deal of actual experimentation such as my readers are not likely to be in a position to carry out; they cannot adequately be described in words. It goes without saying, too, that intellectual effort and aesthetic discrimination of graphic and

lineal qualities are required in a high degree, and I have not set out to scale these heights.

Some idea of the difficulty of attaining a high standard in the art, even after undergoing a thorough training, is conveyed in this second quotation from Sun Ta-Yü:

As regards the common faults, there is not so much a great variety of these as a wide prevalence of two or three. Some writers indulge in a running hand because they do not know how to linger; others favour a lingering one because they cannot trust themselves to move at the right speed if they try one of the flowing styles. Ideally, speed is the flash of inspiration, slowness the prolonging of pleasure. To hurry only over intervals is the secret of perfection; but to be slow on every occasion is to renounce all possibility of achieving the extraordinary. To hasten when the occasion does not demand haste is tantamount to dawdling; to linger merely out of sluggishness brings no enjoyment. Unless the mind is at ease and the hand alert and responsive, the two qualities of speed and leisureliness rarely favour one person. . . .

Thus, it is easier to excel in one way than in many ways. Aspirants who begin by following the same master will end by developing different styles: their own traits will ultimately emerge in place of those of the master. Straightforward, simple people will always write with austerity and vigour; the style of obstinate ones is harsh and unattractive. Reserved persons exhibit a stiff and stilted manner. Undisciplined natures violate alike the rules which can and those which cannot be violated. Unrelieved gentleness ultimately proves effeminate; untempered courage produces stridence. Then there are the cautious ones who perpetually hesitate to strike, and become stale; the dull ones, oppressed by their own clumsiness; and the trite and vulgar whose style reproduces their qualities.[1]

I will close this chapter with a few stories about famous Chinese calligraphers. In China such stories have always been a favourite way of explaining the significance of artistic training and technique—analogous to the Biblical parables.

It is said that Chang Chih, a great master of the Grass

[1] From an essay ' On the Fine Art of Chinese Calligraphy ' adapted from the translation by Sun Ta-Yü in the ' *T'ien Hsia Monthly* ', September, 1935.

Style in the Han dynasty, practised his calligraphy out of doors and left the water of a pool near which he worked entirely black. Chung Yu, another great master, the founder of the Regular Style of the Wei period, withdrew for about ten years to the mountain called Pao-Tu (抱犢) in order to practise calligraphy in quiet, and left nearly all the trees and rocks about him stained with ink. Wang Hsi-Chih, the Chin dynasty master alluded to on pages 67–8, practised all his life yet was not satisfied with his work until he was past fifty. The monk Chih-Yung (智永), of the T'ang dynasty, lived in the upper floor of a temple and in forty years' practising of calligraphy filled nearly five large baskets with worn-out brush-hairs. Chao Meng-Fu, a great painter and calligrapher of the Yuan dynasty, devoted himself for a long time to copying the writing of Wang Hsi-Chih, and it is told that he wore out the sleeve of one coat after another with his labours.

Natural objects and movements have often served to awaken or inspire the talents of Chinese artists. The Grass Style writing of Chang Hsü was greatly improved after he had seen the dancing of Lady Kung-Sun (公 孫). Huang T'ing-Chien attained a new posture for his writing from watching boats being rowed with oars. The monk Huai-Su realized the infinite variety possible in *Ts'ao-Shu* by watching summer clouds wafted by the wind. Wên T'ung (文 同) made a sudden step forward with his *Ts'ao-Shu* after seeing some snakes fighting. And so on.

Helpful as these stories are in putting the student on the right path, there is, in the appreciation of art as in its perform-ance, no substitute for individual talent. In a book one can explain only the how and the why. Personal effort and capacity must do the rest. Confucius said : ' There is no one who

does not eat and drink. But few there are who really know the taste of what they eat and drink.' [1] This book is designed to enable the reader to eat and drink the aesthetic food of Chinese calligraphy : it cannot ensure that he tastes the food and drink.

[1] From ' *The Conduct of Life* ', translated by Ku Hung-Ming.

IX

CALLIGRAPHY AND PAINTING

IT is my strong belief that for beauty and for artistic value one should not discriminate between the arts of East and West: that is to say, a great work of art, particularly pictorial art, will remain great in all eyes, at all times, and in all places, whether it is produced in Europe, Africa, America, or Asia. There are differences, however, particularly in the technique and training of the individual artists, as well as their separate artistic and cultural traditions.

In the West the art of painting is closely related to sculpture. Western painters have traditionally sought to give realistic solid form to their subject-matter, emphasizing light and shade with the help of different colors to produce a realistic perspective. But painting developed very differently in China. The earliest written scripts were pictorial, evolving gradually into abstract structures of finely shaped calligraphic strokes without any concern for light and shade. These calligraphic strokes were later employed in a similar manner to create paintings in which light and shade also played little part. Chinese calligraphy and painting are both derived from ancient Chinese scripts and executed with the same type of brush and ink, on the same kind of paper or silk.

It is quite common for a Chinese painter to say not that he is

'painting a painting' but 'writing a painting'. Technically speaking, the Chinese painter handles his brush and manipulates the ink no differently from a calligrapher. The Chinese calligrapher who aims to achieve the 'seven mysteries' described in Chapter IV, by imparting a sense of living movement to every stroke, has the same goal as the Chinese painter who tries to fill his whole creation with life through the living quality of each stroke. The power to imbue strokes with life is acquired from training in calligraphy. A Chinese painting is essentially subjective; its aim is not to depict an object as it might be analyzed scientifically, but as it is seen through the lens of an individual mind. Drastic simplification is always effected. The painter follows a process similar to the one used by the creators of the ancient scripts; he observes the object carefully all around, memorizes its essential features, and finally works out its simplified form in the fewest possible strokes. In Chapter II, I explained that the written characters originally were nothing but simplifications of observed objects; so Chinese painting and calligraphy have another similarity.

The treatment of the brush stroke is the basis for both calligraphy and painting. Whether it is rough or delicate, heavy or light, quick or slow, oblique or regular, curved or straight, the brush stroke must, above all things, be sure and spontaneous, giving an impression of life. In forming a calligraphic composition, the combination of these sure-yet-spontaneous living strokes should be so composed as to liberate the visual beauty of an abstract structure of lines. In painting, too, the design is constructed from the same living strokes in order to create the simplified object conceived in the mind of the painter. In calligraphy or painting no 'dead' stroke should be allowed to

exist, not even the smallest superfluous dot. It is not surprising that a good painting is often the work of a well-trained calligrapher.

To clarify this point it may be best to discuss some particular illustrations. Though Chinese painting extends back more than two thousand years, with a wide-ranging subject-matter, the works are generally grouped into three categories: figure painting, landscape painting, and bird-and-flower painting. For each type, two fundamentally different techniques may be used: the *Kung Pi*, or 'fine-stroke' method, which renders the subject in careful and delicate strokes; or the *Ta Pi*, 'big-stroke' method, in which the artist paints rapidly with firm, vivid strokes. The very terms *Kung Pi* and *Ta Pi* make it clear that the painter approaches his work through calligraphic training. Plate VI, a portion of the long scroll 'Admonition of the Imperial Instructress' by Ku K'ai-Chih (顧愷之) (c. 4th century), in the British Museum, London, is an example of *Kung Pi*. The contour lines around the faces and those of the draperies are carefully and delicately drawn, in even thickness, akin to the calligraphic 'small-seal' style shown in Figs. 18, 19, and 20. It must be realized that the even thickness of the lines was achieved not with the nib of a pen but with the tip of a fine brush.

The same applies to Plate VII, one of the thirteen 'Emperors' painted by Yen Li-Pen (閻立本) (c. 8th century). But Plate VIII, 'Feng-Kan Sleeping on His Tiger', said to be a work of Monk Shih K'o (石恪) (12th century), is executed in the *Ta Pi* or 'big-stroke' method corresponding to the *Ts'ao-Shu* style of calligraphy in Figs. 64 and 66. Plate IX, 'The Sixth Patriarch Tearing up a Sutra' by Liang K'ai (梁楷) (active in the first half

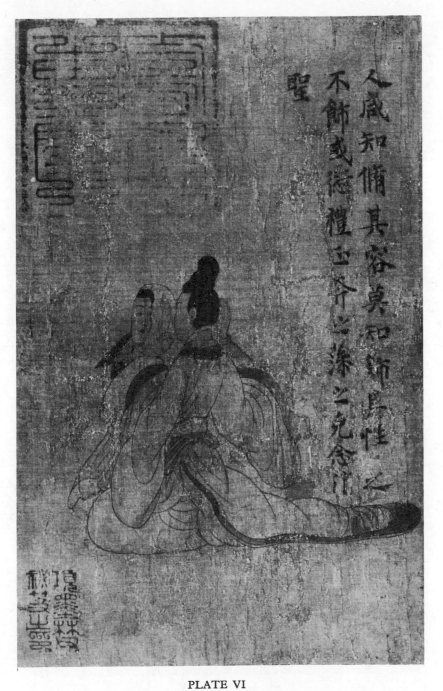

PLATE VI

A portion of 'Admonition of the Imperial Instructress' by Ku Kai-chih
(*Collection of the British Museum*)

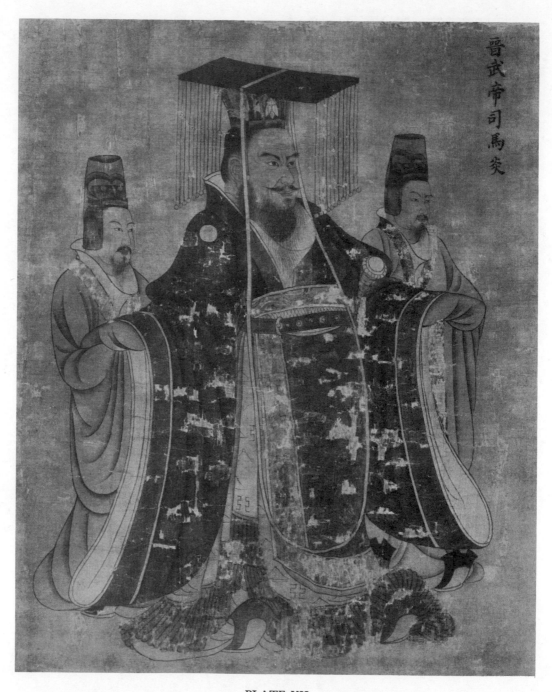

晉武帝司馬炎

PLATE VII

'One of the Thirteen Emperors' by Yen Li-pen (閻立本), eighth century
(*Collection of the Boston Museum of Fine Arts*)

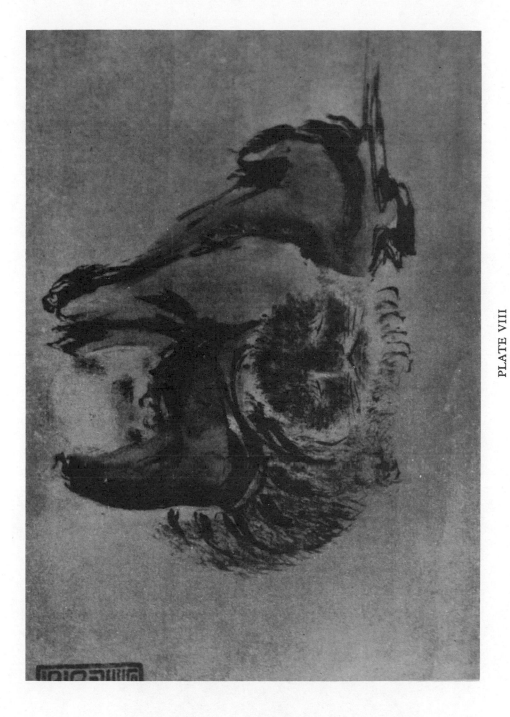

PLATE VIII

'Feng-Kan Sleeping on His Tiger', in the style of Shih-K'o (石恪)

(Tokyo National Museum, Imperial Cultural Properties)

PLATE IX

'The Sixth Patriarch Tearing the Sutra' by Liang K'ai (梁楷)

(*Collection of Mitsui Takanaru Tokyo*)

of the 13th century), employs the *Ta Pi* method corresponding to the *Hsing-Shu* style of Fig. 56 as well as to the *Ts'ao-Shu* style of Fig. 63.

The Chinese term for landscape painting is *Shan-Shui*, meaning 'mountain-water', neither qualifying the other. In Chinese *Shan-Shui* paintings the variation in brush-strokes is far greater than in figure paintings. In Plate X, a scene from 'Emperor Ming-huang's Journey to Shu' by an anonymous painter of the T'ang dynasty (618–905), the same careful and delicate *Kung Pi* method is employed as in Plates VI and VII. But Plate XI, a part of the long hand-scroll 'Pure and Remote View of Streams and Hills' by Hsia Kuei (夏圭) (active c. 1190–1225), employs the combined methods of the *Ts'ao-Shu* and *Hsing-Shu* styles. Each stroke, each single dot, was executed swiftly, yet with firm assurance.

Plate XII shows a portion of the long hand-scroll 'Fishermen on the River' by Tai Chin (戴進) (active in the early 15th century), which employs the *Hsing-Shu* style with an inclination toward the *Ts'ao-Shu*. The artist had complete mastery of the brush and could manipulate it fast or slowly at will. The brush-strokes of the *Hsing-Shu* style appear more prominently in Plate XIII, 'A Man in a House Beneath a Cliff' by Tao-chi (石濤) (1641– c. 1717). Though the picture has a sketchy appearance, the painter had a sure hand and 'wrote' the intertwining strokes of the trees with spontaneous movement and a great sense of spacing, as if he were writing characters.

The Chinese seem to be particularly partial to painting birds and flowers. The reason may be that the feathers, the beaks and claws, the stems, the petals, the leaves, the branches and twigs of these natural objects, lend themselves so well to

[209]

calligraphic treatment, which embodies the ' rhythmic life ' that is the essence of a painting.

In Plate XIV, ' Two Finches on Twigs of Bamboo ' by the Emperor Hui Tsung (宋徽宗) (ruled 1101–1125), we can see that the birds' bodies and wings are rendered by a great number of fine individual strokes, each bamboo leaf by a single stroke. Plate XV, a portion of the long hand-scroll ' The Flight of Geese over Marshland ' by Ma Fen (active in the second half of the 11th century), illustrates a most successful combination of a number of strokes of varying width for the birds as well as for the reeds. The renowned painter Hsu Wei (徐渭) (1521–1593) ' wrote ' his ' The Vine Plant ', Plate XVI, with bold strokes for both petals and leaves ; he is regarded as the founder of modern Chinese bird-and-flower painting because of his use of free brush-strokes and unusual compositions over three hundred years ago. ' Chinese Orchid Flowers ' by Li Shan (李鱓) (c. 18th century), Plate XVII, shows the artist's masterful skill in depicting a number of orchid flowers along two different stems, one with a dark ink, the other with a lighter one. Plate XVIII, ' Bamboo with Calligraphy ' by Cheng Hsieh (鄭燮) (c. 18th century), illustrates the happy marriage between painting and calligraphy (see Figs. 44 and 56).

Wu Chang-Shih (吳昌碩) (1844–1927) was famous for his calligraphy in the ' big seal ' style, reproduced in Figs. 17 and 21. By employing the same calligraphic strokes he became equally renowned for his paintings of winter plum flowers (Plate XIX). Another noted painter of the twentieth century, Chi Pai-Shih (齊白石) (1863–1957), who employed a type of calligraphic strokes derived from the *Li-Shu* style for his paintings of shrimps, also developed a new quality of transparency in the strokes depicting

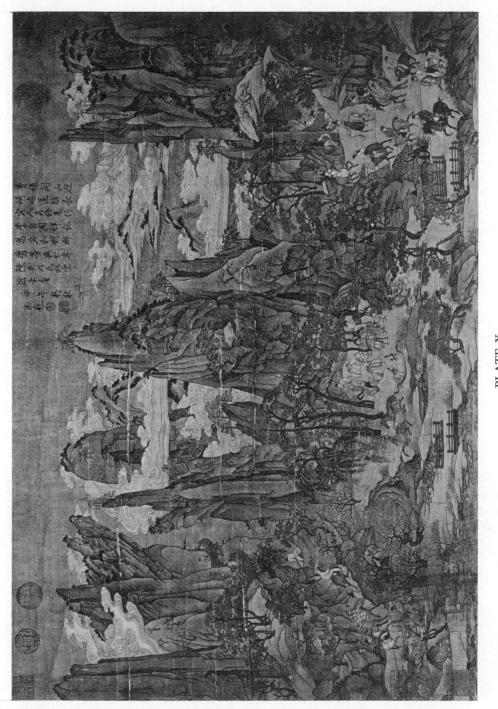

PLATE X

'Emperor Ming-huang's Journey to Shu' by an anonymous artist of the T'ang Dynasty

(618–906)

(National Palace Museum, Taiwan)

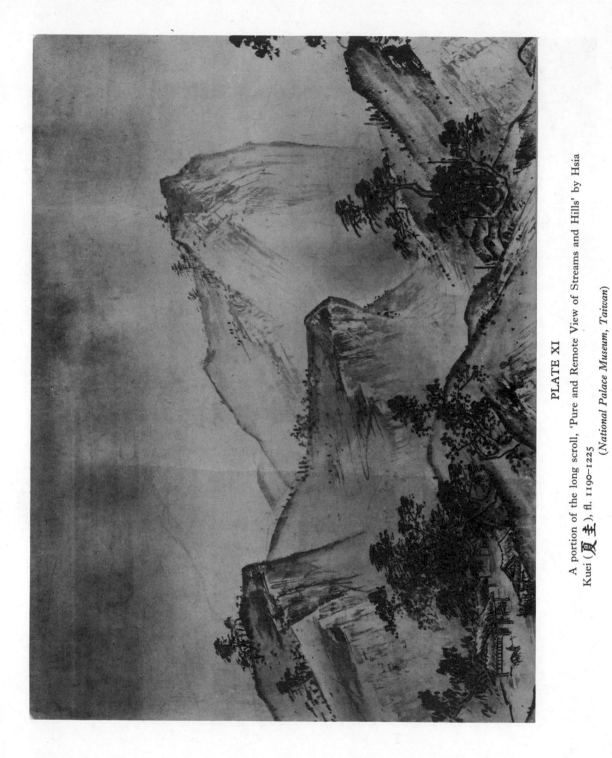

PLATE XI

A portion of the long scroll, 'Pure and Remote View of Streams and Hills' by Hsia Kuei (夏圭), fl. 1190–1225

(National Palace Museum, Taiwan)

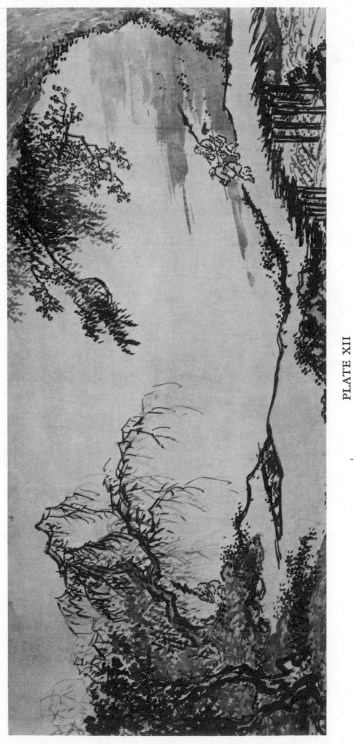

PLATE XII

A portion of the long scroll, 'Fishermen on the River' by Tai Chin (戴 進), active in
the early fifteenth century

(Collection of the Freer Gallery, Washington, D.C.)

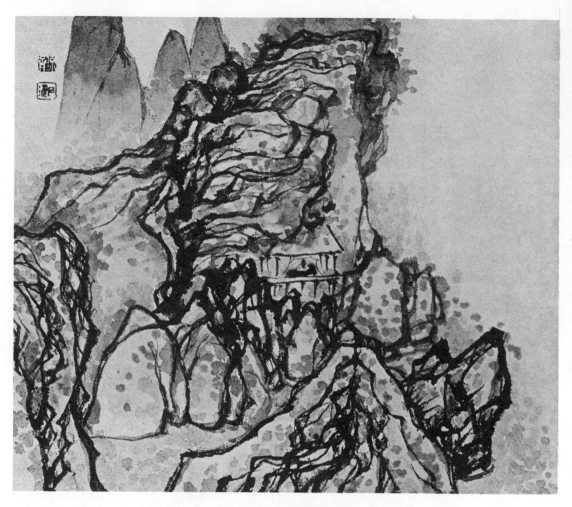

PLATE XIII

'Man in a House Beneath a Cliff' by Tao-chi (石濤)

(*Nü Wa Chai Collection. Reproduced by permission from James Cahill's* Chinese
Painting)

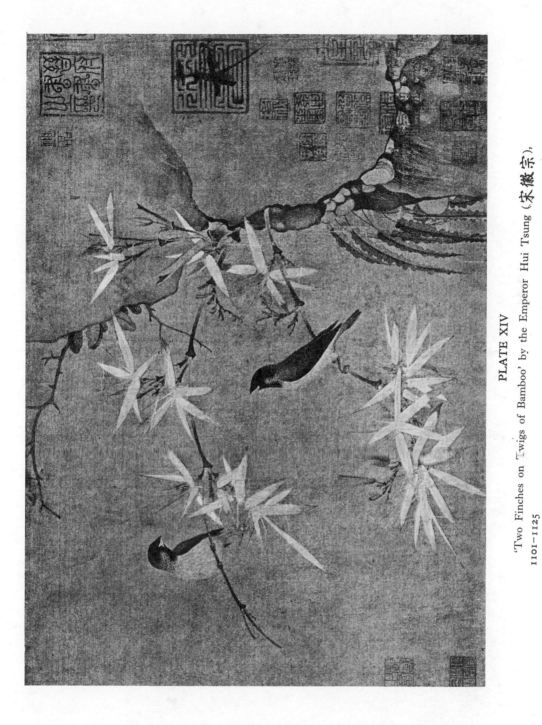

PLATE XIV

'Two Finches on Twigs of Bamboo' by the Emperor Hui Tsung (宋徽宗),
1101–1125

(In the collection of John Crawford, Jr,)

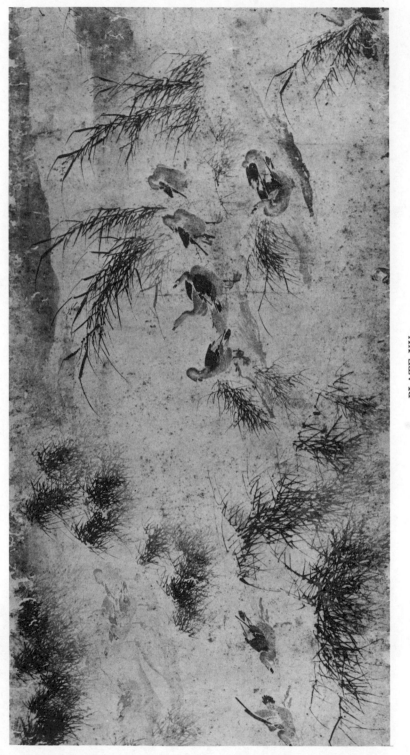

PLATE XV

A portion of the long scroll, 'The Flight of Geese over Marshland' by Ma Fen (馬賁),
active in the second half of the eleventh century
(*Honolulu Academy of Art, Honolulu, Hawaii*)

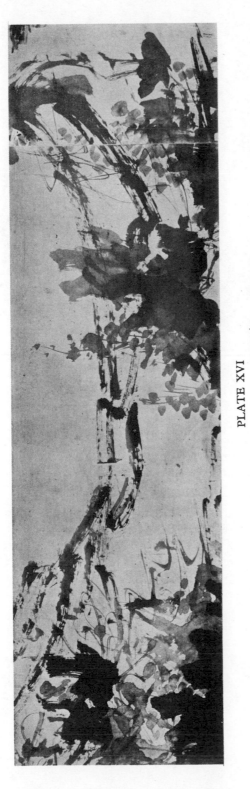

PLATE XVI

'The Vine Plant' by Hsu Wei (徐渭), 1521–1593

(Collection of P'ing Tan Ko, Shanghai)

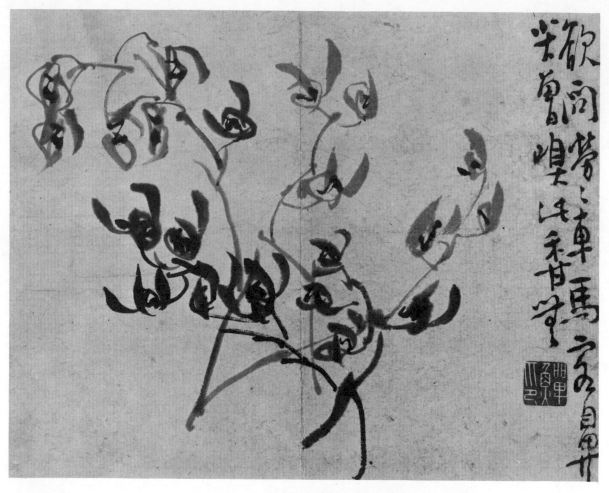

PLATE XVII

'Chinese Orchid Flowers' by Li Shan (李鱓), c. eighteenth century
(*Courtesy of the Art Institute of Chicago*)

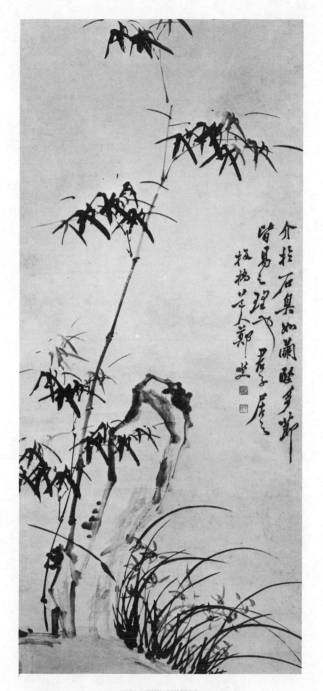

PLATE XVIII

'Bamboo with Calligraphy' by Cheng Hsieh (鄭燮), c. eighteenth century
(*Collection of Rudolph Schaeffer, San Francisco*)

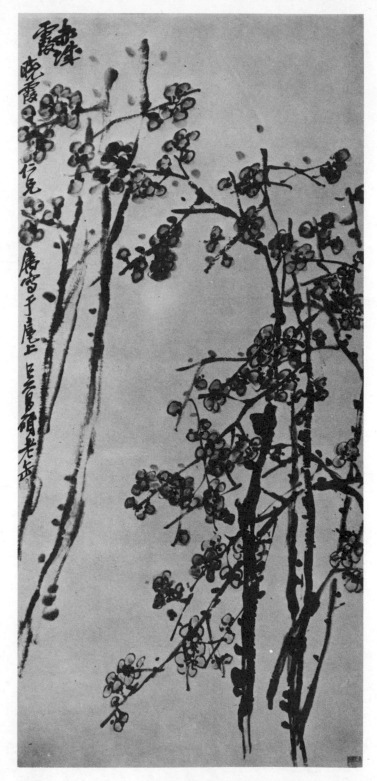

PLATE XIX、

'Winter Plum Flowers' by Wu Ch'ang-shih (吳昌碩), 1844–1927

(*Private collection, Shanghai*)

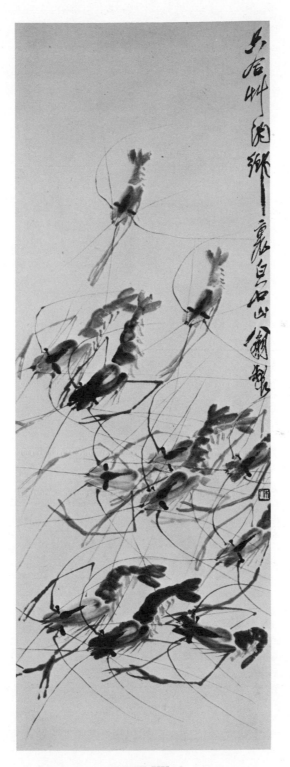

PLATE XX

'Shrimps' by Chi Pai-shih (齊白石), 1863–1957
(*Collection of Chiang Yee, New York*)

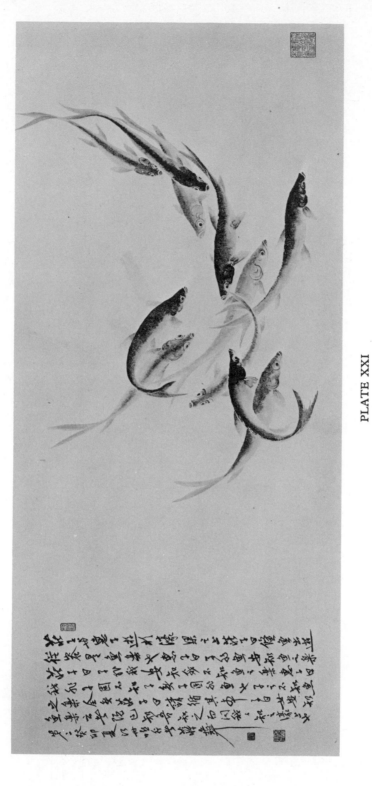

PLATE XXI

'The Happiness of the Fish' by Chiang Yee (蔣 彝), 1903–

(*In the collection of Utah State University*)

their heads and bodies. Plate XX is a picture which he painted for the author when the latter was living in London in 1944. Though Chi Pai-Shih produced many innovations in a host of traditional subjects, he excelled particularly in his paintings of shrimps and crabs. His special technique for shrimps was as follows: first he filled his brush with pure water and dipped the tip of it into a rather pale ink. The amount of water in the brush had to be kept in mind. He then pressed down on the paper the full brush from the tip to the end, so that the pure water was left in the center and the pale ink on the tip spread down both sides to encircle the watery area. This was his secret for producing the effect of transparency, though it took years of practice to achieve. The most interesting part of the process was to watch him add a dark stroke in the middle of the head while it was still wet, and two short dark lines for the eyes. The two short lines drawn sideways from the center demonstrated his power to infuse life into the whole creation, using an extraordinarily simple device. Finally he finished the work by furnishing the necessary long front claws and whiskers. Each claw and each whisker was arranged not in a rigid pattern but in a lively manner, with the appropriate space between them as if he were writing a piece of calligraphy. Though there are about twenty shrimps in Plate XX, each has its own life and none are crowded together. Such a composition needs to be carefully thought out by someone with aesthetic insight and good taste, and then executed swiftly and spontaneously.

When I worked out my painting of ‘ The Happiness of the Fish ’ (Plate XXI), I drew the body of each fish with a single sweep of the brush, graduating the ink from a darker to a lighter color, and suspending the brush in places to leave space for the

eyes, gills, and bellies. I used spontaneous strokes, as Chi Pai-Shih did with his shrimps, but I employed calligraphic strokes and rather slow movements to complete the bodies. It seemed to me that this produced an effect of fish swimming gracefully together without cramping one another.

From a study of even the few plates above one can observe clearly that Chinese painting is closely related to calligraphy. In fact, calligraphic training plays the main part in the creation of a good painting; without it a Chinese artist can hardly be expected to execute a satisfactory painting, however much aesthetic insight and good taste he may have. Of course there are degrees of calligraphic expertise and there have been a few exceptional cases of painters who were indifferent calligraphers, or rather, were not skilled in all styles of writing.

In addition to the calligraphic nature of the technique, a Chinese painting from the Sung period (960–1276) onward often includes a piece of actual writing, an inscription. It is usually a short poem or a brief essay and forms an integral part of the whole composition. Its purpose is to enhance the value of the painting by drawing out an added meaning. On the painting in Plate XXI, I wrote a philosophical discussion on the happiness of the fish from *Chuang Tzu*:

Chuang Tzu, a great philosopher of Chinese Taoism (active in the 3rd century B.C.), and Hui Tzu, another Taoist philosopher, were enjoying themselves on the bridge over the River Hao.

‘ Those little fish swimming hither and thither are very graceful ’ remarked Chuang Tzu, ‘ they are expressing their happiness.’

‘ You are not a fish,’ answered Hui Tzu, ‘ how can you know that the fish are happy ? ’

‘ You are not me,’ rebuked Chuang Tzu, ‘ how can you know that I do not know the happiness of the fish ? ’

‘ Well, I am not you, I naturally don’t know your feeling, ’ resumed Hui

Tzu. ' But obviously you are not a fish and it is plain that you cannot know the happiness of these fish.'

' Please let's go back to where we began,' said Chuang Tzu. ' Your question of how I know the happiness of the fish shows that you already realize that I do know the happiness of the fish. I know it here, above the River Hao, on this bridge.'

If this painting of fish is considered to be well executed it will appeal to the viewer, but with the quotation from *Chuang Tzu*, it should evoke a deeper appreciation.

If an inscription is to be included in the composition, it goes without saying that the painter must have a good calligraphic style. On important paintings we frequently find inscriptions by well-known calligraphers, which are known as ' colophons '. These not only add new meaning to the work but are also witness to its authenticity. The important part played by calligraphy can hardly be ignored in the study of Chinese pictorial art.

X

AESTHETIC PRINCIPLES

A WORK of art represents the mind of the people who created it; the mind of the people was molded within the frame of the traditional philosophies and conventional ideas which in turn had been deduced from their daily ways of living in a specific geographical position and a specific climate. The ancient Chinese came to live in Far Eastern Asia, in a temperate zone. The most profound philosophy of ancient China has been crystallized in a book entitled *I-Ching* or ' *Book of Changes* ', whose original corpus is based on a system of linear combinations. The system is said to have been devised by the legendary ruler Fu Hsi (c. 28th–30th century B.C.) to represent all the observed phenomena under heaven and above earth. He was probably sitting on the top of a mound of sand, and while observing the phenomena found a scratch on the sand, suggesting a short line. It occurred to Fu Hsi that if he drew a line of similar length and broke it in the middle, it would denote another quality of a substance. The first line with its full length represents the straight, complete, strong, and solid; the second, broken line stands for that which is incomplete, weak, and breakable. With these two opposite, though not hostile, qualities, Fu Hsi must then have reached a conclusion later known as Chinese dualism or the *Yin* and *Yang* system of

thought. The first line is known as *Yang* or ' Positive sign ', and the second *Yin* or ' Negative sign '. Not content to have only two signs to represent all the different phenomena in the universe, Fu Hsi then created the system known as *Pa-Kua* or ' Eight Trigrams ' as described in the beginning of Chapter II :

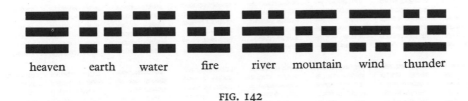

heaven earth water fire river mountain wind thunder

FIG. 142

These eight trigrams were then further tiered to form sixty-four hexagrams (Fig. 143). The sixty-four combinations formed out of the two original lines, one complete and the other broken, are fully described in ' *The Book of Changes* ' (first translated into German by Richard Wilhelm and later rendered into English by Cary F. Baynes, a book that has been very popular with thousands of readers). The premise of its profound philosophy is that the entire universe has been in a constant state of change from its beginning, and that each change can be interpreted from the conditions and situations of the individual lines forming any one hexagram. Yet all sixty-four hexagrams originated from a single straight line and its division into two ; and that first one single line is the origin of everything. Lao Tzu says in his *Tao Te Ching* that one produces two and two produce three and three produce everything and all things. In other words, the original single line produces all things and all things are sprung from one. ' One ' is the beginning of everything ; the word ' one ' represents ' the beginning ' and means ' oneness ' as well. The aesthetics

[215]

Fig. 143

of Chinese art are also centered on this very ' oneness ', and on the very first line or stroke ; for this first line or stroke, set down by a well-disciplined hand, is the seed of any artistic creation. The first aesthetic principle requires the soundness or excellence of the very first movement of the brush.

Shih T'ao, the famous monk-painter of the late seventeenth century, wrote :

> In the ancient days there was no method for the creation of art ; all things were combined in one wholeness. When this very wholeness began to separate, the method for creation started. How did this method start ? It started from ' yi-hua ' or ' one brush-stroke '. This very first ' one brush-stroke ' or ' yi-hua ' is the origin of all compositions and the root of the myriad phenomena. It is innate in the power of the supernatural being but can be employed by men. The method of ' one brush-stroke ' springs from the calligrapher or painter himself.

Although Shih T'ao's discussion of aesthetic principles is concerned with painting, its emphasis on the first stroke of the brush is especially pertinent to calligraphy ; for each Chinese character is built up from one basic brush stroke, on whose degree of excellence depends the excellence of the finished character, and that of the entire piece of calligraphy.

Today a comprehensive Chinese dictionary contains nearly half a million characters, each of which could be regarded as deriving from the first single brush stroke. Of the six methods of constructing new characters, four became aesthetic principles for calligraphy which hold equally true for all other forms of Chinese art. First comes the important principle of ' simplicity ': the simple image of an object should be constructed with the least number of strokes. The second principle applies to characters in which an original, simplified image acquires an extended or

new meaning by the addition of one or more extra strokes. Because the addition suggests something new and distinct from the original meaning we call this aesthetic principle ' suggestiveness ' or ' suggestion '. The third aesthetic principle is born through the construction of characters by logical combination. The meaning of characters formed by combining two or more simple images comes not from a single component but from the significance of the synthesized whole, just as in a painting every element in the work combines to embody the artist's creative idea. This new meaning can be sensed through imagination, so we call this third aesthetic principle ' imagination '. Because the function of the ancient scripts was to record things and events, their construction was as simple and easily recognizable as possible. Each character had to be easily understood by all, so each embodied a universal quality and value. In their later development the characters became, of course, more complex, and their meaning no longer readily apparent : yet the universal quality and value of the ancient scripts remained and inevitably affected the later characters, to give the fourth aesthetic principle of universality '. Universality is necessary for any form of Chinese art, but particularly for calligraphy, since the characters are to be learned by all. A work of Chinese art tends more often to have a universal appeal than an obstruse or complex implication ; a bird, an animal, a flower, or a piece of natural scenery, if well executed, reveals its plain and uninvolved aspect with a philosophically soothing effect.

These four aesthetic principles, together with the fundamental *yi-hua* or ' one brush-stroke ', governed the origin and construction of Chinese characters, which gradually evolved into the fine art of calligraphy—an art form that above all others reflects

the most basic ideals of the Chinese mind. The manipulation of the brush, the general layout of the composition with its balance of the spaces between strokes, the smoothness of the ink, the living movement of the strokes, the strength, harmony, cohesion of all the linear elements would be taken into consideration in judging the merits of a piece of calligraphy, or a painting. Very similar standards also apply to other forms of art such as jade and wood carving, silk tapestry, and ceramics.

The construction of the character provides the calligrapher with every opportunity to display his artistic insight, in the shaping of single strokes, and in each movement of his brush, whether ' forward ' or ' backward ', ' confronting ' or ' backing away ', ' strong ' or ' weak ', ' wet ' or ' dry ', ' fast ' or ' slow ', ' crowded ' or ' sparse ', ' fat ' or ' lean ', ' thick ' or ' thin ', ' connected ' or ' disconnected '. By each movement of the brush, a calligrapher can transform his style. Although Chinese scripts were invented in about the twenty-fifth century B.C., at the dawn of Chinese civilization, the variety of Chinese calligraphic styles has never been exhausted. The countless styles created by innumerable famous calligraphers from one period to another can only be sampled in an introductory book such as this.

In Chapter VII the terms *Fen-Chien* or ' relative division ' and *Pu-Pai* or ' arrangement of spaces ' were illustrated with fourteen of the thirty-six rules set out by Ou-Yang Hsün of the T‘ang dynasty. Each example shows clearly that the characters were not composed symmetrically, with exactly equal components right and left or above and below. The device of an imaginary nine-fold square in the composition of each character gives the component with fewer strokes one third of the total space, while the components with the greater number of strokes

occupies two-thirds; this marks a most important insight into the aesthetic arrangement of the strokes, that it should be asymmetrical rather than symmetrical. Symmetrical arrangement tends to form a pattern, and a pattern means artificiality and lack of free movement. Asymmetrical arrangement tends away from pattern, toward naturalness—freedom and originality. Thus, another important aesthetic principle for the composition of any form of Chinese art aims at asymmetry rather than symmetry: asymmetry is a key word for Chinese composition.

Tu Meng 竇蒙 of the T'ang dynasty (618–905) developed one hundred and twenty expressions to describe different types of calligraphy and to set up criteria for them. The following are nineteen of the more important ones (their names are italicized):

能：千種風流曰能　　A work of *ability* presents a thousand possibilities.

妙：百般滋味曰妙　　*Mysterious* work stirs the imagination.

精：功業雙絕曰精　　A *carefully executed* work demands both inspiration and technique.

逸：縱任無方曰逸　　A *carefree* style has no fixed direction.

穩：結構平正曰穩　　A *well-balanced* composition indicates serenity.

放：流浪不窮曰放　　An *unrestrained* composition implies daring.

老：無心自達曰老　　A *matured* work is free from sentimentality.

壯：力在意先曰壯　　A *virile* work is one in which strength is paramount.

秀：翔集難名曰秀　　A *gracefully executed* work has no peer.

魯：本宗淡泊曰魯　　A *sober* work is one without pretension.

緊：團合密緻曰緊　　A *well-knit* work is one that is both well conceived and well developed.

散：有初無終曰散　　A work that starts well but tails off is called *prolix*.

豐：筆墨相副曰豐　　A work of *richness* implies perfect harmony between brushwork and ink.

茂：字外情多曰茂　　An *exuberant* work is one full of feeling and vigor.

典：從師約法曰典　　A scholastic work can be termed *classical*.

拔：輕駕超殊曰拔　　An *eminent* work has an ease in surpassing others.

貞：骨清神潔曰貞　　A *pure* work is one in which the structure is clean and the feeling fresh.

潤：旨趣調暢曰潤　　A *polished* work is one which is pleasant and harmonious.

神：非意所到可以識知曰神　　A *divine* work is achieved not through human understanding but by intuition.

These nineteen types of calligraphy can be illustrated from the works of the ancient master-calligraphers, but the last, the 'divine', has been achieved by only a few such as Wang Hsi-Chih, Chang Hsü, Monk Huai-Su, Yen Chen-Ch'ing, and Huang T'ing-Chien. How a human being's effort can progress toward the 'divine' may be illustrated by the following story about Cook Ting, told by the philosopher Chuang Tzu (translated by Professor Burton Watson):

Cook Ting was cutting up an ox for Lord Wen-hui. At every touch of his hand, every heave of his shoulder, every move of his feet, every thrust of his knee—zip! zoop! He slithered the knife along with a zing, and all was in perfect rhythm, as though he were performing the dance of the Mulberry Grove or keeping time to the Ching-shou music.

' Ah, this is marvelous ! ' said Lord Wen-hui. ' Imagine skill reaching such heights ! '

Cook Ting laid down his knife and replied, ' What I care about is the Way, which goes beyond skill. When I first began cutting an oxen all I could see was the ox itself. After three years I no longer saw the whole ox. And now—now I go at it by spirit and don't look with my eyes. Perception and understanding have come to a stop and spirit moves where it wants. I go along with the natural makeup, strike in the big hollows, guide the knife through the big openings, and follow things as they are. So I never touch the smallest ligament or tendon, much less a main joint.

' A good cook changes the knife once a year—because he cuts. A mediocre cook changes the knife once a month—because he hacks. I've had this knife of mine for nineteen years and I've cut up thousands of oxen with it, and yet the blade is as good as though it had just come from the grindstone. There are spaces between the joints, and the blade of the knife has really no thickness. If you insert what has no thickness into such spaces, then there's plenty of room —more than enough for the blade to play with it. That's why after nineteen years the blade of my knife is still as good as when it first came from the grindstone.

' However, whenever I come to a complicated place, I size up the difficulties, tell myself to watch out and be careful, keep my eyes on what I'm doing, work very slowly, and move the knife with the greatest subtlety, until—flop! the whole thing comes apart like a clod of earth crumbling to the ground. I stand there holding the knife and look all around me, completely satisfied and reluctant to move on, and then I wipe off the knife and put it away.'

' Excellent ! ' said Lord Wen-hui. ' I have heard the words of Cook Ting and learned how to care for life ! '

A good calligrapher, whenever he comes to ' a complicated place ', should ' size up the difficulties ', tell himself ' to watch out and be careful, keep his eyes on what he is doing, work very slowly ', and move the brush ' with the greatest subtlety ', until something unusual happens to his complete satisfaction though not to his surprise. Cook Ting was no commonplace cook and not every cook could reach his skill. To achieve the ' divine ' in calligraphy requires years of practice ; but for one

[223]

who merely practices, without aesthetic insight and innate artistic power, learning the ' way ' will not be easy. A master-calligrapher, like the master-cook Ting, must reach the point of handling his brush for nineteen years as if it were still new, and of writing as if there were no obstruction like a main joint. The calligrapher will produce a ' *divine* ' work only through knowledge of the ' way '. Lord Wen-hui learned how to care for life, the ' way ' to live well and long, from Cook Ting's words; it is generally believed in China that a calligrapher, by the constant practice of his art, can live well and to a good old age.

XI

THE RELATIONS BETWEEN CALLIGRAPHY
AND OTHER FORMS OF CHINESE ART

IN the preceding chapters various links between calligraphy
and the other graphic and plastic arts have been mentioned.
The reader has probably already perceived that in China
these different genres of art are in less discrete compartments
than they are in the West. The uniting element is *line*. We
call it 'linear rhythm', because that phrase conveys more truly
the beauty of line desired. 'Beauty,' says Sir Herbert Read,[1]
'to use the good medieval definition, is *id quod visum placet*,
that which being seen pleases. And in a very real sense, plastic
form and linear rhythm resolve into the question of visual
comfort. The rhythm of a composition may have other
qualities; it may be static and restful, or dynamic and exciting.
But primarily form in plastic art is related to a pleasant sense
of visual comfort.' There you have in a nutshell the quality
of the line in Chinese art—'a pleasant sense of visual comfort'.

We commonly think of the visual arts as falling under three
heads: painting, sculpture, and architecture. In the West,
painting is subdivided according to the tool or pigment used
—oils, water-colours, drawings, etchings, &c. In China we have
only one important medium—ink: the medium of calligraphy.

[1] '*Art Now*', page 79.

For us, sculpture includes most of the arts which in the West are generically called plastic : engraving on stone ; modelling in earthenware ; the casting of bronze and iron ; engraving on wood ; and the carving of jade.

Architecture comprises not only the planning of buildings but the designing of furniture.

In the pages that follow I propose to discuss Chinese art under these three heads, relating each branch to calligraphy and proving, I hope, that an understanding of calligraphy is necessarily a substantial aid to the comprehension of Chinese art in general.

PAINTING AND CALLIGRAPHY

It is easy to see that no rigid barrier exists between these two arts. I explained in Chapter II how the earliest forms of the written characters can be regarded as pictures ; and although the later forms develop further and further away from direct pictorial representation, it is still possible to trace in them common visual links. There is, for example, a strong similarity between the ' Seal ' characters of the Chou dynasty and the designs on bronzes of the same period.[1] In the Han dynasty, when *Li-Shu*, *K'ai-Shu*, *Hsing-Shu* and *Ts'ao-Shu* were all practised, the linear movements discernible in contemporary paintings bore a marked resemblance to those in these four styles of calligraphy. Han tiles and mirrors, too, engraved with both characters and designs, follow the same principles of *patternization* as Han calligraphy.[1] If you compare the painting of

[1] No paintings from Chou or Han times remain to-day. We are accustomed to think of the designs, after paintings, made on bronzes, tiles, &c., *as* paintings.

Ku K'ai-Chih, an example of which is in the British Museum,[1] with the calligraphy of Wang Hsi-Chih, who lived in the same dynasty, you will notice a similar suppleness of stroke, a distinctive suppleness which was an innovation to both arts.

Chinese art critics continually debate the question whether Chinese painting and calligraphy were in origin the same or independent. Some hold that they sprang from the same root but parted company at an advanced stage of development. I cannot myself see that they have ever diverged far. The technique of the two is still very similar, and precisely the same medium is employed—ink—except that occasionally a few pale or rich colours are added to a painting, for embellishment rather than for their intrinsic qualities. And it cannot be gainsaid that now, as always, monochrome is preferred for most paintings—black monochrome, the ink of calligraphy. Moreover, we customarily speak, not of 'painting' a picture, but of 'writing' it. However the theoreticians may argue, I believe that instinctively the Chinese think of painting and calligraphy as branches of the same art.

The first two essentials of good calligraphy are a simulation of life in the strokes and a dynamic equilibrium in the design. Any Chinese painter would confirm that these are also the first two essentials of painting. Again, in making a piece of writing a calligrapher thinks first of the structure of the single characters with a view to their forming pleasing patterns in themselves; then he considers their arrangement in the whole. A painter devotes himself first to composing each component part of his picture well, then to arranging the parts into the design of the whole.

[1] It is called 'The Admonitions of the Instructress'.

Chinese paintings are far less detailed than most Western paintings, and the equilibrium of line and space has therefore to be very carefully considered. Everything which is not vital to the onlooker's comprehension is eliminated. Or perhaps it would be truer to say, everything which is not essential to the artist's vision : for Chinese painting is essentially ' subjective '; its aim is not to depict an object as it scientifically *is* but as it is seen through the lens of an individual mind. Hence drastic simplification is always effected. But, as I explained in Chapter II, the characters of calligraphy were originally nothing but simplifications of observed objects ; so here is another similarity.

Let me drive the point home with a concrete example. The written character for a tree is a complex of lines embodying the prime attributes of the tree : in later styles it is simply a vertical stroke, representing the trunk, with a horizontal stroke and two oblique strokes for the branches. In many paintings clumps of trees—on the side of a mountain or along a river-bank—are shown thus or even simply by clusters of vertical strokes. Perspective and chiaroscuro are ignored alike in painting and calligraphy.

Every calligrapher strives to attain, within the bounds of tradition and good taste, a striking and unusual style. The counterpart of this in painting is an element of the grotesque. A painter will tend to exaggerate some part or object in order to emphasize his personal approach.

In the West a painting is said to be a work of art if it has what is called ' quality '. In China we call this necessary element Rhythmic Vitality. It is the first thing we look for in a painting, and we require that it shall be present not only in the picture as a whole but in each separate stroke. We object

to the presence of a single 'dead' stroke. Now, the power to imbue strokes with life is acquired from training in calligraphy, in the manner described in Chapter VIII. 'Writing' lines are used very extensively in Chinese paintings, which indeed are built up of them. Even solid objects usually have their contours outlined, and the merit of a picture is largely estimated by the excellence with which these structural lines are formed and placed. They seldom run continuously round the object. Except in delicate or elaborate work we prefer to use a few simple and carefully selected strokes to convey the essentials of the form. A 'dead' stroke among these few is very apparent and causes visual discomfort to the onlooker.

You have probably noticed how partial the Chinese are to flower paintings. Orchids, chrysanthemums, the blossoms of winter plums and cherry trees are perpetually recurring subject-matter. I am convinced that one of the reasons for this is that the stems, leaves, branches, and petals of these natural growths lend themselves so well to calligraphic brush treatment—that treatment in which is embodied the 'rhythmic life' that is the essence of a painting, whether it is in colour or in monochrome.

SCULPTURE AND CALLIGRAPHY

The similarity here is not nearly so immediately apparent as that between painting and calligraphy, but it is none the less present. In my opinion the somewhat extreme simplicity of our carved, engraved, modelled, or cast forms derived in the first instance a good part of their inspiration from calligraphy. I do not mean that our craftsmen and sculptors had definite calligraphic models in mind when they worked, but that their

early training must have so familiarized them with the shapes and patterns of writing that these patterns emerged in their sculptured or engraved designs.

There is a great variety of design in early Chinese pottery. An almost sophisticated individuality seems sometimes to have possessed its creators, to which they sacrificed even regularity and utility. I give below seven different forms of the character *Hu*, ' pot ', in the ancient script.

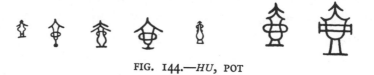

FIG. 144.—*HU*, POT

A comparison of these with those real pots which one might have seen in the Chinese Exhibition in London or in some big museum leaves no doubt in the mind that the two were contemporaneous. The earliest inventors of handwriting modelled their characters upon actual objects, but I am not at all sure that the earliest pot-makers did not find some of their patterns among the already beautified forms of characters. At any rate the characters had *some* effect on the pots.

You have probably noticed that the animal forms carved upon stone, jade and bronze are far from realistic, but possibly you have not noticed how closely the principles of simplification employed by the artists correspond with those practised by the precedent calligraphers who invented the characters for the same animals. The examples in Plate XXII show the resemblance clearly.

I could easily multiply examples to prove the impression I have had for a long time that almost all Chinese carving followed

the designs of the ancient script ; but it is not my object in this book to prove such points. The examples given amply show that some connexion existed between the two arts, and I need not go further.

Chinese bronzes of the 12th and 13th centuries B.C. are as varied in form as the pottery. They are rarely symmetrical, for the Chinese have always found asymmetry agreeable, and this preference enlarges the variety of possible forms.

Ancient jades are usually simple in design, but even the simplest of them have unmistakable aesthetic quality. A few bear engravings of dramatic stories ; the majority have only natural objects, stylised for the purpose. The bronze fish in Plate XXII, for example, bears little resemblance to any fish that ever swam in water, but nevertheless indubitably 'lives'. Its life is the life of art—the life that stirs in the strokes of a good calligrapher.

The most characteristic Chinese sculptures are the figures of Buddhist and Taoist deities : figures which to many Western people are the very emblem of Chinese art. Here again realism is absent. Neither the expressions of the figures nor their proportions are life-like in the way that many Christian pictures are life-like. Philosophic ideas are conveyed in the modelling of the faces and the attitudes of the figures. Philosophic and religious ideas do not, of course, themselves vary from epoch to epoch, but it is not so much these which are depicted in the sculptures as the artists' personal responses to the Buddhist and Taoist religions. The power of Chinese sculpture depends not upon mass, as in the West, so much as upon *line*. From the smallest jade to the most colossal Buddhist image, line is the distinctive quality. In the huge figures, where delicacy of feature is not

attainable, the beauty lies in the folds of the drapery—line again. And the quality of this line derives from calligraphy.

In modern sculpture the prevailing tendency is towards the simple and 'primitive'. The following characters from ancient

FIG. 145

Chinese script are characteristic specimens of the designs drawn upon. Their analogy with the designs frequently to be seen

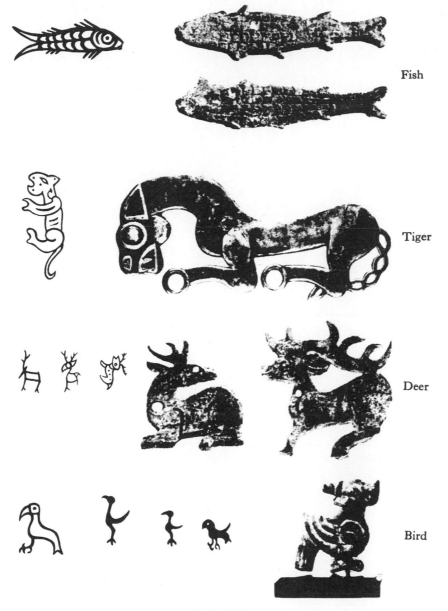

Fish

Tiger

Deer

Bird

PLATE XXII

Early Calligraphy Forms *compared with* Sculptured Forms

in the West to-day prompts the suggestion that European sculptors too might do well to give some attention to ancient Chinese script.

In calligraphy the essential *nature* only of the object is depicted ; and to this the sculptor adds perhaps a few judicious touches to make his work more lively. All the finest examples of Chinese sculpture possess in a high degree this almost uncanny alliance of liveliness and abstract beauty.

ARCHITECTURE AND CALLIGRAPHY

The suggestion that there is anything fundamentally in common between calligraphy and architecture probably sounds far-fetched. Yet I can affirm that there is no type of Chinese building—pavilion, terrace, temple, bower, or house—whose harmony and form are not derived from calligraphy.

Architecture makes no attempt, either in the West or in the East, to imitate nature. It has been called the most abstract of the arts. Its basis is utilitarian and its laws are its own. The first buildings were, it is evident, not intended to be aesthetic objects, but just piles of stone or timber to provide shelter from rain and wind. The builder's task was to find the way to erect his edifice in the most stable and convenient manner. Many plans were no doubt tried before a satisfactory shape was found and the builder could turn his attention to artistic considerations.

Now consider the developing forms of the character *Shih*, ' house ', in the ancient script. Sixteen forms are shown in Fig. 144. The first three depict crude shelters ; but it is clear from the last five that in time houses came to have their walls decorated in recognized ways.

[233]

Shih (室), ' house '

T'ing (亭), ' bower '

FIG. 146

Did the ancient builders invent these (comparatively) elaborate designs for their own purposes and the calligraphers follow them, or were the designs suggested by primitive writing forms? I am considering, remember, two *arts*: obviously there could be no character for a house before houses existed; but when conscious design appeared, was it the work of architects or calligraphers? No positive answer can be given. Probably the two groups of artists influenced one another. But at least it can be said that one of the most typical forms in Chinese architecture, the sagging roof, must surely have come from calligraphy. In ancient script the roof of a house is represented by an inverted ' V '. And that is the roof-shape of most primitive dwellings; indeed, it is the roof-shape of the thatched cottages of Chinese peasants to this day. But in later script an added grace was given to the inverted ' V ' by making it

[234]

slightly curved. And, parallel with this change, the roofs of houses began to curl.

FIG. 147

But the influence of calligraphy upon architecture is usually more subtle than this. It can be discerned in the general structure, the form and proportions, of buildings. The Chinese do not hide the supporting framework of their buildings. The skeleton—the pillars, rafters, and beams—is left visible both outside and inside. The pillars, which are usually of wood, are naturally erected first, then the beams and rafters, then the walls are merely filled in with bricks and the roof covered with tiles. The structure has to be balanced firmly on its foundations just as a character has to be poised on its base in the manner described on pages 171–2.

An even more interesting connexion between calligraphy and architecture is the use made by architects of the shapes of characters for their ground plans. The buildings sometimes follow the characters Chung (中) and Pin (品) in the disposition of the rooms, halls, and courtyards.

Architectural detail too has characters incorporated in its designs. Windows and fences in particular show this. Glass windows were introduced into China only recently; formerly the window-spaces were filled with wooden lattice work covered with thin paper. The lattice work was often elaborately carved into characters with propitious meanings such as 'Happiness', 'Longevity', 'Kindness', and so on.

[235]

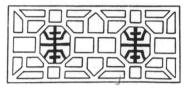

Shou (壽), ' Longevity '

Fu (福), ' Happiness '

FIG. 148

* * *

SEAL-ENGRAVING is one of the most characteristic forms of Chinese art. I might have included it in the present chapter under Sculpture, for it is carried out with cutting tools. But its relation to calligraphy is so obvious—it is, indeed, actually a form of calligraphy—that I have preferred to deal with it separately. Most Europeans have seen on the bottoms of pieces of Chinese porcelain small marks, usually in red, which are generally known as seals, *Yin* (印). These are merely period marks and have no aesthetic value. The seals with which we are here concerned are the personal stamps of artists, in which the arrangements of the characters, the shaping of the strokes, and the patterns, are all carefully worked out and stylized. The practice of cutting seals has been going on in China since the Chou dynasty, and there have been many changes of style from

FIG. 149.—ANCIENT SEALS OF
CHOU AND CH'IN PERIOD
(周秦古璽)

FIG. 150.—SEAL OF
HAN PERIOD
(漢官印)

FIG. 151.—OFFICIAL SEALS OF CHIN PERIOD
(金官印)

FIG. 152.
By Chao Meng-Fu
of Yüan dynasty

[237]

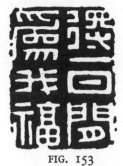

FIG. 153

By Wên P'êng (文彭)
of Ming dynasty

FIG. 154

By Hsü San-Kêng (徐三庚)
of Ching dynasty

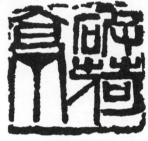

FIG. 155

By Wu Ch'ang-Shih

FIG. 156

By Chao Chih-Ch'ien

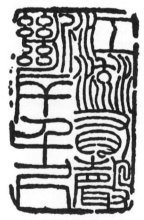

FIG. 157

By Têng Shih-Ju

period to period. The examples given on the two previous pages speak for themselves and should be studied carefully. The art is a subtle one, requiring great manual skill as well as skill in designing. The quality of the seal is often made the final test of a possibly counterfeit painting.

* * *

To summarize : In China, anything which can claim to be a work of art has some connexion, obvious or subtle, with calligraphy. The common factor may lie in the design itself or in the introduction of some calligraphic *motif*. Further, many forms of Chinese art have actual writing upon them—to fill awkward blanks, complete a design, or add some meaning. We frequently, for example, write poems or descriptions on pictures and sculptures, and even on walls and pillars. The smallest *objet d'art* bears, for preference, one or two characters.

But we do not regard calligraphy as merely, or even primarily, an embellishment for other arts. We consider it to be itself the chief of all the arts. Without an appreciative knowledge of it no real understanding is possible of the Chinese aesthetic.

BIBLIOGRAPHY

FOR those acquainted with the Chinese language and desirous of making a closer study of calligraphy than the present work affords, the following books are recommended. I give only a handful of titles under each head because the available literature in each case is enormous and confusing.

(1) On the Origin and Construction of the Characters and their Modifications.

許慎 Hsü Shen: 說文解字 ' Shuo-Wên-Chui-Tzŭ '

華石斧 Hua Shih-Fu: 國文探索一斑 ' Kuo-Wên-T'an-So-I-Pan '

蔣善國 Chiang Shan-Kuo: 中國文字之起源及其構造 Chung-Kuo-Wên-Tzŭ-Chih-Ch'i Yüan-Chi-Ch'i-Kou-Tsao '

呂思勉 Lü Szŭ-Mien: 中國文字變遷考 Chung-Kuo-Wên-Tzŭ-Pien-Ch'ien-K'ao

顧實 Ku shih: 中國文字學 ' Chung-Kuo-Wên-Tzŭ-Hsüeh '

(2) On the Ancient Scripts.

羅振玉 Lo Chên-Yü: 殷虛書契考釋 ' Yin-Hsü-Shu-Ch'i-K'ao-Shih '

阮元 Yuan Yüan: 集古齋鐘鼎彜器款識 ' Chi-Ku-Ch'ai-Chung-Ting-I-Ch'i-K'uan-Shih '

高田忠周 Takada Tadachika: 古籀篇 and 學古發凡 ' Ku-Chou-Pien ' and ' Hsueh-Ku-Fa-Fan '

(3) Historical.

米芾 Mi Fei: 書史 ' Shu-Shih '

毛晉 Mao Chin: 宣和書譜 ' Hsüan-Ho-Shu-Pu '

陳繼儒 Chen Chi-Jü: 書畫史 ' Shu-Hua-Shih '

陶九成 T'ao Chiu-Ch'êng: 書史會要 ' Shu-Shih-Hui-Yao '

(4) Comprehensive Treatises on Theory and Technique.

宋曹 Sung Ts'ao: 書法約言 ' *Shu-Fa-Yüeh-Yen* '

汪挺 Wang-T'ing: 書法粹言 ' *Shu-Fa-Ts'ui-Yen* '

項穆 Han Mu: 書法雅言 ' *Shu-Fa-Ya-Yen* '

蔣驥 Chiang Chi: 續書法論 ' *Hsü-Shu-Fa-Lun* '

姚孟起 Yao Meng-Ch'i: 字學憶參 ' *Tzû-Hsüeh-i-Ts'an* '

魯一貞 Lu I-Chen
張延相 Chang T'ing-Hsiang } 玉燕樓書法 ' *Yü-Yen-Lou-Shu-Fa* '

何良俊 Ho Liang-Chün: 四友齋書論 ' *Szu-Yu-Ch'ai-Shu-Lun* '

包世臣 Pao Shih-Ch'en: 藝舟雙楫 and 戈守智 ' *Yi-Chou-Shuang-Chi* ' and ' *Shu-Fa-Chin-Liang* '

康有為 K'ang Yu-Wei: 廣藝舟雙楫 ' *Kuang-Yi-Chou-Shuang-Chi* '

(5) Practical Advice on the Elements of Theory and Technique.

戈守智 Ko Shou-Chih: 漢溪書法通解 ' *Han-Ch'i-Shu-Fa-T'ung-Chieh* '

馮武 Fêng Wu: 書法正傳 ' *Shu-Fa-Chêng-Chuan* '

陳彬龢 Cheng Ping-Ho: 中國文字與書法 ' *Cheng-Kuo-Wên-Tzŭ-Yü-Shu-Fa* '

王大錯 Wang-Ta-Ts'o: 書法指南 ' *Shu-Fa-Chih-Nan* '

(6) Lastly I will mention two books not directly connected with our subject

梁聞山 Liang Wên-Shan: 評書帖 ' *P'ing-Shu-T'ieh* '

歐陽甫 Ou-Yang Fu: 集古求真 *Chi-Ku-Ch'iu-Chên* '

　　These contain discussions, from more personal angles, of ancient rubbings and masterpieces. They will be found very useful in selecting specimens.

INDEX

[243]

INDEX

INDEX

INDEX

INDEX

INDEX

INDEX

INDEX